green | designed

Ulrich Bethscheider-Kieser

Future Cars

BIO FUEL . HYBRID . ELECTRIC . HYDROGEN . FUEL ECONOMY IN ALL SIZES AND SHAPES

BIO-TREIBSTOFF . HYBRID . ELEKTRO . WASSERSTOFF . SPARSAME AUTOS IN ALLEN KLASSEN UND FORMEN

avedition

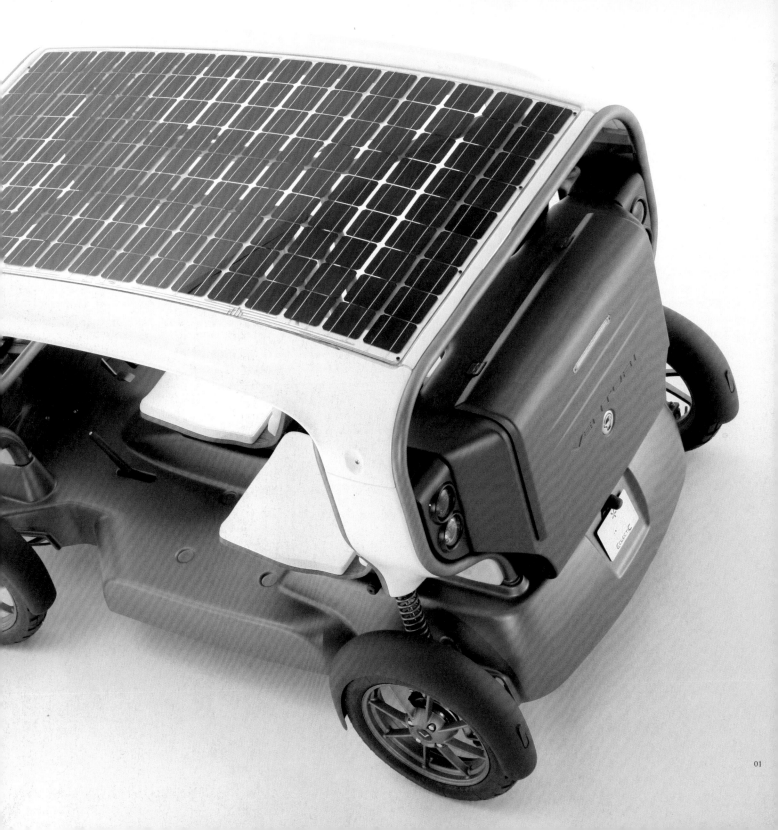

EDITORIAL		4	
BIO FUEL	BIO-TREIBSTOFF		
Daimler AG	Mercedes-Benz E 200 NGT	8	
Rinspeed AG	Rinspeed Exasis	10	
Saab	Saab Aero X	14	
HYBRID	HYBRID		
Audi AG	Audi Metroproject Quattro	18	
Audi AG	Audi Q7 Hybrid	22	
BMW AG	BMW Concept X6 ActiveHybrid	24	
Automobiles Citroën	Citroën C4 Hybrid HDi	28	
Automobiles Citroën	Citroën C-Cactus	30	
General Motors	GMC Graphyte	34	
General Motors	Chevrolet Tahoe Hybrid	38	
Honda Motors	Honda CR-Z	40	
Hyundai Motor	Hyundai i-Blue	44	
Toyota Motor Corporation	Lexus LS 600h	46	
Mazda	Mazda Senku	50	
Mazda	Mazda Premacy Hydrogen RE Hybrid	54	
Daimler AG	Mercedes-Benz F 700	56	
Daimler AG	Mercedes-Benz S 300 Bluetec Hybrid	62	
Automobiles Peugeot	Peugeot 308 HybridHDi	64	
Saab	Saab Bio Power 100	66	
Toyota Motor Corporation	Toyota 1/X	70	
Toyota Motor Corporation	Toyota FT-HS	74	
Toyota Motor Corporation	Toyota Hybrid X	78	
Toyota Motor Corporation	Toyota Prius	82	
Volkswagen AG	VW Space Up! Blue	84	
Fisker Automotive Inc.	Fisker Karma	88	
ELECTRIC	ELEKTRO		
Aptera Motors	Aptera Typ-1	90	
General Motors	Chevrolet Volt	94	
Commuter Cars	Tango T600	100	
Nissan Motor Co., Ltd.	Nissan Mixim	102	
Nissan Motor Co., Ltd.	Nissan Pivo 2	108	
Daimler AG	Smart Fortwo ed & mhd	112	
Tesla Motors	Tesla Roadster	114	
Fuji Heavy Industries Ltd.	Subaru G4e Concept	118	
Venturi Automobiles	Venturi Astrolab	120	
Venturi Automobiles	Venturi Eclectic	122	
Venturi Automobiles	Venturi Fetish	124	
Adam Opel AG	Opel Flextreme	128	
Volvo	Volvo C30 ReCharge Concept	134	
Think	TH!NK city	138	
HYDROGEN	WASSERSTOFF		
BMW AG	BMW Hydrogen 7	140	
General Motors	Chevrolet Equinox Fuel Cell	142	
Ford Motor Company	Ford Airstream Concept	144	
Honda	Honda FCX Clarity	146	
Daimler AG	Mercedes-Benz B-Class Fuel Cell	150	
Automobiles Peugeot	Peugeot 207 Epure	152	
FUEL ECONOMY	SPARSAME AUTOS		
Loremo AG	Loremo LS & GT	156	
Daimler AG	Mercedes-Benz Bionic Car	162	
IMPRINT / PHOTO CREDITS		168	

01 02

A Green Ride

Oil is an expensive commodity, and it is also limited. Experts presume that the supplies of the valuable raw material will be exhausted in 50 years. How long the classic combustion engine will be the basic drive in cars is therefore just a question of time. This is especially true because the car, as one of the many causes of CO_2 emissions, contributes to environmental pollution and climate change. As a result, car manufacturers are intensively working on new concepts. On the one hand, this is a race of the systems in which the engineers are placing

the hybrid drive—the combination of combustion engine and electric motor—at the focus of attention. Some of these are already in series production while others are almost there. However, on the other hand, this is also a matter of concepts that produce either no exhaust fumes, at least not directly at the car, or just a minimum amount. A realistic path is shown by the vehicles with an electric motor that refuel with electricity from the outlet. But their range is limited. The challenge for the manufacturers and suppliers is therefore to also increase the efficiency,

reliability, and safety of batteries. The idea that cars will one day drive in cities and no longer produce exhaust fumes is a beautiful vision. But electricity, as long as it comes from the outlet, must first be manufactured somewhere else – and this sometimes also creates CO_2 emissions. Unless the electrical energy comes from regenerative and therefore eco-friendly sources. An even better idea is to have the eco-friendly energy suppliers directly on board. The fuel cell that delivers energy from hydrogen and oxygen, producing only steam as exhaust, is

already approaching series production—even if this is only in small series and (still) involves immense costs. But the hydrogen required for the drive must also first be produced with the respective expenditure of energy. Not to mention an extensive network of filling stations. Many concepts of alternative drives have already been realized, but many more are brought to fruition in the development departments of the vehicle manufacturers. Especially the concept cars, which allow a glimpse of the future as the bearers of visions, are a distinct expression of utmost creativity—not only in the technical perspective but also in their design. Far away from the pressures of everyday traffic and registration regulations, they allow their shapes to play and display new paths of design. And, as this book demonstrates, they are simultaneously geared to the eco-friendly future of the car—in other words, green design.

Ulrich Bethscheider-Kieser

01 | Saab Aero X

02 | Citroën C-Cactus

03 | VW Space Up! Blue

04 | Chevrolet Volt

05 06

Fahrt ins Grüne

Erdöl ist ein teures Gut, und endlich ist es überdies. Experten vermuten, dass die Vorräte des wertvollen Rohstoffs in 50 Jahren erschöpft sein werden. Daher ist es nur eine Frage der Zeit, wie lange klassische Verbrennungsmotoren den entscheidenden Antrieb im Auto stellen werden. Zumal das Auto als einer von vielen Verursachern von CO_2-Ausstoß seinen Teil zu Umweltverschmutzung und Klimawandel beiträgt. Intensiv arbeiten daher die Autohersteller an neuen Konzepten. Es ist ein Wettlauf der Systeme, in dem die Ingenieure einerseits den Hybridantrieb

– die Kombination von Verbrennungs- und Elektromotor – in den Mittelpunkt stellen. Teils schon in der Serienfertigung, teils kurz davor. Doch es geht andererseits auch um Konzepte, die zumindest unmittelbar am Auto keine oder nur wenige Abgase produzieren. Einen realistischen Weg zeigen die Fahrzeuge mit Elektromotor auf, die mit Strom aus der Steckdose betankt werden. Doch deren Reichweite ist begrenzt. Die Herausforderung für die Hersteller und Zulieferer liegt also auch darin, die Effizienz, Zuverlässigkeit und Sicherheit von Batterien zu

erhöhen. Dass eines Tages Autos in den Städten fahren, die keine Abgase mehr produzieren, ist eine schöne Vision. Der Strom muss aber, sofern er aus der Steckdose kommt, andernorts erst hergestellt werden – und das geht mitunter nicht ohne CO_2-Ausstoß. Es sei denn, die elektrische Energie wird aus regenerativen und somit umweltschonenden Quellen gewonnen. Noch besser ist es, den umweltfreundlichen Energielieferanten direkt an Bord zu haben. Die Brennstoffzelle, die Energie aus Wasserstoff und Sauerstoff liefert und als Abgas nur Was-

Bio-Treibstoff . Hybrid . Elektro .Wasserstoff . Sparsame Autos in allen Klassen und Formen

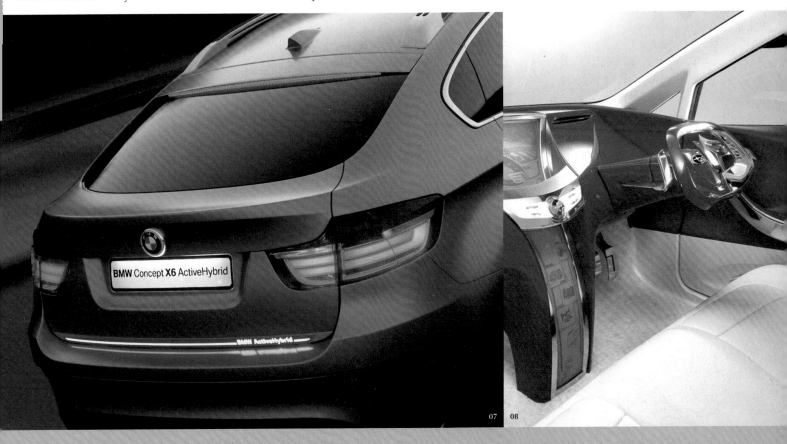

07 | 08

serdampf produziert, nähert sich bereits der Serienfertigung – wenn auch nur in Kleinserien und zu (noch) immensen Kosten. Aber auch der für den Antrieb notwendige Wasserstoff muss mit entsprechendem Energieaufwand erst gewonnen werden. Ganz zu schweigen von einem flächendeckenden Tankstellennetz. Viele Konzepte alternativer Antriebe sind heute schon realisiert, noch viel mehr reifen in den Entwicklungsabteilungen der Fahrzeughersteller. Gerade die Concept-Cars, die als Träger von Visionen einen Blick in die Zukunft erlauben,

sind ein deutlicher Ausdruck höchster Kreativität – nicht nur in technischer Sicht, sondern auch in ihrem Design. Fernab der Zwänge von Alltagsverkehr und Zulassungsbestimmungen lassen sie ihre Formen spielen, zeigen neue gestalterische Wege. Und sind dabei, wie dieses Buch zeigt, gleichzeitig auf die umweltfreundliche Zukunft des Autos eingestellt – eben green designed.

Ulrich Bethscheider-Kieser

05 | Mazda Senku

06 | Nissan Mixim

07 | BMW Concept X6 ActiveHybrid

08 | Subaru G4e Concept

Data and Facts	E 200 NGT
Engine Type \| Antriebsart	gasoline petroleum gas Benzin-Erdgas
Status \| Status	2004
Displacement \| Hubraum	1796 cm³
Output \| Leistung	120 kW; 163 HP \| PS
Fuel Consumption \| Verbrauch	26 mpg \| 9 l/100 km
CO₂ Emission \| CO₂-Ausstoß	168-215 g/km
Cruising Range \| Reichweite	621 mi \| 1000 km
Acceleration \| Beschleunigung	10.7 s (0-60 mph \| 0-100 km/h)
Max. Speed \| Geschwindigkeit	141 mph \| 227 km/h

Mercedes-Benz E 200 NGT | Daimler AG

Really Stepping on the Gas | Wirklich Gas geben
www.daimler.com

Natural-gas drive represents one possibility of noticeably reducing CO_2 emissions without extensive technical efforts. In comparison to conventional gasoline propulsion, natural gas produces about 20 percent less carbon dioxide. Since 2004, Mercedes-Benz has offered the E-Class as E 200 NGT (Natural Gas Technology) in series production. The natural-gas drive is not only kind to the environment, but also to the wallet. Because natural gas is available for considerably less than gasoline, the operating costs are reduced—and this is especially attractive for people who are on the road a lot. The 163 HP four-cylinder engine of the E 200 NGT has a bivalent drive system, which means that it can also use con-ventional gasoline. Once the supply in the gas tank is exhausted, the E-Class continues to drive with super unleaded gasoline. This also increases the maximum distance to about 621 miles. Drivers can decide which propulsion energy to use: With the help of the buttons on the multi-function steering wheel and the central display in the combi instrument, they can switch between natural gas and gasoline. A special electronic control unit provides a gentle, smooth transfer and individually controls the process for each cylinder.

Erdgasantrieb stellt eine Möglichkeit dar, ohne großen technischen Aufwand die CO_2-Emssionen deutlich zu verringern. Im Vergleich zum konventionellen Benzinantrieb produziert Erdgas rund 20 Prozent weniger Kohlendioxid. Seit 2004 bietet Mercedes-Benz die E-Klasse als E 200 NGT (Natural Gas Technology) in Serie an. Der Erdgasantrieb schont nicht nur die Umwelt, sondern auch den Geldbeutel. Weil Erdgas erheblich günstiger als Benzin angeboten wird, reduzieren sich die Betriebskosten – das ist besonders für Vielfahrer attraktiv. Der 163 PS starke Vierzylindermotor des E 200 NGT ist bivalent ausgelegt, er kann also auch mit konventionellem Benzin fahren. Ist der Vorrat der Gastanks erschöpft, fährt die E-Klasse mit bleifreiem Superbenzin weiter. Nebenbei erhöht sich so die maximale Reichweite auf rund 1000 Kilometer. Der Autofahrer entscheidet selbst, welche Antriebsenergie zum Einsatz kommen soll: Mit Hilfe der Tasten im Multifunktionslenkrad und des Zentral-Displays im Kombi-Instrument kann er zwischen Erdgas und Benzin umschalten. Eine spezielle elektronische Steuerung sorgt für einen sanften, ruckfreien Wechsel und steuert die Umschaltung für jeden Zylinder einzeln.

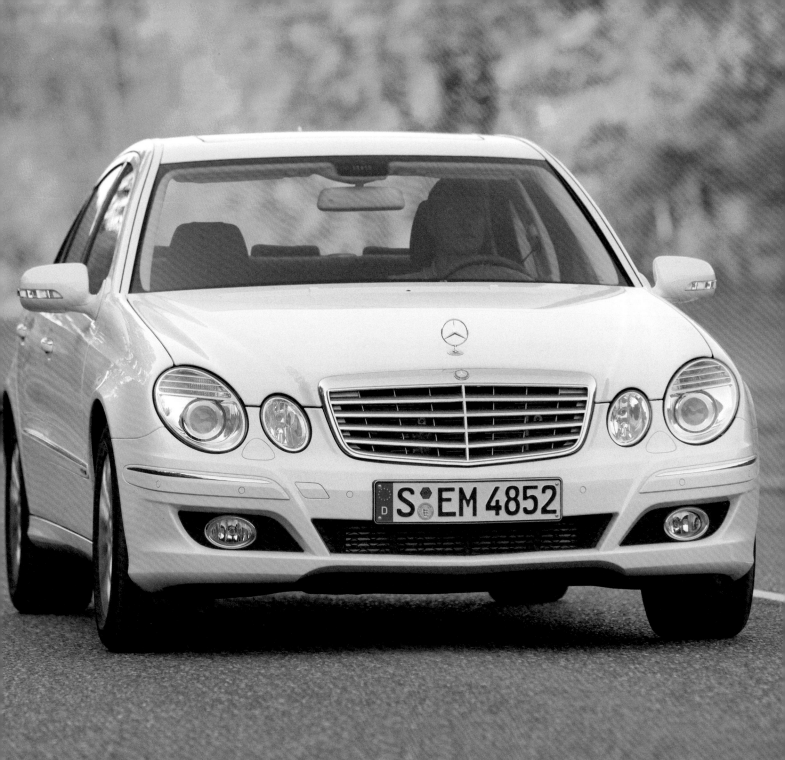

Data and Facts		Exasis
Engine Type \| Antriebsart		bioethanol \| Bioethanol
Status \| Status		concept car
Displacement \| Hubraum		750 cm³
Output \| Leistung		110 kW; 150 HP \| PS
Fuel Consumption \| Verbrauch		no data \| keine Angaben
CO₂ Emission \| CO₂-Ausstoß		no data \| keine Angaben
Cruising Range \| Reichweite		no data \| keine Angaben
Acceleration \| Beschleunigung		4.8 s (0-60 mph \| 0-100 km/h)
Max. Speed \| Geschwindigkeit		130 mph \| 210 km/h

Rinspeed Exasis | Rinspeed AG

Swiss Insight | Schweizer Einsichten

www.rinspeed.com

The Swiss Frank M. Rinderknecht actually operates a company that specializes in tuning. But he surprises the car world time and again at the annual Geneva Automobil Salon with unusual concept cars. Rinderknecht created an especially light and, above all, transparent vehicle with the Exasis that was presented in 2007. The open sports car that is only 4.2 feet tall has a transparent body and a body platform made of polycarbonate plastic Makrolon. The Exasis is driven by a light two-cylinder engine that is customarily used in snow-mobiles. Despite its small cubic capacity of 750 cubic centimeters, it delivers 150 HP. The Exasis is eco-friendly because of its light construction and the type of fuel it uses. The two-cylinder works with bioethanol (E85). This fuel is composed of 85 percent ethanol and 15 percent regular gasoline. Ethanol is a renewable bio-fuel that is mostly CO_2-neutral when it is burned. The Exasis has also awakened interest on the political level. The concept car was created with the participation of the Swiss Federal Office of Energy (BFE), which gained insights about energy efficiency through the lightweight construction and energy supply with renewable energy.

Der Schweizer Frank M. Rinderknecht betreibt eigentlich ein auf Tuning spezialisiertes Unternehmen. Doch zum alljährlich stattfindenden Genfer Automobilsalon überrascht er die Autowelt immer wieder mit außergewöhnlichen Concept-Cars. Mit dem 2007 vorgestellten Exasis schuf Rinderknecht ein besonders leichtes und vor allem durchsichtiges Fahrzeug. Der offene, nur 1,28 Meter hohe Sportwagen besitzt eine transparente Karosserie und eine aus dem Polycarbonat-Kunststoff Makrolon gefertigte Bodengruppe. Für den Antrieb des Exasis sorgt ein leichter Zweizylindermotor, der gewöhnlich in Schneemobilen zum Einsatz kommt und trotz seines geringen Hubraums von 750 Kubikzentimetern 150 PS leistet. Umweltfreundlich ist der Exasis durch den Leichtbau und den verwendeten Treibstoff. Der Zweizylinder arbeitet mit Bioethanol (E85). Dieser Kraftstoff besteht zu 85 Prozent aus Ethanol und 15 Prozent herkömmlichem Benzin. Ethanol ist ein erneuerbarer Biotreibstoff und bei seiner Verbrennung weitgehend CO_2-neutral. Interesse hat der Exasis auch auf politischer Ebene erweckt. Das Concept-Car entstand unter Mitwirkung des Schweizer Bundesamtes für Energie (BFE), das Erkenntnisse über Energieeffizienz durch Leichtbau und Energieversorgung mit erneuerbarer Energie gewann.

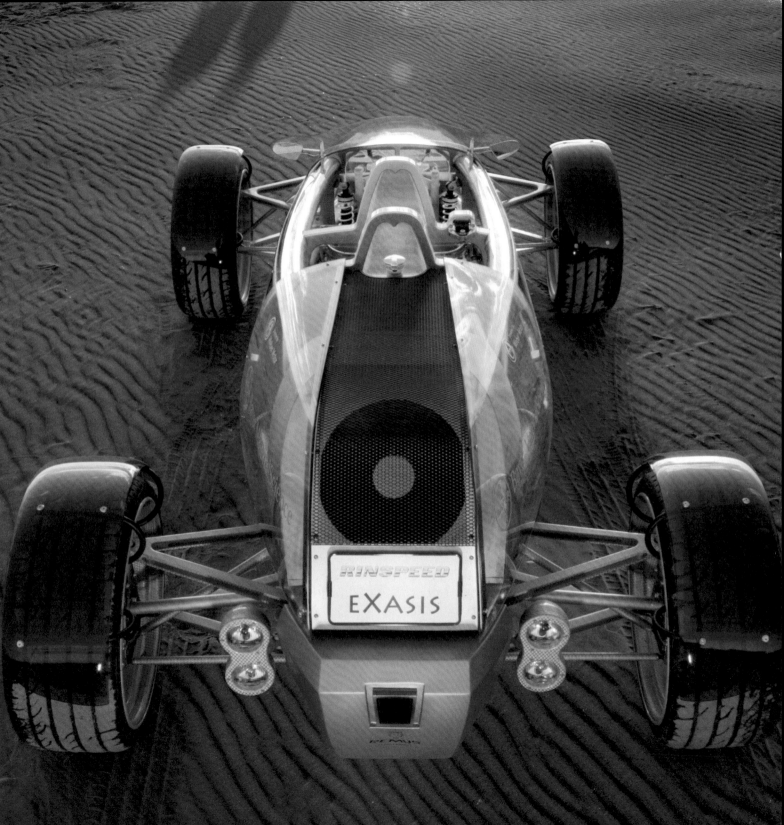

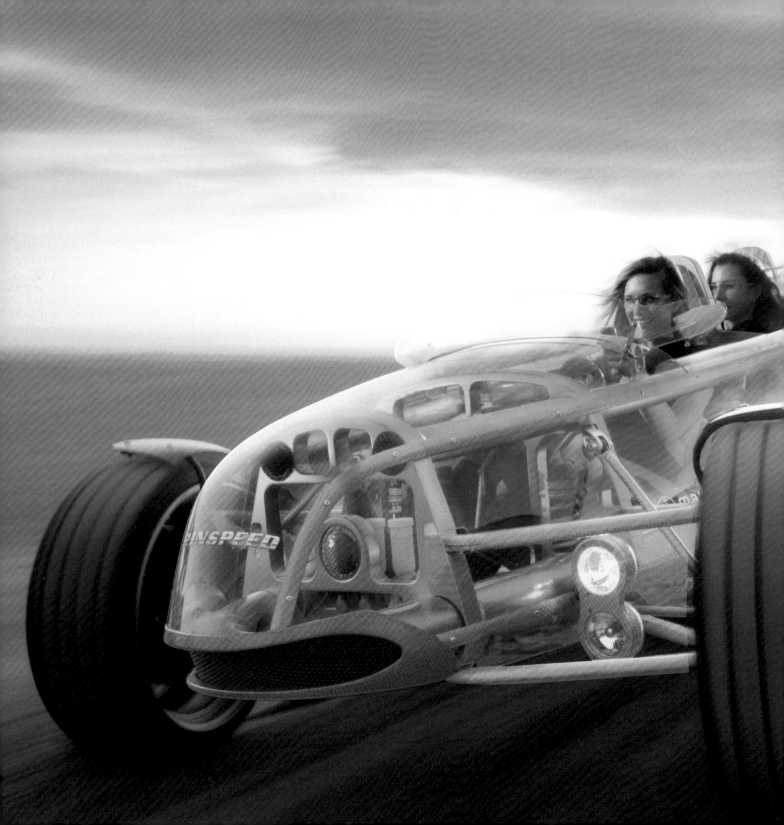

Data and Facts		Aero X
Engine Type \| Antriebsart		ethanol \| Ethanol
Status \| Status		concept car
Displacement \| Hubraum		2792 cm³
Output \| Leistung		294 kW; 400 HP \| PS
Fuel Consumption \| Verbrauch		no data \| keine Angaben
CO₂ Emission \| CO₂-Ausstoß		no data \| keine Angaben
Cruising Range \| Reichweite		no data \| keine Angaben
Acceleration \| Beschleunigung		4.9 s (0-60 mph \| 0-100 km/h)
Max. Speed \| Geschwindigkeit		155 mph \| 250 km/h

Saab Aero X | Saab

Just Like Flying | Wie im Flug
www.saab.com

Many people do not know that the Swedish brand Saab has its roots in aviation. However, this fact can be seen in the name because Saab has stood for Svenska Aeroplan Aktiebolaget since 1937. With this background, it's no wonder that the concept car Aero X, which was introduced at the beginning of 2006, clearly has visual similarities with an airplane. The dynamic study is intended to reflect the impression of a jet in particular by emphasizing the cockpit for the pilot. The glass roof, which opens from the front, is one of the most conspicuous details of this vehicle. The windshield, which has the panorama typical of Saab's brand concept, has been developed even more intensely in the Aero X so that dispensing with the A-pillar reveals a 180-degree perspective for the driver. A remote control opens the windshield and roof for entry. The low height of just 4.2 feet underscores the sporty character of the study. This is matched by the drive, which is presented as high-powered on the one hand and eco-friendly on the other. The V-six-cylinder engine is oriented toward operation with E100, the 100-percent bioethanol.

Dass die schwedische Marke Saab ihre Wurzeln in der Fliegerei hat, ist vielen unbekannt – dabei offenbart sich diese Tatsache bis heute im Namen, denn Saab steht seit 1937 für Svenska Aeroplan Aktiebolaget. Vor diesem Hintergrund verwundert es nicht, dass das Anfang 2006 vorgestellte Concept-Car Aero X optisch deutliche Anleihen an einem Flugzeug nimmt. Die dynamische Studie soll die Anmutung eines Düsenjets widerspiegeln, in dem das Cockpit für den Piloten besonders betont wird. Das von vorne zu öffnende Glasverdeck ist eines der auffälligsten Fahrzeugdetails. Die nach dem Saab-Verständnis markentypische Panorama-Frontscheibe wurde beim Aero X noch stärker entwickelt, so dass sich dem Fahrer durch den Verzicht auf die A-Säulen eine 180-Grad-Perspektive offenbart. Durch eine Fernbedienung lassen sich Frontscheibe und Dach für den Einstieg öffnen. Die niedrige Höhe von nur 1,27 Metern unterstreicht den sportlichen Charakter der Studie. Dazu passt der Antrieb, der sich einerseits leistungsstark, andererseits umweltfreundlich präsentiert. Der V-Sechszylindermotor ist auf den Betrieb mit E100, dem 100-prozentigen Bioethanol, ausgerichtet.

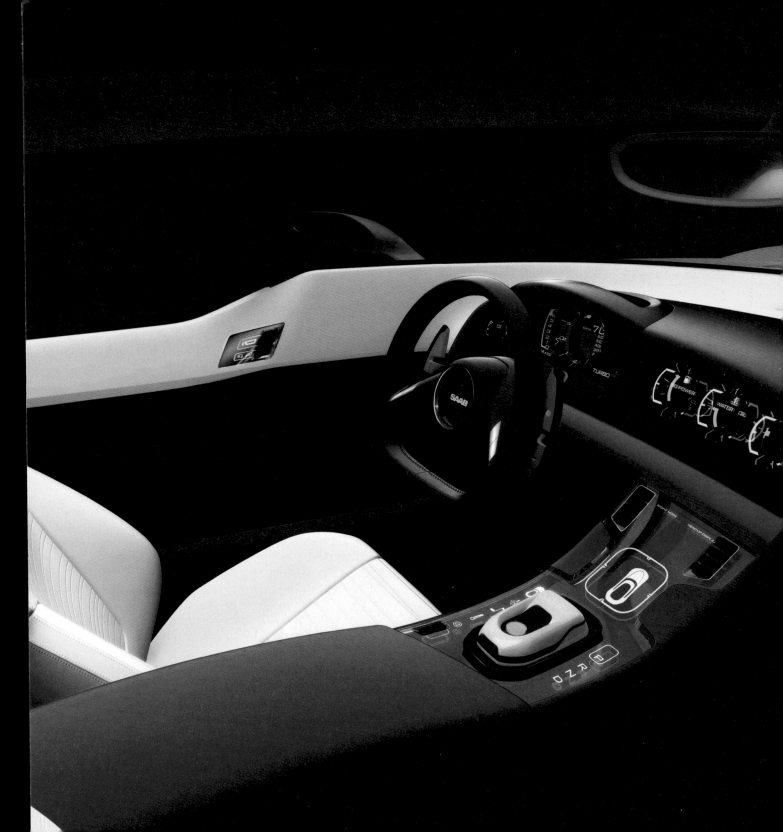

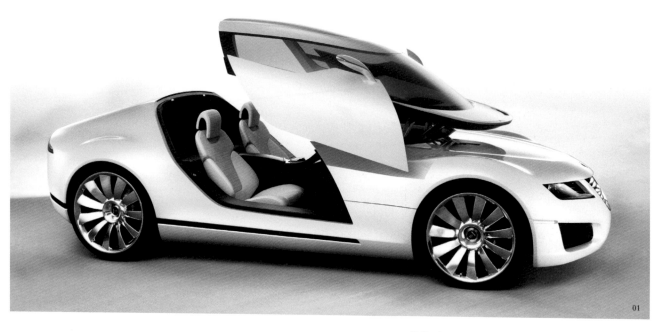

01 | Inspires associations with an airplane canopy: folding roof on the Saab Aero X.

Weckt Assoziationen an ein Flugzeug: aufklappbares Dach am Saab Aero X.

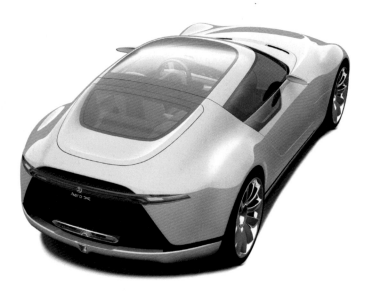

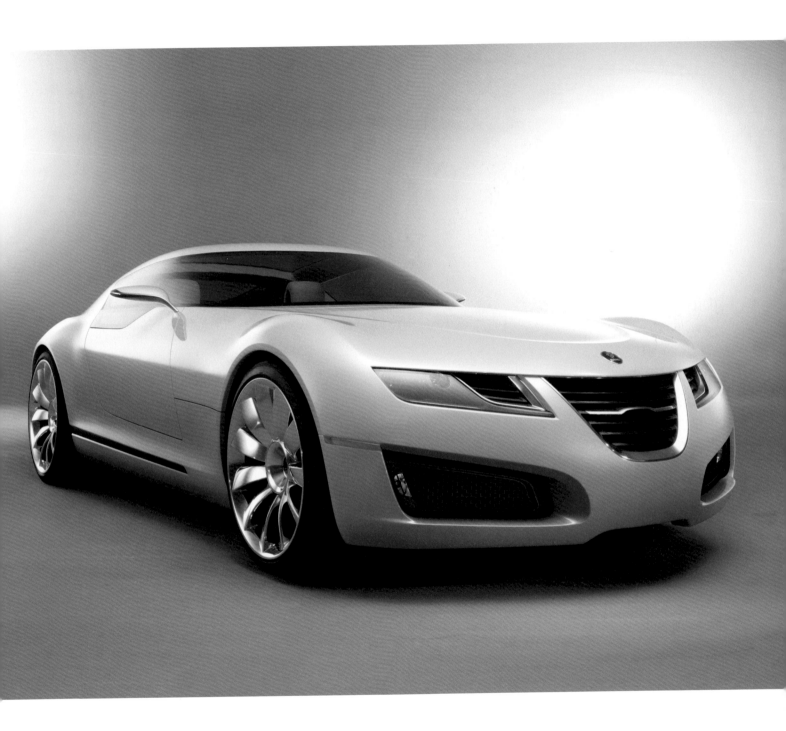

Data and Facts	Metroproject
Engine Type \| Antriebsart	gasoline hybrid \| Benzin-Hybrid
Status \| Status	2010
Displacement \| Hubraum	1390 cm³
Output \| Leistung	110 kW; 150 HP \| PS (gasoline) 30 kW; 41 HP \| PS (electro)
Fuel Consumption \| Verbrauch	48 mpg \| 4,9 l/100 km
CO₂ Emission \| CO₂-Ausstoß	112 g/km
Cruising Range \| Reichweite	62 mi \| 100 km (electro)
Acceleration \| Beschleunigung	7.8 s (0-60 mph \| 0-100 km/h)
Max. Speed \| Geschwindigkeit	130 mph \| 210 km/h

Audi Metroproject Quattro | Audi AG

On the Way to Being a Series | Auf dem Weg zur Serie
www.audi.com

Concept cars are primarily intended to show the creative potential of the car manufacturer's designers and occasionally also the technical visions. Automobile studies quite often also permit a look at models that will enrich what will be offered by the brand in the very near future. One example is the Audi Metroproject Quattro presented at the Tokyo Motor Show 2007. The designers were not only permitted to passionately express themselves, but also revealed the lines of a future small car by Audi that will probably be called the A1. However, the 12.82-feet study also conceals an innovative technical concept in its interior. A 1.4 liter gasoline engine works under the front hood, transferring its power to the front wheels. An additional electric aggregate with 30 kW (41 HP) delivers more power on the rear axle. When both aggregates work together, the front-drive car turns into a four-wheeler. The electric motor can also drive the car on its own, which means without emissions. The energy of the lithium-ion storage battery is sufficient for distances of up to 62 miles. It can be recharged at any outlet. Speeds of 62 mph and above can be achieved with the electric drive. Thanks to the start/stop automatic transmission, energy recovery and phases of using only the electric drive reduce consumption and emissions by about 15 percent in comparision to the conventional combustion engine.

Concept-Cars sollen in erster Linie das kreative Potenzial der Designer des Autoherstellers und bisweilen auch technische Visionen aufzeigen. Nicht selten lassen die automobilen Studien auch einen Blick auf Modelle zu, die schon in naher Zukunft das Angebot der Marke bereichern. Ein solches Beispiel ist der auf der Tokyo Motor Show 2007 präsentierte Audi Metroproject Quattro. Hier durften sich die Designer nicht nur austoben, sondern sie zeigen auch die Linien eines zukünftigen, voraussichtlich A1 genannten Kleinwagens von Audi. Die 3,91 Meter lange Studie verbirgt in ihrem Innern aber überdies ein innovatives technisches Konzept. Unter der vorderen Haube arbeitet ein 1,4 Liter großer Benzinmotor, der seine Kraft an die Vorderräder überträgt. An der Hinterachse liefert ein zusätzliches, 30 kW (41 PS) starkes Elektroaggregat weitere Antriebskraft. Arbeiten beide Aggregate gemeinsam, wandelt sich der Fronttriebler zum Allradler. Der Elektromotor vermag das Auto auch alleine und damit emissionsfrei anzutreiben. Die Energie der Lithium-Ionen-Akkus reicht für bis zu 100 Kilometer Strecke, die Wiederaufladung kann an jeder Steckdose erfolgen. Im Elektroantrieb lassen sich mehr als 100 km/h erreichen. Dank Start/Stopp-Automatik, Energierückgewinnung und Phasen reinen Elektrobetriebs reduzieren sich Verbrauch und Emissionen um rund 15 Prozent im Vergleich zum konventionellen Verbrennungsmotor.

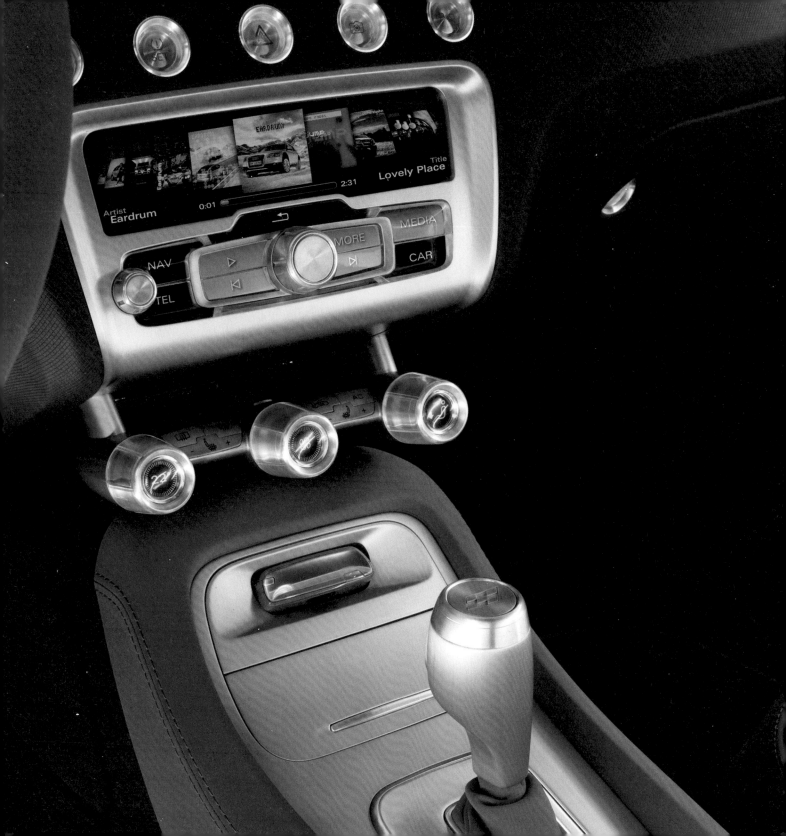

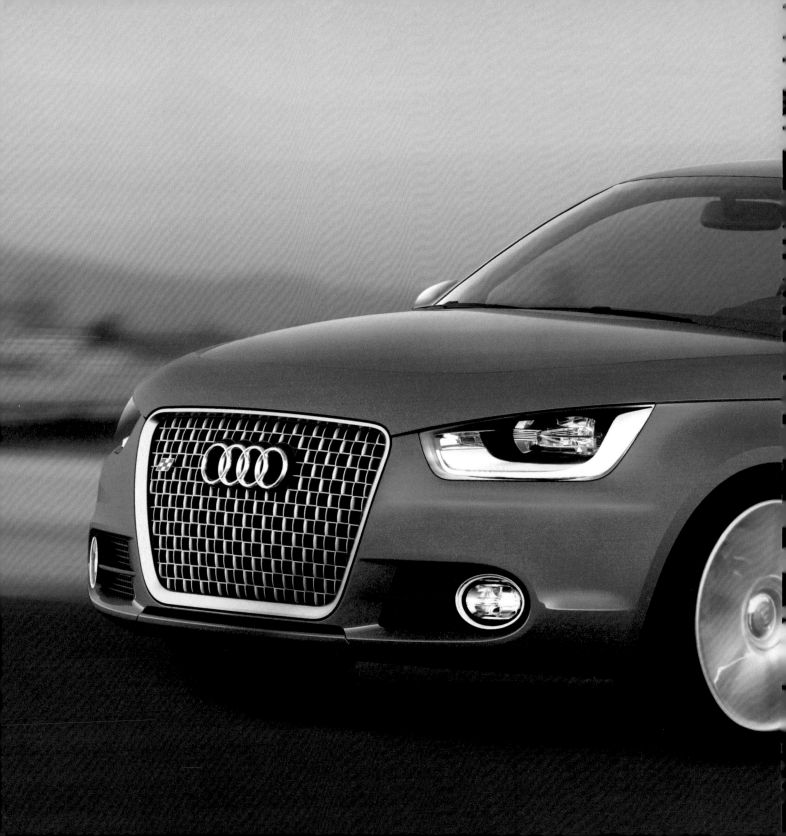

Data and Facts	Q7 Hybrid
Engine Type \| Antriebsart	gaoline hybrid \| Benzin-Hybrid
Status \| Status	2009
Displacement \| Hubraum	3597 cm³
Output \| Leistung	206 kW; 280 HP \| PS (gasoline) 32 kW; 44 HP \| PS (electro)
Fuel Consumption \| Verbrauch	24 mpg \| 9,8 l/100 km
CO₂ Emission \| CO₂-Ausstoß	231 g/km
Cruising Range \| Reichweite	634 mi \| 1020 km
Acceleration \| Beschleunigung	7.6 s (0-60 mph \| 0-100 km/h)
Max. Speed \| Geschwindigkeit	140 mph \| 225 km/h

Audi Q7 Hybrid | Audi AG

Four-Ring Fighter | Vier-Ringe-Kämpfer

www.audi.com

If you use a lot of fuel, you can also save in a big way. Audi shows the current hybrid technology's potential for economy with the big Q7. The hybrid SUV is equipped with a 3.6-liter six-cylinder engine, which functions as a gasoline engine with direct injection and achieves 280 HP. In addition, it uses an electric engine with 44 HP that is integrated into the driveline. Despite its empty weight of 5,467 pounds, the Q7 Hybrid's fuel consumption is at 24 miles per gallon—23 percent less than comparable standard model without hybrid technology. Three driving states are basically possible. The FSI and the electric engine can each function on their own as propulsion or accelerate the vehicle with combined forces. The electric engine can manage the driving alone and almost silently at speeds up to 31 mph—for operation in the city, for example. However, the capacity of the batteries only lasts for two kilometers (1.25 miles), then the combustion engine must go back to work and provide the power for the drive and load the battery. If the Q7 Hybrid rolls without activation of the gas pedal, the combustion engine turns off to save gasoline—this "sailing" is possible up to a speed of 74.6 mph. Energy is also recovered when operated in the coasting mode and when braking. A mathematical comparison documents the dimension that this achieves: At an average driving distance of 12,427 miles per year, the Q7 hybrid recovers about 720 kWh of energy—which corresponds to about one-sixth of what a four-person household uses in one year.

Wer viel Kraftstoff verbraucht, kann auch viel sparen. Audi zeigt das Einspar-Potenzial der aktuellen Hybridtechnik am großen Q7. Der Hybrid-SUV ist mit einem 3,6 Liter großen Sechszylindermotor ausgestattet, der als Benzin-Direkteinspritzer arbeitet und 280 PS leistet. Zusätzlich kommt ein in den Antriebsstrang integrierter Elektromotor mit 44 PS zum Einsatz. Trotz seines Leergewichts von 2480 Kilogramm soll der Q7 Hybrid durchschnittlich nur 9,8 Liter Kraftstoff auf 100 Kilometer verbrauchen – 23 Prozent weniger als beim vergleichbaren Serienmodell ohne Hybridtechnik. Grundsätzlich sind drei Fahrzustände möglich. Der FSI oder der Elektromotor können jeweils alleine als Antrieb agieren oder das Fahrzeug mit vereinten Kräften beschleunigen. Der Elektromotor vermag bei Geschwindigkeiten bis 50 km/h – also im Stadtbetrieb – allein und annähernd lautlos für Vortrieb zu sorgen. Allerdings reicht die Kapazität der Batterien nur für zwei Kilometer, dann muss der Verbrennungsmotor wieder arbeiten und für Antrieb und Batterieladung Leistung erbringen. Rollt der Q7 Hybrid ohne Gaspedalbetätigung, wird der Verbrennungsmotor zum Spritsparen abgeschaltet – dieses „Segeln" ist bis Tempo 120 km/h möglich. Ebenso wird im Schubbetrieb und beim Bremsen Energie zurückgewonnen. Welche Dimension dies erreicht, dokumentiert ein mathematischer Vergleich: Bei einer durchschnittlichen Fahrstrecke von 20.000 Kilometern pro Jahr gewinnt der Q7 Hybrid etwa 720 kWh Energie zurück – das entspricht etwa einem Sechstel dessen, was ein Vier-Personen-Haushalt im Jahr verbraucht.

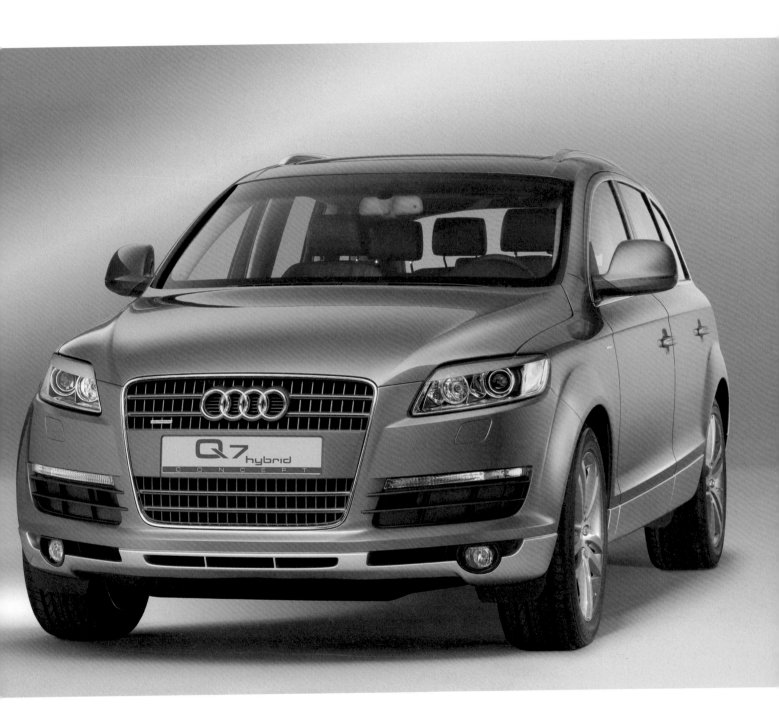

Data and Facts	X6
Engine Type \| Antriebsart	gasoline hybrid \| Benzin-Hybrid
Status \| Status	end of 2009 \| Ende 2009
Displacement \| Hubraum	no data \| keine Angaben
Output \| Leistung	no data \| keine Angaben
Fuel Consumption \| Verbrauch	no data \| keine Angaben
CO_2 Emission \| CO_2-Ausstoß	no data \| keine Angaben
Cruising Range \| Reichweite	no data \| keine Angaben
Acceleration \| Beschleunigung	no data \| keine Angaben
Max. Speed \| Geschwindigkeit	no data \| keine Angaben

BMW Concept X6 ActiveHybrid | BMW AG

An SUV Becomes a Coupé | Ein SUV wird zum Coupé

www.bmw.com

Car manufacturers are coming up with increasingly specialized vehicle concepts. The trend is called crossover, the blending of classic concepts with each other. With the X6, BMW has created the cross between an SUV and a coupé that is called the Sports Activity Coupé. But because the related SUVs are now notorious as gas-guzzlers, BMW is also presenting the concept of a hybrid version next to the conventional X6 at the IAA 2007. The BMW Concept X6 ActiveHybrid is reportedly up to 20 percent better in its consumption and emission values than a comparable vehicle with the customary drive. For the first time, BMW has combined the combustion engine and two high-performance electric engines in such a way that the efficiency advantage of the hybrid technology can be used over a distinctly larger speed range than in customary hybrid vehicles. The hybrid system comes from a cooperation entered into by the BMW Group with Daimler und General Motors. The hybrid version of the BMW X6 is supposed to be launched by the end of 2009 to the market. More detailed facts, such as performance and consumptions data, BMW is not mentioning yet.

Immer speziellere Fahrzeugkonzepte lassen sich die Autohersteller einfallen. Crossover heißt der Trend, bei dem klassische Konzepte miteinander verschmelzen. Mit dem X6 schafft BMW die Kreuzung zwischen einem SUV und einem Coupé und nennt dies Sports Activity Coupé. Weil aber die verwandten SUV inzwischen als Spritfresser verschrien sind, präsentierte BMW auf der IAA 2007 neben dem konventionellen X6 auch gleich das Konzept einer Hybridversion. Der BMW Concept X6 ActiveHybrid soll bei seinen Verbrauchs- und Emissionswerten um bis zu 20 Prozent besser sein als ein vergleichbares Fahrzeug mit herkömmlichem Antrieb. BMW hat den Verbrennungsmotor und zwei leistungsstarke Elektromotoren erstmals so miteinander kombiniert, dass der Effizienzvorteil der Hybridtechnik über einen deutlich größeren Geschwindigkeitsbereich hinweg genutzt werden kann als bei herkömmlichen Hybrid-Fahrzeugen. Das Hybridsystem entstammt einer Kooperation, die die BMW Group mit Daimler und General Motors eingegangen ist. Die Hybrid-Version des BMW X6 soll Ende 2009 auf den Markt kommen. Genauere Daten wie die Leistungs- und Verbrauchsdaten, nennt BMW noch nicht.

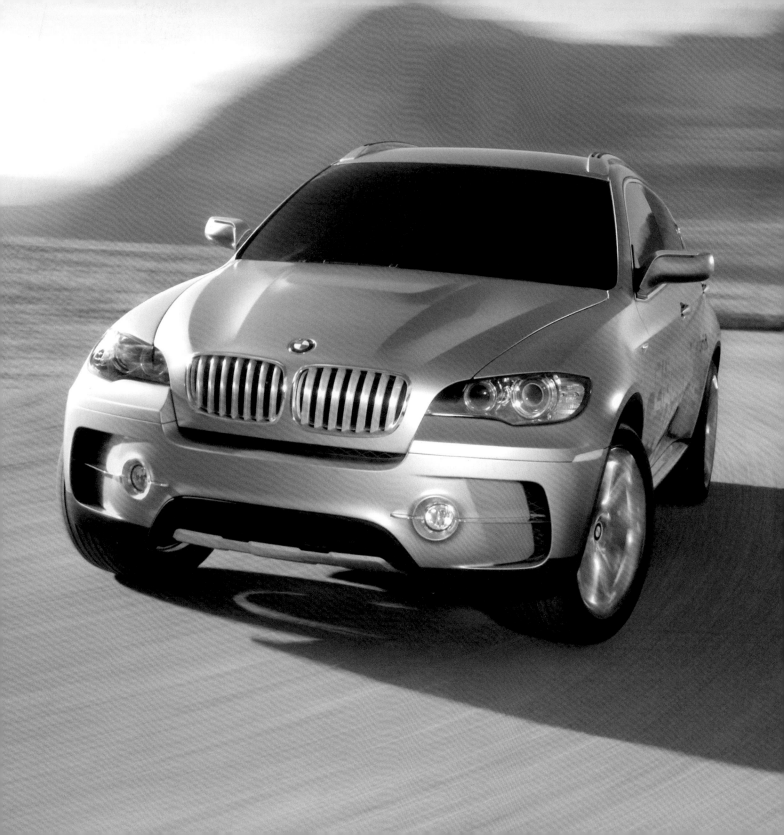

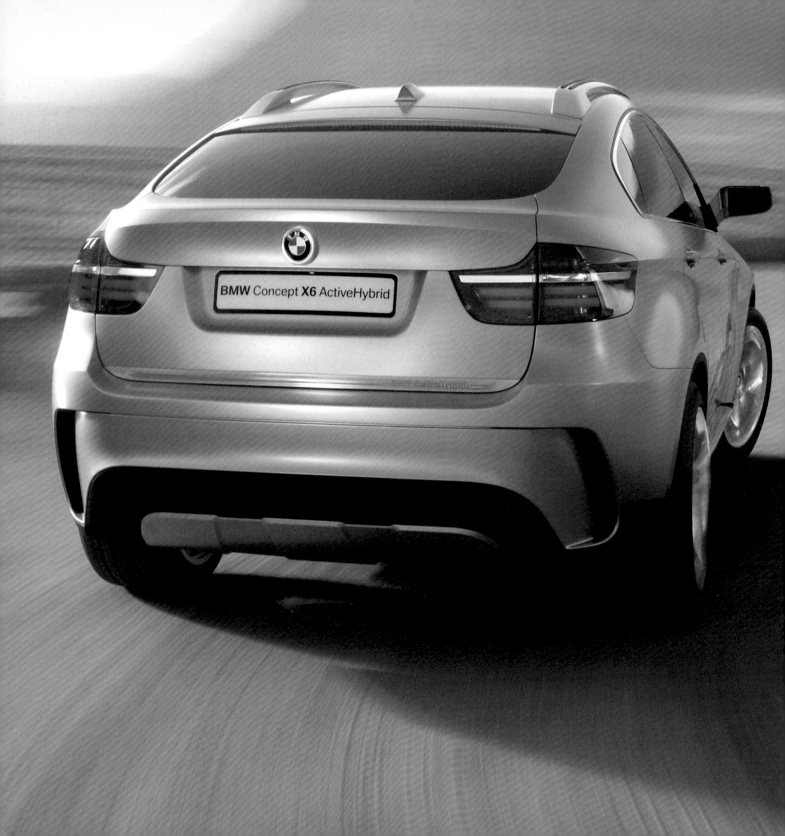

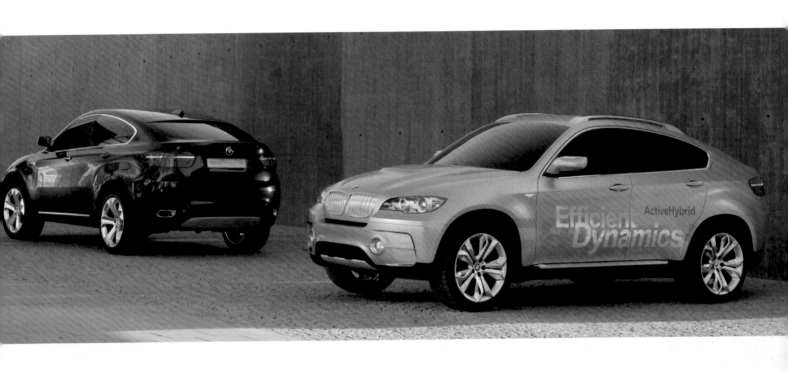

Data and Facts	C4 Hybrid HDi
Engine Type \| Antriebsart	diesel hybrid \| Diesel-Hybrid
Status \| Status	2010
Displacement \| Hubraum	1580 cm³
Output \| Leistung	66 kW; 92 HP \| PS (diesel) 23 kW; 31 HP \| PS (electro)
Fuel Consumption \| Verbrauch	69 mpg \| 3,4 l/100 km
CO₂ Emission \| CO₂-Ausstoß	90 g/km
Cruising Range \| Reichweite	1096 mi \| 1765 km
Acceleration \| Beschleunigung	12.4 s (0-60 mph \| 0-100 km/h)
Max. Speed \| Geschwindigkeit	112 mph \| 181 km/h

Citroën C4 Hybrid HDi | Automobiles Citroën

Twice as Economical with the Double Angle | Doppel-Spareffekt mit Doppelwinkel

www.citroen.com

The French manufacturer Citroën has never been at a loss for innovative technological solutions. While many manufacturers rely on a combination of a gasoline engine with an electric motor when it comes to hybrids, Citroën does battle with the diesel. And there is a good reason for this: The fuel savings of 20 percent that some manufacturers of gasoline hybrid cars advertize could be achieved through the use of a diesel engine alone, in the opinion of the French manufacturer with the double angle as its trademark. As a result, a diesel-hybrid should offer a greater savings potential. For the C4 Hybrid HDi, this is primarily obvious in the city where the electric motor can provide the thrust on its own at times and even do so without emissions. Optimized aerodynamics with a drag coefficient of 0.28, the start-stop system, an automated transmission, as well as energy recovery should also further reduce consumption. When the driver takes the foot off the gas pedal at a speed of less than 37 mph, the combustion engine switches off and is separated from the drive line. The electric motor then provides the engine-braking effect and recovers the kinetic energy of the vehicle. Citroën wants to put the diesel hybrid on the market in 2010.

Um innovative technische Lösungen war der französische Hersteller Citroën noch nie verlegen. Während viele Hersteller beim Thema Hybrid auf die Kombination von einem Benzinmotor mit einem Elektromotor setzen, zieht Citroën mit dem Diesel zu Felde. Aus gutem Grund: Die Kraftstoffersparnis von 20 Prozent, mit der manche Hersteller von Benzin-Hybrid-Autos werben, ließe sich nach Meinung des französischen Herstellers mit dem Doppelwinkel als Markenzeichen allein durch den Einsatz eines Dieselmotors erreichen. Ein Diesel-Hybrid soll demnach ein noch größeres Sparpotenzial bieten. Beim C4 Hybrid HDi macht sich das vor allem in der Stadt bemerkbar, wo der Elektromotor sogar zeitweise allein und somit abgasfrei für Vortrieb sorgt. Eine optimierte Aerodynamik mit einem Luftwiderstandsbeiwert von 0,28, das Start/Stopp-System, ein automatisiertes Schaltgetriebe sowie Energierückgewinnung sollen den Verbrauch ebenfalls weiter senken. Wenn der Fahrer bei einer Geschwindigkeit von weniger als 60 km/h den Fuß vom Gaspedal nimmt, wird der Verbrennungsmotor abgestellt und vom Antriebsstrang getrennt. Der Elektromotor sorgt dann für die Motorbremswirkung und gewinnt die kinetische Energie des Fahrzeugs zurück. 2010 will Citroën den Diesel-Hybrid auf den Markt bringen.

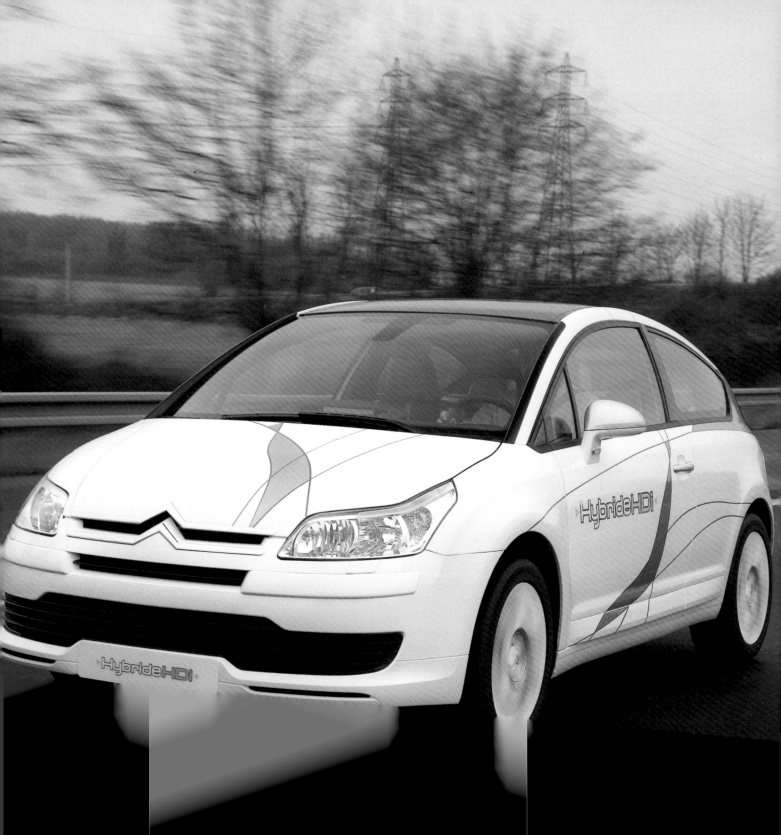

Data and Facts	C-Cactus
Engine Type \| Antriebsart	diesel hybrid \| Diesel-Hybrid
Status \| Status	concept car
Displacement \| Hubraum	1398 cm³
Output \| Leistung	52 kW; 70 HP \| PS (diesel) 22 kW; 30 HP \| PS (electro)
Fuel Consumption \| Verbrauch	69 mpg \| 3,4 l/100 km
CO₂ Emission \| CO₂-Ausstoß	78 g/km
Cruising Range \| Reichweite	no data \| keine Angaben
Acceleration \| Beschleunigung	no data \| keine Angaben
Max. Speed \| Geschwindigkeit	93 mph \| 150 km/h

Citroën C-Cactus | Automobiles Citroën

Undemanding as a Cactus | Genügsam wie ein Kaktus
www.citroen.com

Abstention is usually difficult, but the French manufacturer Citroën shows how modesty can even be attractive with its concept car C-Cactus. The study presented at the IAA Frankfurt 2007 concentrates on the essentials, saves on material, and therefore embodies a distinctly eco-friendly car—coupled with witty design solutions. Many recycled or recylable materials are employed in this car. For example, the floor covering consists of recycled leather made of leather scraps. Many parts are composed of cork, the felt of the door panelings and the compartments in the dashboard are made of naturally treated and, above all, completely recyclable and biodegradable wool. The overall interior of the C-Cactus consists of half as many components as are customary in this class. Mechanisms and individual parts have been extremely simplified. The door panelings consist of two parts, although a normal sedan has twelve installed. The seats are constructed of just two parts: a formed foam pad with a dyed skin cover and a solid shell that holds the foam pad. A diesel engine with particle filter and an electric engine serves as the drive. When it comes to consumption, the concept car presents itself with the frugality of a cactus: Thanks to the diesel hybrid and its very low total weight, the consumption is at 69 miles per gallon.

Verzicht fällt meistens schwer, doch der französische Hersteller Citroën zeigt mit seinem Concept-Car C-Cactus, wie Bescheidenheit sogar gefallen kann. Die auf der IAA Frankfurt 2007 präsentierte Studie konzentriert sich auf Wesentliches, spart an Material und verkörpert dabei ein ausgesprochen umweltfreundliches Auto – gepaart mit witzigen Design-Lösungen. Bei diesem Auto kommen viele recycelte oder recycelbare Werkstoffe zum Einsatz. Die Bodenverkleidung besteht beispielsweise aus wiederverwertetem Leder, für das Lederreste verwendet wurden. Zahlreiche Teile sind aus Kork, der Filz der Türverkleidungen und der Ablagen im Armaturenbrett aus natürlich behandelter und vor allem völlig recycelfähiger und biologisch abbaubarer Wolle gefertigt. Insgesamt setzt sich der Innenraum des C-Cactus aus halb so vielen Teilen zusammen, wie dies in dieser Klasse üblich ist. Mechanismen und Einzelteile wurden extrem vereinfacht. Die Türverkleidungen bestehen aus zwei Teilen, wo in einer normalen Limousine zwölf eingebaut werden. Die Sitze sind aus nur zwei Teilen zusammengebaut: einem Formschaumpolster mit eingefärbter Haut und einer festen Schale, die das Schaumpolster hält. Als Antrieb dienen ein Dieselmotor mit Partikelfilter und ein Elektromotor. Im Verbrauch präsentiert sich das Concept-Car genügsam wie ein Kaktus: Dank des Diesel-Hybrids und des geringen Gesamtgewichts beträgt der Verbrauch nur 3,4 Liter auf 100 Kilometer.

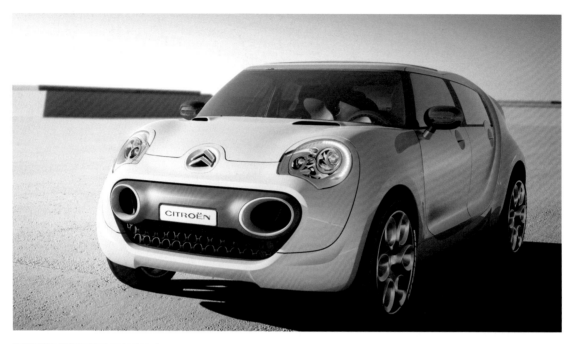

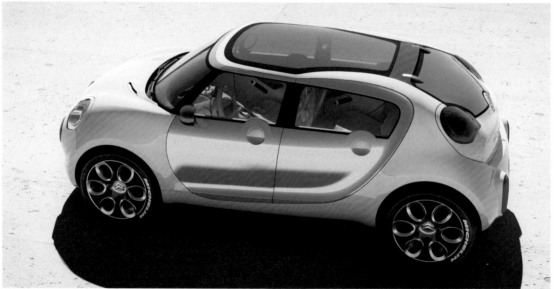

01 | The C-Cactus has been resolutely trimmed for lightweight construction, but there is still room for the creative design of the seats.

Der C-Cactus ist konsequent auf Leichtbau getrimmt. Dennoch bleibt Platz für kreative Gestaltung der Sitze.

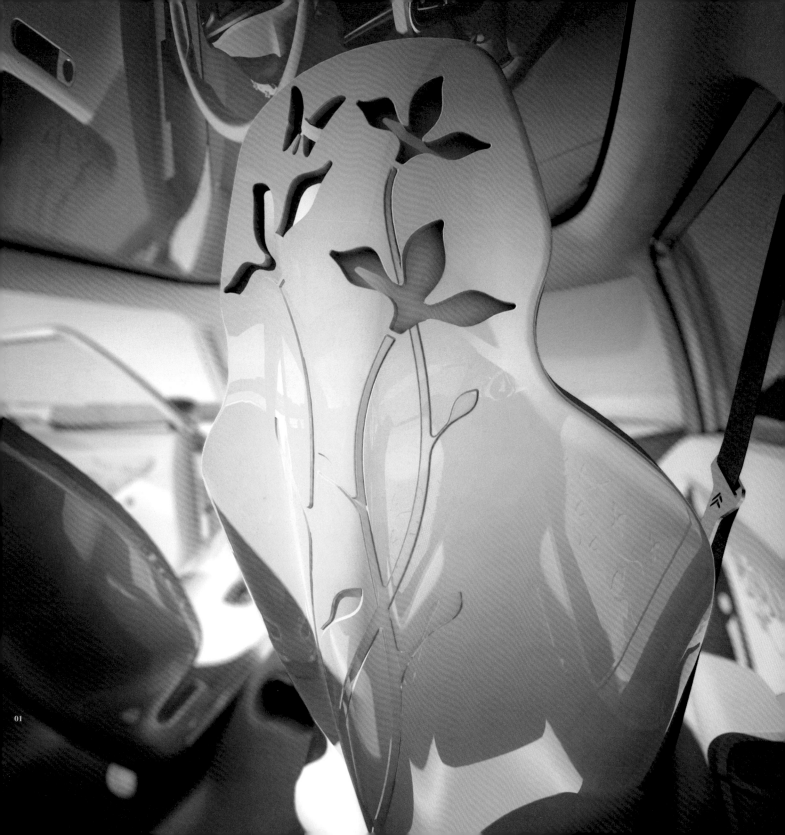

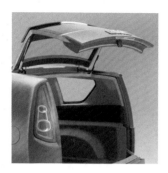

Data and Facts		Graphyte
Engine Type \| Antriebsart		gasoline hybrid \| Benzin-Hybrid
Status \| Status		concept car
Displacement \| Hubraum		5300 cm³
Output \| Leistung		224 kW; 300 HP \| PS
Fuel Consumption \| Verbrauch		no data \| keine Angaben
CO₂ Emission \| CO₂-Ausstoß		no data \| keine Angaben
Cruising Range \| Reichweite		no data \| keine Angaben
Acceleration \| Beschleunigung		no data \| keine Angaben
Max. Speed \| Geschwindigkeit		no data \| keine Angaben

GMC Graphyte | General Motors

Lower If Necessary | Bei Bedarf tiefer

www.gm.com

General Motors already introduced the study of an SUV with hybrid drive in 2005, first at the Detroit Motor Show and then at the IAA in Frankfurt—it is still as up to date today. The prototype, which was designed and built in the GM Advanced Design Studio in Coventry (England), reportedly can save up to 25 percent of the fuel in comparison to a conventional drive—which is also a very praiseworthy intention in view of the 5.3 liter V-eight-cylinders. On the one hand, this should succeed through a bi-modal full-hybrid system; on the other hand, the eight-cylinder has a cylinder shutoff: The individual cylinders are turned off when not needed and therefore do not use any gas. A special feature of the GMC Graphyte is displayed in its chassis. If necessary, the driver can reduce the ground clearance of the SUV by 4.7 inch. In the lower position, the air resistance of the vehicle is reduced and it saves fuel as a result; however, the off-road capabilities of the 15.6 feet long concept car that rolls on 22-inch magnesium wheels with special cross-country tires improve in the upper position.

Bereits 2005 hat General Motors zunächst bei der Detroit Motor Show und anschließend auf der IAA in Frankfurt die Studie eines SUV mit Hybridantrieb vorgestellt – sie hat an Aktualität bis heute nichts verloren. Der Prototyp, der im GM Advanced Design Studio in Coventry (England) entworfen und gebaut wurde, soll im Vergleich zu einem konventionellen Antrieb bis zu 25 Prozent Kraftstoff sparen können – was angesichts des 5,3 Liter großen V-Achtzylinders auch durchaus ein löbliches Vorhaben ist. Dies soll zum einen durch ein bi-modales Vollhybrid-System gelingen, zum anderen verfügt der Achtzylinder über eine Zylinderabschaltung: Je nach Bedarf werden einzelne Zylinder abgeschaltet und verbrauchen damit keinen Sprit. Eine Besonderheit des GMC Graphyte zeigt sich in seinem Fahrwerk. Der Fahrer kann bei Bedarf die Bodenfreiheit des SUV um 120 Millimeter verringern. In der unteren Stellung wird der Luftwiderstand des Fahrzeugs verringert und somit Kraftstoff gespart, in der oberen Stellung verbessert sich dagegen die Geländetauglichkeit des 4,77 Meter langen Concept-Cars, das auf 22 Zoll großen Magnesiumrädern mit speziellen Geländereifen rollt.

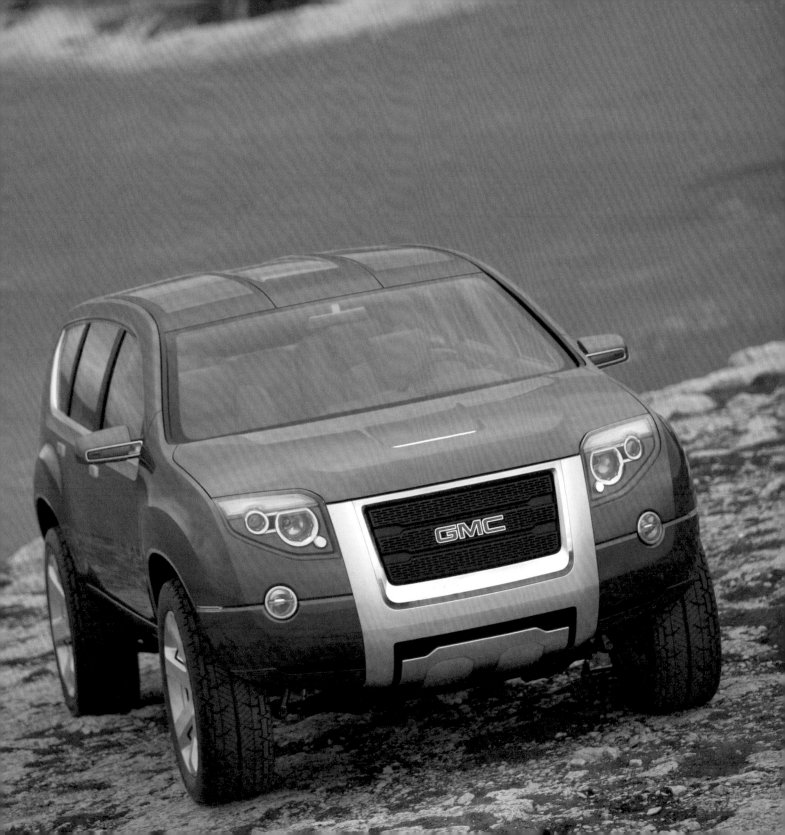

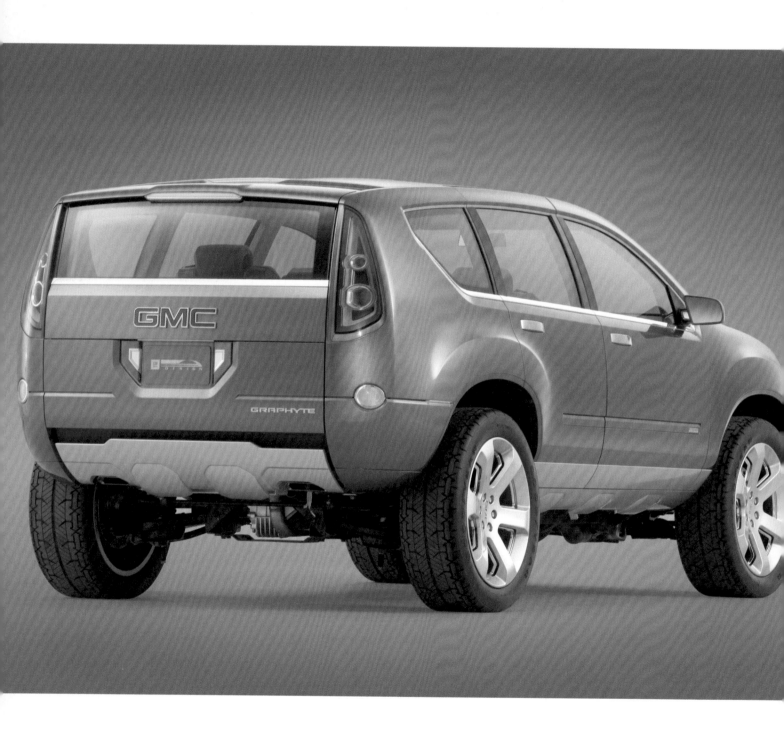

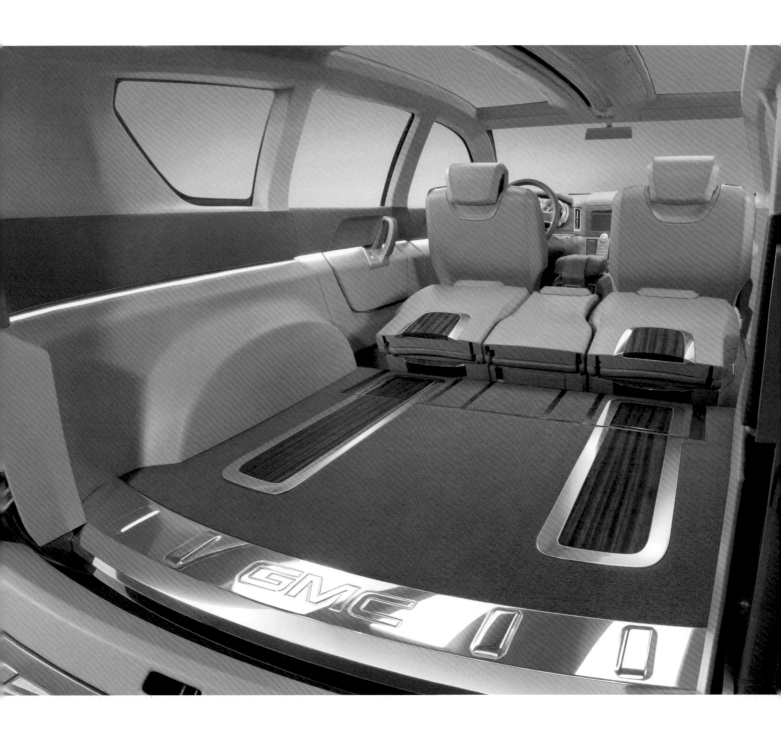

Data and Facts	Tahoe Hybrid
Engine Type \| Antriebsart	gasoline hybrid \| Benzin-Hybrid
Status \| Status	2008
Displacement \| Hubraum	6000 cm³
Output \| Leistung	248 kW; 332 HP \| PS
Fuel Consumption \| Verbrauch	22 mpg \| 10,7 l/100 km
CO_2 Emission \| CO_2-Ausstoß	no data \| keine Angaben
Cruising Range \| Reichweite	539 mi \| 867 km
Acceleration \| Beschleunigung	no data \| keine Angaben
Max. Speed \| Geschwindigkeit	no data \| keine Angaben

Chevrolet Tahoe Hybrid | General Motors

Award-Winning Green | Grün mit Auszeichnung

www.gm.com

The intention is laudable and necessary: Because the big, heavy SUVs from the USA in particular have the reputation of being much too wasteful with precious gasoline, these vehicles have an especially high potential for improvements. Beginning in 2008, Chevrolet will offer the Tahoe also as a hybrid version. Its 6.0 liter V-eight-cylinder gasoline engine is complemented by two electric motors. In city traffic, the Tahoe Hybrid reportedly uses half as much as its sister model with a conventional engine, which has an eight-cylinder with 5.3 liters of cubic capacity. According to GM, the gasoline consumption in the city is about the same as for a four-cylinder sedan. No wonder: The hybrid can take full advantage of its assets especially in city traffic because it drives only with electric energy at times and also recovers energy each time the brakes are used. In addition to recognition, this already brought the Tahoe Hybrid a coveted award: On the occasion of the Los Angeles Motor Show 2007, the 2.7 ton SUV was voted the Green Car of the Year 2008.

Das Ansinnen ist löblich und nötig: Weil gerade die großen und schweren SUV aus den USA im Ruf stehen, allzu verschwenderisch mit dem kostbaren Benzin umzugehen, findet sich bei diesen Fahrzeugen ein besonders hohes Potenzial für Verbesserungen. Chevrolet bietet ab 2008 den Geländewagen Tahoe auch als Hybridversion an, bei der der 6,0 Liter große V-Achtzylinder-Benzinmotor durch zwei Elektromotoren ergänzt wird. Im innerstädtischen Verkehr soll der Tahoe Hybrid etwa halb soviel verbrauchen wie sein konventionell motorisiertes Schwestermodell, bei dem ein Achtzylinder mit 5,3 Liter Hubraum zum Einsatz kommt. Innerorts soll der Benzinverbrauch laut GM auf dem Niveau einer Vierzylinder-Limousine liegen. Kein Wunder: Gerade im Stadtverkehr kann der Hybrid seine Vorteile voll ausspielen, indem er zeitweise nur mit elektrischer Energie fährt und zudem bei jedem Bremsvorgang Energie zurückgewonnen wird. Das brachte dem Tahoe Hybrid bereits einen begehrten Preis nebst Anerkennung ein: Anlässlich der Los Angeles Motor Show 2007 wurde der 2,7 Tonnen schwere SUV zum Green Car of the Year 2008 gewählt.

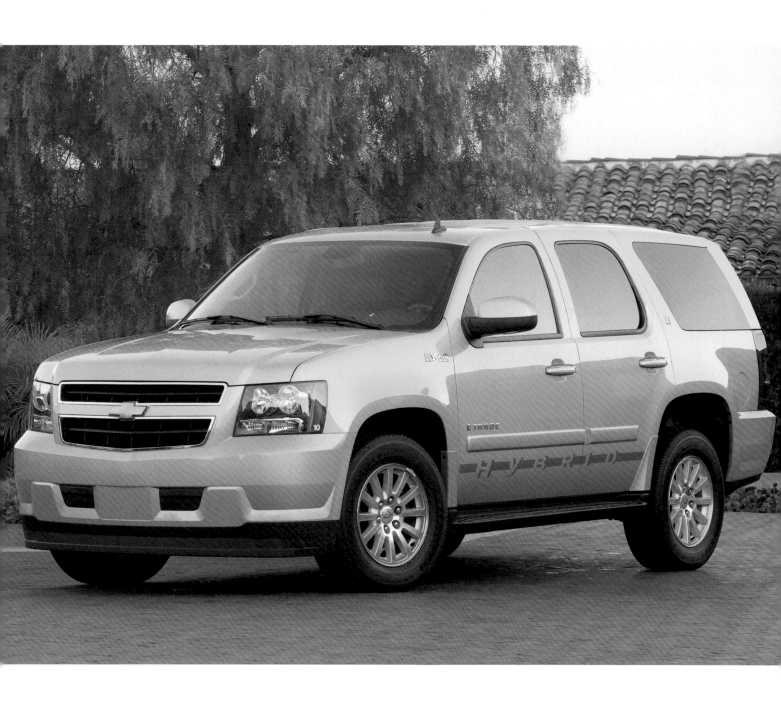

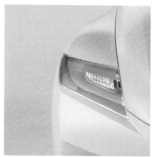

Data and Facts	CR-Z
Engine Type \| Antriebsart	gasoline hybrid \| Benzin-Hybrid
Status \| Status	no data \| keine Angaben
Displacement \| Hubraum	no data \| keine Angaben
Output \| Leistung	no data \| keine Angaben
Fuel Consumption \| Verbrauch	no data \| keine Angaben
CO_2 Emission \| CO_2-Ausstoß	no data \| keine Angaben
Cruising Range \| Reichweite	no data \| keine Angaben
Acceleration \| Beschleunigung	no data \| keine Angaben
Max. Speed \| Geschwindigkeit	no data \| keine Angaben

Honda CR-Z | Honda Motors

In the Starting Formation | In der Startaufstellung
www.honda.com

In addition to Toyota, Honda is currently the only large-scale series manufacturer with hybrid drive in the model program. The Japanese would like to further expand this offer—also in the sense of sportiness. This is clearly demonstrated by the concept car CR-Z, which was presented to the public for the first time at the Tokyo Motor Show 2007. CR-Z stands for Compact Renaissance Zero—a concept that Honda believes will give the design of compact vehicles a new boost. At the same time, Honda wants to make clear that eco-friendly vehicles can also be quite exciting, sporty, and chic. With a length of more than four meters, the CR-Z—which is powered by a gasoline engine in combination with an electric motor—promises agile behavior on the road and a lot of driving fun with low fuel consumption. This may soon be a reality. Honda has already announced that it will continue developing CR-Z to start series production. This may be one of the reasons why the technical details have not yet been presented.

Neben Toyota hat derzeit lediglich Honda als Großserienhersteller Fahrzeuge mit Hybridantrieb im Modellprogramm. Dieses Angebot wollen die Japaner weiter ausbauen – auch in sportlicher Hinsicht. Dies macht das Concept-Car CR-Z deutlich, das auf der Tokio Motor Show 2007 erstmals der Öffentlichkeit präsentiert wurde. CR-Z steht für Compact Renaissance Zero – einem Konzept, das nach Meinung von Honda dem Design von kompakten Fahrzeugen neuen Schwung geben soll. Zugleich will Honda deutlich machen, dass umweltschonende Fahrzeuge sehr wohl auch aufregend, sportlich und chic sein können. Mit gut vier Meter Länge verspricht der CR-Z, der von einem Benzinmotor in Kombination mit einem Elektromotor angetrieben wird, agiles Fahrverhalten und jede Menge Fahrspaß bei niedrigem Spritverbrauch. Schon bald womöglich in der Realität. Denn Honda hat schon angekündigt, den CR-Z für die Serienfertigung weiterzuentwickeln. Das mag einer der Gründe sein, warum technische Details noch nicht veröffentlicht wurden.

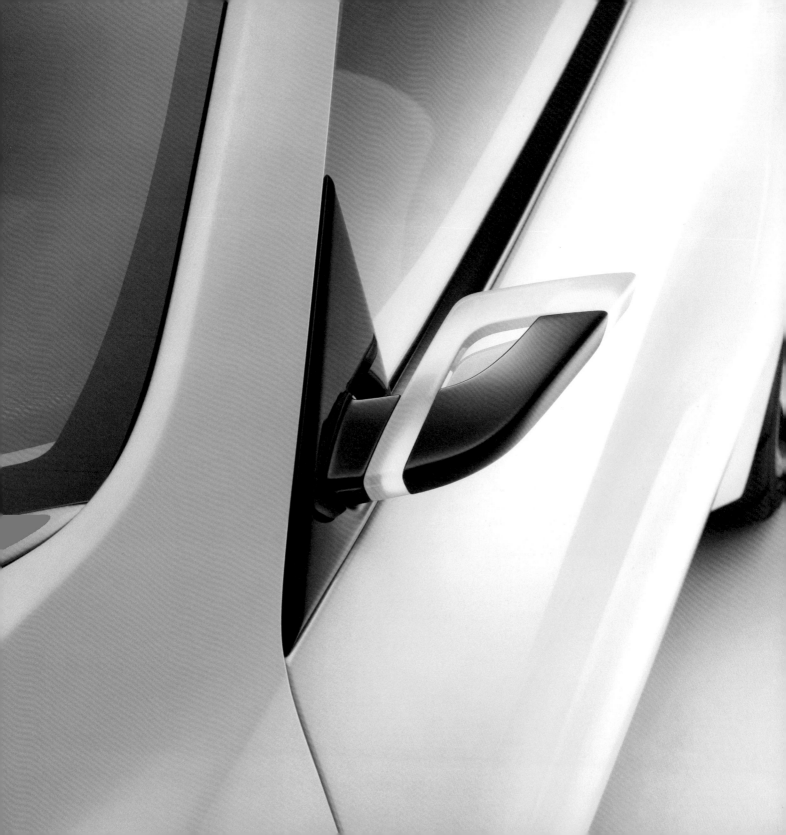

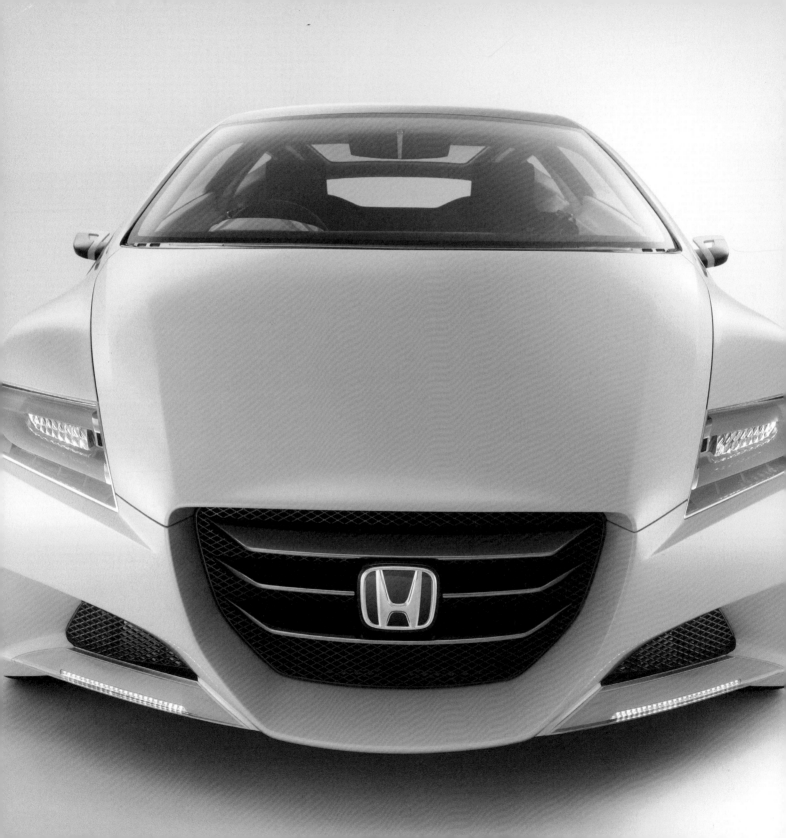

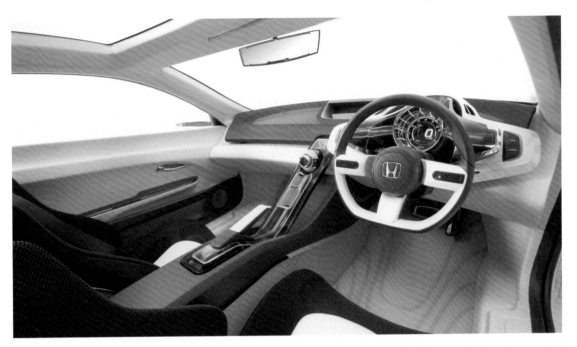

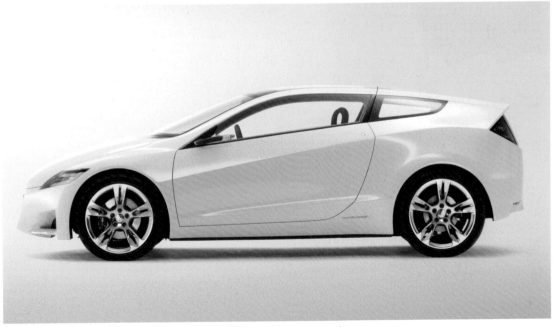

Data and Facts		i-Blue	
Engine Type	Antriebsart	hydrogen fuel cell hybrid Brennstoffzelle Hybrid	
Status	Status	concept car	
Displacement	Hubraum	-	
Output	Leistung	100 kW; 136 HP	PS
Fuel Consumption	Verbrauch	no data	keine Angaben
CO₂ Emission	CO₂-Ausstoß	0 g/km	
Cruising Range	Reichweite	372 mi	600 km
Acceleration	Beschleunigung	no data	keine Angaben
Max. Speed	Geschwindigkeit	no data	keine Angaben

Hyundai i-Blue | Hyundai Motor

Use with Flashing Lights | Einsatz mit Blaulicht

www.hyundai-motor.com

The Korean car manufacturers have conquered a place on the markets in Europe and the USA with vehemence. They have also attracted attention with interesting studies for quite some time now. One example is the i-Blue created by Hyundai. The 15.9 feet long crossover unites the features of the van and coupé, offering four seats under its elegant hull. Driven by a fuel cell from Hyundai's eco-technological research institute in the Korean city of Mabuk, the i-Blue presented at the IAA in Frankfurt in 2007 drives almost without emissions. Its fuel cell of the third generation provides 136 HP and is linked to a 450-volt battery. The i-Blue reportedly is able to drive up to 372 miles with its supply of hydrogen. Not only the technology is unusual, but also the design of the study. In addition to the elegant chassis form, the blue illuminated radiator grill and the headlights shining in the same color stand out.

Mit Vehemenz haben sich die koreanischen Autohersteller einen Platz auf den Märkten in Europa und den USA erobert. Längst sorgen sie auch mit interessanten Studien für Aufmerksamkeit. Ein Beispiel ist der von Hyundai kreierte i-Blue. Der 4,85 Meter lange Crossover vereint Eigenschaften von Van und Coupé und bietet unter seiner eleganten Hülle vier Sitzplätze. Angetrieben von einer Brennstoffzelle aus dem Öko-Technologischen Forschungsinstitut von Hyundai im koreanischen Mabuk fährt der 2007 auf der IAA in Frankfurt präsentiere i-Blue nahezu emissionsfrei. Seine Brennstoffzelle der dritten Generation leistet 136 PS und ist an eine 450-Volt-Batterie gekoppelt. Bis zu 600 Kilometer weit soll der i-Blue mit seinem Wasserstoffvorrat fahren können. Außergewöhnlich ist nicht nur die Technik, sondern auch das Design der Studie. Neben der eleganten Karosserieform fallen der blau illuminierte Kühlergrill und die im selben Farbton strahlenden Scheinwerfer auf.

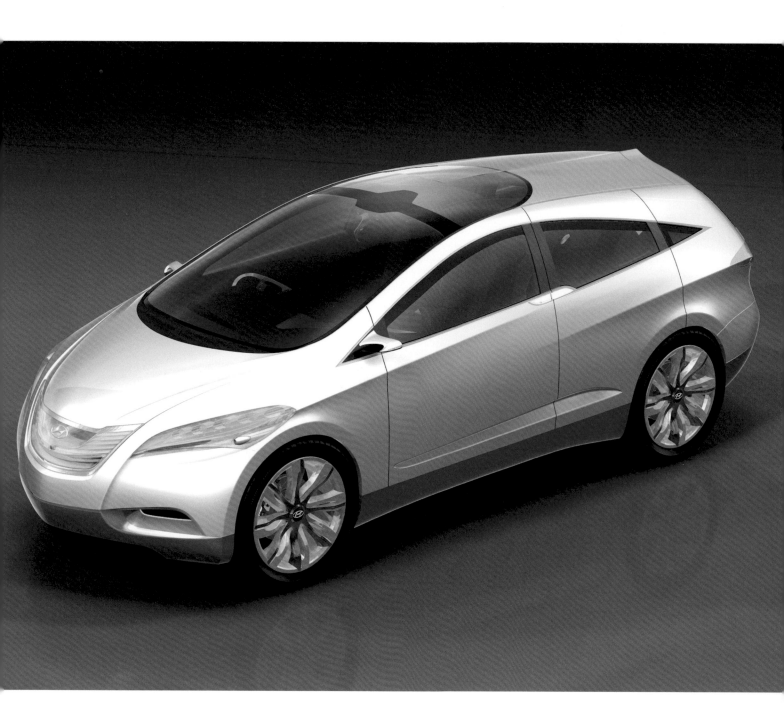

Data and Facts	LS 600h
Engine Type \| Antriebsart	gasoline hybrid \| Benzin-Hybrid
Status \| Status	2007
Displacement \| Hubraum	4969 cm³
Output \| Leistung	290 kW; 394 HP \| PS (gasoline) 165 kW; 225 HP \| PS (electro)
Fuel Consumption \| Verbrauch	25 mpg \| 9,3 l/100 km
CO₂ Emission \| CO₂-Ausstoß	219 g/km
Cruising Range \| Reichweite	567 mi \| 913 km
Acceleration \| Beschleunigung	6.3 s (0-60 mph \| 0-100 km/h)
Max. Speed \| Geschwindigkeit	155 mph \| 250 km/h

Lexus LS 600h | Toyota Motor Corporation

Hybrid Drive in the Luxury Class | Hybrid-Antrieb in der Luxusklasse
www.lexus.com

Following the Prius, the Japanese manufacturer Toyota has also extended the hybrid technology to its Lexus luxury brand. In addition to the RX 400h and GS 450h models, the big LS 600h is the third Lexus with the hybrid system. However, the combination with a V-eight-cylinder engine is new in the luxury class. The LS 600h has a powerful electric motor in addition to the large 5.0 liter gasoline-driven engine. All four wheels of the sedan, which is about five meters long, are driven through an electronically controlled, continuously variable transaxle. On the one hand, Lexus promises a high degree of performance with the hybrid technology; on the other hand, it ensures a very pronounced eco-friendliness. Thanks to its hybrid drive, the LS 600h reportedly offers the hybrid propulsion of a twelve-cylinder with the consumption of a six-cylinder. With its average consumption of 25 miles per gallon, the big Lexus has the lowest fuel consumption for its class according to the manufacturer's information — however, the advantage of the hybrid drive is primarily noticeable in city traffic where the electric drive can be used part of the time.

Nach dem Prius hat der japanische Hersteller Toyota die Hybrid-Technik auch auf seine Luxusmarke Lexus ausgeweitet. Neben den Modellen RX 400h und GS 450h ist der große LS 600h der dritte Lexus mit Hybrid-System. Neu ist allerdings die Kombination mit einem V-Achtzylindermotor in der Luxusklasse. Der LS 600h besitzt neben dem 5,0 Liter großen Benziner einen kraftvollen Elektromotor. Über eine elektronisch gesteuerte, stufenlose Getriebeautomatik werden alle vier Räder der rund fünf Meter langen Limousine angetrieben. Lexus verspricht mit der Hybridtechnik einerseits hohe Leistungsfähigkeit, andererseits ausgeprägte Umweltfreundlichkeit. Der LS 600h soll dank seines Hybridantriebs die Fahrleistungen eines Zwölfzylinders beim Verbrauch eines Sechszylinders bescheren. Mit einem Durchschnittsverbrauch von 9,3 Litern auf 100 Kilometer weist der große Lexus nach Herstellerangaben den niedrigsten Kraftstoffverbrauch seiner Klasse auf – allerdings macht sich der Vorteil des Hybridantriebs vor allem im innerstädtischen Verkehr bemerkbar, wo zeitweise mit Elektroantrieb gefahren werden kann.

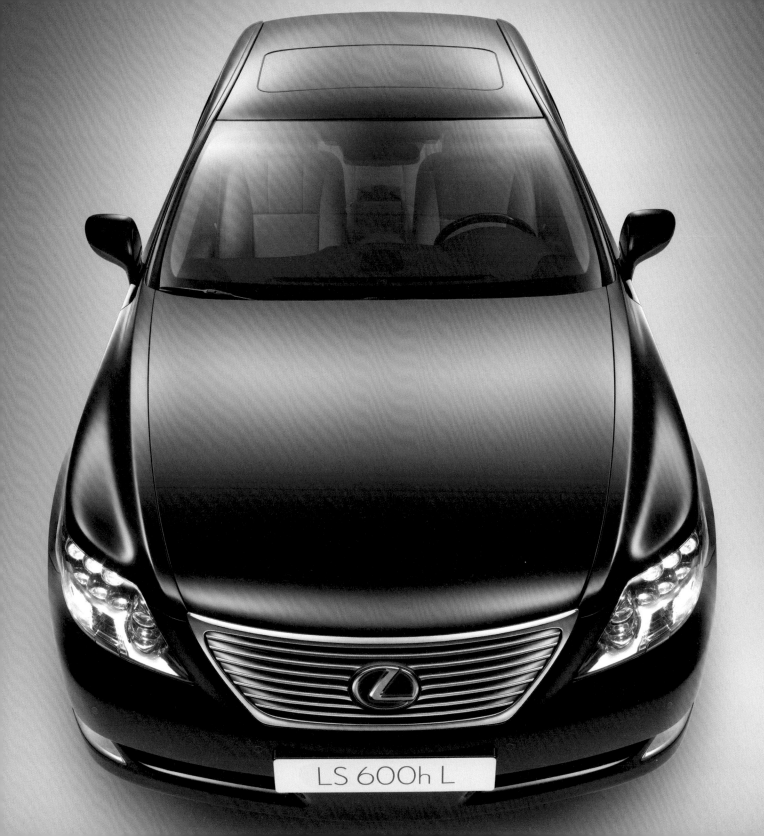

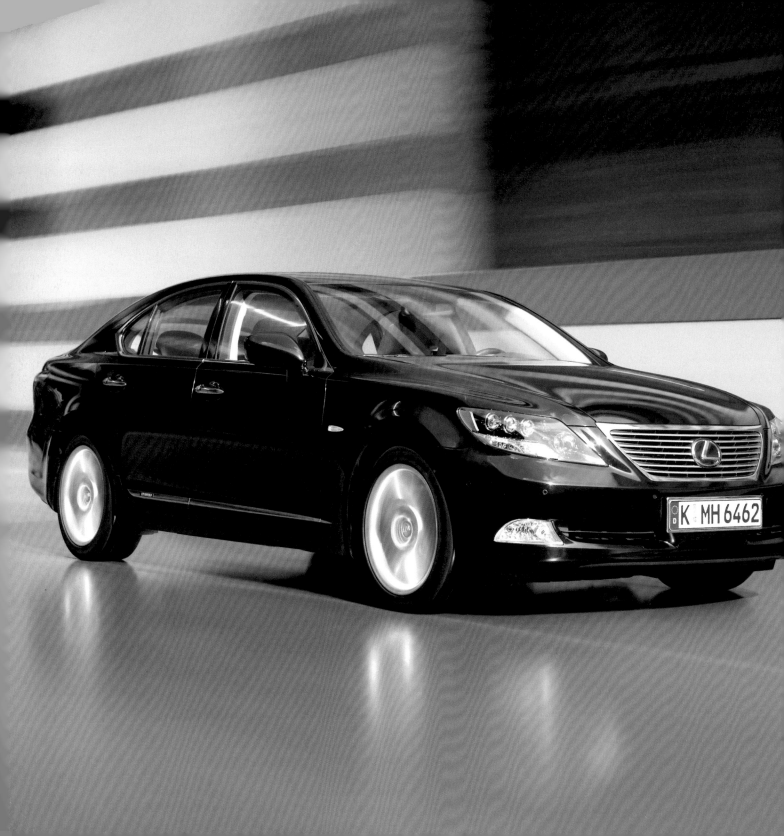

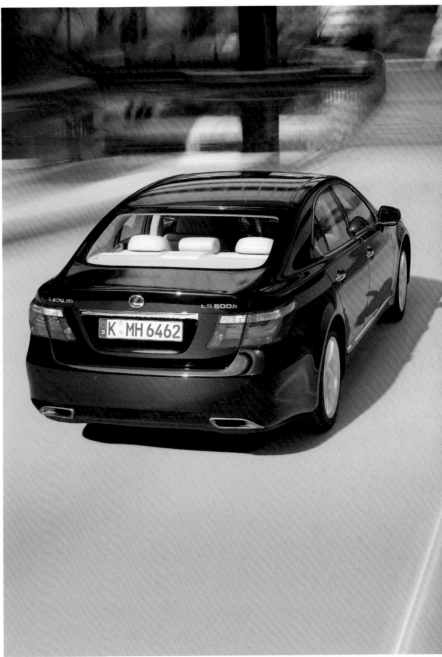

Data and Facts		Senku	
Engine Type	Antriebsart	gasoline hybrid	Benzin-Hybrid
Status	Status	concept car	
Displacement	Hubraum	no data	keine Angaben
Output	Leistung	no data	keine Angaben
Fuel Consumption	Verbrauch	no data	keine Angaben
CO₂ Emission	CO₂-Ausstoß	no data	keine Angaben
Cruising Range	Reichweite	no data	keine Angaben
Acceleration	Beschleunigung	no data	keine Angaben
Max. Speed	Geschwindigkeit	no data	keine Angaben

Mazda Senku | Mazda

The Color of the Knife | Die Farbe des Messers

www.mazda.com

The Senku study, which was first presented by Mazda at the Tokyo Motorshow 2005, makes a very dynamic impression. The Japanese model name stands for the term "pioneer," and the Senku is intended as a pioneer for the Japanese brand in terms of both technology and design. The concept car created in Mazda's design studio in Yokohama is fascinating because of its purist-elegant design. The very long wheelbase emphasizes the flowing lines. One of the unusual solutions offered by the Senku are the sliding doors on the sides. The 32-inches-wide opening makes it possible for up to four passengers to comfortably get in and out. The Mazda Senku is driven by hybrid propulsion. In the process, Mazda stays faithful to the unusual solution of a rotary engine. Mazda is the only car manufacturer to use it. The Senku's engine is designed with direct injection. In addition, it uses a hybrid system with an electric motor and start/stop automatic transmission. The rear portion of the glass roof is also equipped with solar cells. The collectors feed additional electric energy into the hybrid drive system during operation. At the same time, they keep the board system running when the engine is turned off. Incidentally, the designers let themselves be inspired by a sushi knife in selecting the Senku's color: This is why the color of the car shimmers between bronze and aluminum.

Überaus dynamisch wirkt die von Mazda erstmals auf der Tokio Motorshow 2005 vorgestellte Studie Senku. Die japanische Typbezeichnung steht für den Begriff Pionier, und der Senku will sowohl in Technik als auch Design ein Pionier für die japanische Marke sein. Das im Mazda-Designstudio in Yokohama entworfene Concept-Car besticht durch sein puristisch-elegantes Design. Der sehr lange Radstand betont die fließenden Linien. Zu den ungewöhnlichen Lösungen des Senku zählen die seitlichen Schiebetüren. Dank der 80 Zentimeter breiten Einstiegsöffnung ermöglichen sie ein bequemes Ein- und Aussteigen für bis zu vier Passagiere. Angetrieben wird der Mazda Senku durch einen Hybridantrieb. Mazda bleibt dabei der außergewöhnlichen Lösung eines Kreiskolbenmotors treu, die Mazda als einziger Autohersteller anwendet. Der Motor des Senku ist als Direkteinspritzer ausgelegt. Darüber hinaus kommt ein Hybridsystem mit Elektromotor und Start/Stopp-Automatik zum Einsatz. Außerdem ist der hintere Teil des Glasdachs mit Solarzellen bestückt. Die Kollektoren speisen während der Fahrt zusätzliche elektrische Energie in das Hybrid-Antriebssystem ein. Zugleich halten sie bei abgestelltem Motor die Bordsysteme in Betrieb. Bei der Wahl der Farbe des Senku ließen sich die Designer übrigens von einem Sushi-Messer inspirieren: Daher changiert die Farbe des Autos zwischen Bronze und Aluminium.

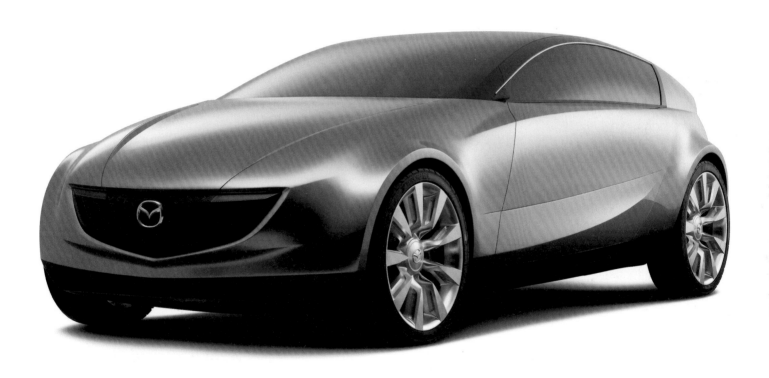

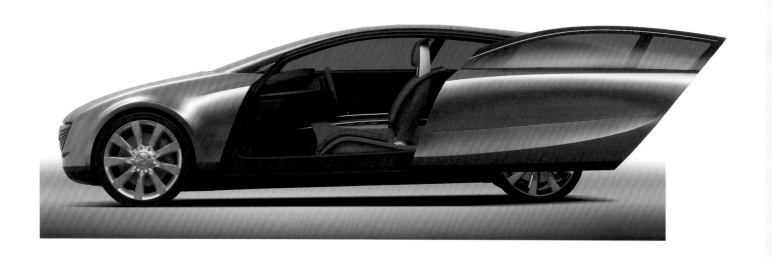

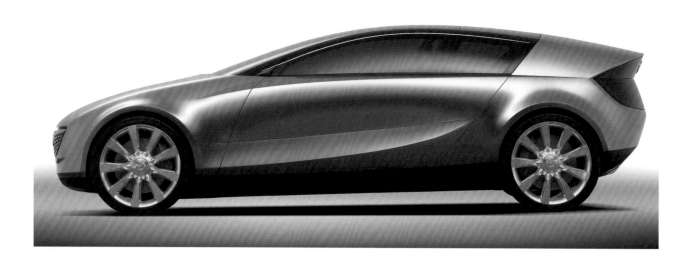

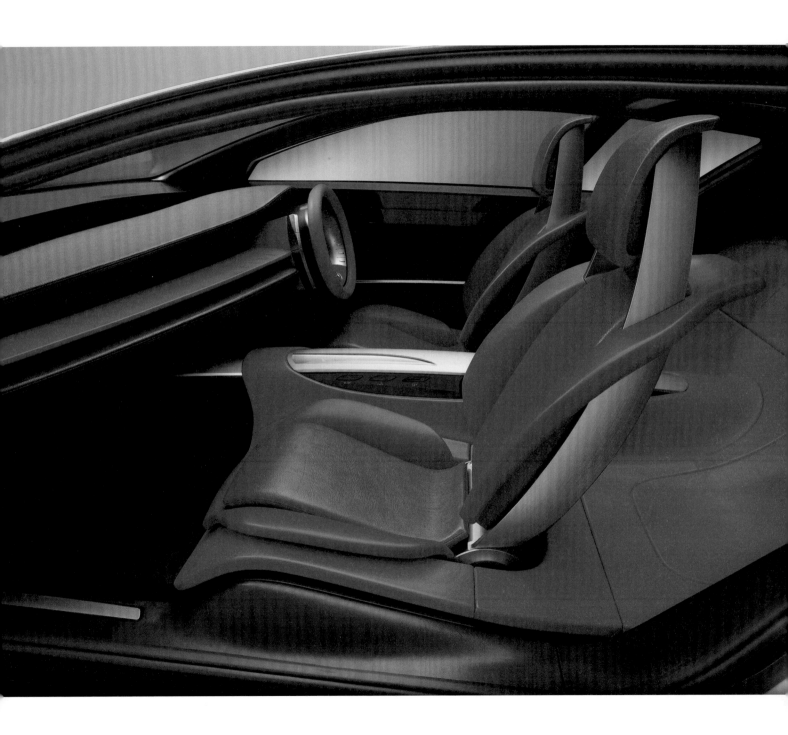

Data and Facts	Hydrogen RE Hybrid
Engine Type \| Antriebsart	hydrogen/dual-fuel Wasserstoff/dual-Fuel
Status \| Status	2008
Displacement \| Hubraum	no data \| keine Angaben
Output \| Leistung	110 kW; 150 HP \| PS
Fuel Consumption \| Verbrauch	no data \| keine Angaben
CO₂ Emission \| CO₂-Ausstoß	no data \| keine Angaben
Cruising Range \| Reichweite	124 mi \| 200 km
Acceleration \| Beschleunigung	no data \| keine Angaben
Max. Speed \| Geschwindigkeit	no data \| keine Angaben

Mazda Premacy Hydrogen RE Hybrid | Mazda

Rotation Principle | Rotations-Prinzip

www.mazda.com

Mazda is the only manufacturer that has dedicated itself to the principle of the rotary engine, which is based on an invention by the German design engineer Felix Wankel. The Mazda Premacy Hydrogen RE Hybrid proves that this engine principle is also suitable for new energy sources. The van, which has a variation with a conventional drive that is sold in Europe and USA as Mazda 5, is equipped with a hydrogen rotary engine. The hybrid system changes the energy created in the combustion of hydrogen into electric current to power the electric motor of the vehicle. The interior has space for five adults, in addition to luggage. Mazda wants to release the Premacy Hydrogen RE Hybrid in 2008 to public agencies and companies interested in leasing. The Japanese company already conducted a field test with the RX-8 Hydrogen RE. The Premacy Hydrogen RE Hybrid has a dual-fuel system that allows a switch from the hydrogen to the gasoline mode and vice versa. Energy recovery when braking and a start-stop automatic transmission increase the overall energy balance.

Als einziger Hersteller widmet sich Mazda dem Prinzip des Kreiskolbenmotors, der auf eine Erfindung des deutschen Konstrukteurs Felix Wankel zurückgeht. Dass auch dieses Motorenprinzip für neue Energiequellen tauglich ist, beweist der Mazda Premacy Hydrogen RE Hybrid. Der Van, dessen konventionell angetriebene Variante in Europa und USA als Mazda 5 verkauft wird, besitzt einen Wasserstoff-Kreiskolbenmotor. Das Hybridsystem wandelt die bei der Verbrennung des Wasserstoffs gewonnene Energie in elektrischen Strom um, mit dem der Elektromotor des Fahrzeugs angetrieben wird. Im Innenraum finden fünf Erwachsene nebst Gepäck Platz. Mazda will den Premacy Hydrogen RE Hybrid 2008 zum Leasing an interessierte Behörden und Unternehmen freigeben. Bereits 2006 hatte das japanische Unternehmen einen Feldversuch mit den RX-8 Hydrogen RE durchgeführt. Der Premacy Hydrogen RE Hybrid verfügt über ein Dual-Fuel-System, das jederzeit ein Umschalten vom Wasserstoff- in den Benzin-Modus und umgekehrt gestattet. Eine Energierückgewinnung beim Bremsen und eine Start/Stopp-Automatik steigern die Gesamtenergiebilanz.

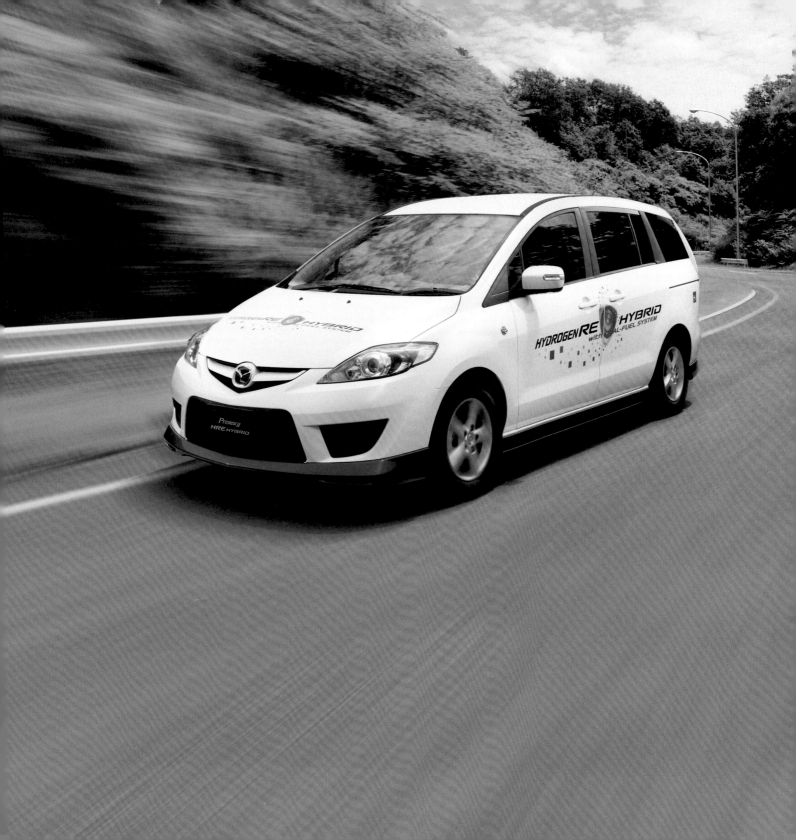

Data and Facts	F 700
Engine Type \| Antriebsart	DIESOTTO-Hybrid \| DIESOTTO-Hybrid
Status \| Status	research car
Displacement \| Hubraum	1800 cm³
Output \| Leistung	175 kW; 238 HP \| PS (gasoline) 15 kW; 20 HP \| PS (electro)
Fuel Consumption \| Verbrauch	44 mpg \| 5,3 l/100 km
CO₂ Emission \| CO₂-Ausstoß	127 g/km
Cruising Range \| Reichweite	no data \| keine Angaben
Acceleration \| Beschleunigung	7.5 s (0-60 mph \| 0-100 km/h)
Max. Speed \| Geschwindigkeit	124 mph \| 200 km/h

Mercedes-Benz F 700 | Daimler AG

When the Diesel and the Otto... | Wenn der Diesel mit dem Otto...
www.daimler.com

There were actually just two principles among the combustion engines for more than 100 years: the gasoline engine and the diesel engine. However, cars can also be driven by engines in the future that unite both principles. In its research car F 700, Mercedes-Benz introduces for the first time a DIESOTTO engine that combines the merits of the low-emission gasoline engine with the consumption advantages of the diesel engine. Under full load, the gasoline fuel injector works like an gasoline engine; under the frequently used partial load conditions, it is a self-igniting diesel. This saves fuel in the same way as the hybrid module with the integrated start-stop automatic transmission, with which the F 700 is also equipped. In addition, the sedan with a length of 17 feet gives a stylish preview of how the large touring sedans of the future might look according to the ideas of the Mercedes designers. The body forms of the F 700 were created in the Mercedes-Benz Advanced Design Studio in Irvine (California). Mercedes calls the soft, flowing design language "Aqua Dynamic". The special features of the F 700 also include the back doors on the right and left side that open in different directions, as well as the REVERSE-seat in the back that allows the passenger to face the opposite direction of travel.

Unter den Verbrennungsmotoren gab es über 100 Jahre lang eigentlich nur zwei Prinzipien: den Benzin- oder Ottomotor und den Dieselmotor. In Zukunft könnten Autos aber auch von Motoren angetrieben werden, in denen beide Prinzipien verschmelzen. Mercedes-Benz hat in seinem Forschungsfahrzeug F 700 erstmals einen DIESOTTO-Motor vorgestellt, der die Vorzüge des schadstoffarmen Ottomotors mit den Verbrauchsvorteilen des Dieselaggregats verbindet. Unter Volllast arbeitet der Benzindirekteinspritzer wie ein Ottomotor, im häufig genutzten Teillastbereich wie ein selbstzündender Diesel. Das spart ebenso Kraftstoff wie das Hybridmodul mit integrierter Start/Stopp-Automatik, mit dem der F 700 ebenfalls bestückt ist. Darüber hinaus gibt die 5,18 Meter lange Limousine einen stilistischen Ausblick darauf, wie die große Reiselimousine der Zukunft nach Vorstellung der Mercedes-Designer aussieht. Die Karosserieformen des F 700 wurden im Mercedes-Benz Advanced Design Studio in Irvine (Kalifornien) entworfen. Die weiche, fließende Formensprache nennt Mercedes „Aqua Dynamic". Zu den Besonderheiten des F 700 gehören auch die in unterschiedliche Richtungen öffnenden hinteren Türen auf der rechten und linken Seite sowie der REVERSE-Sitz im Fond, der dem Passagier dort eine Sitzposition entgegen der Fahrtrichtung erlaubt.

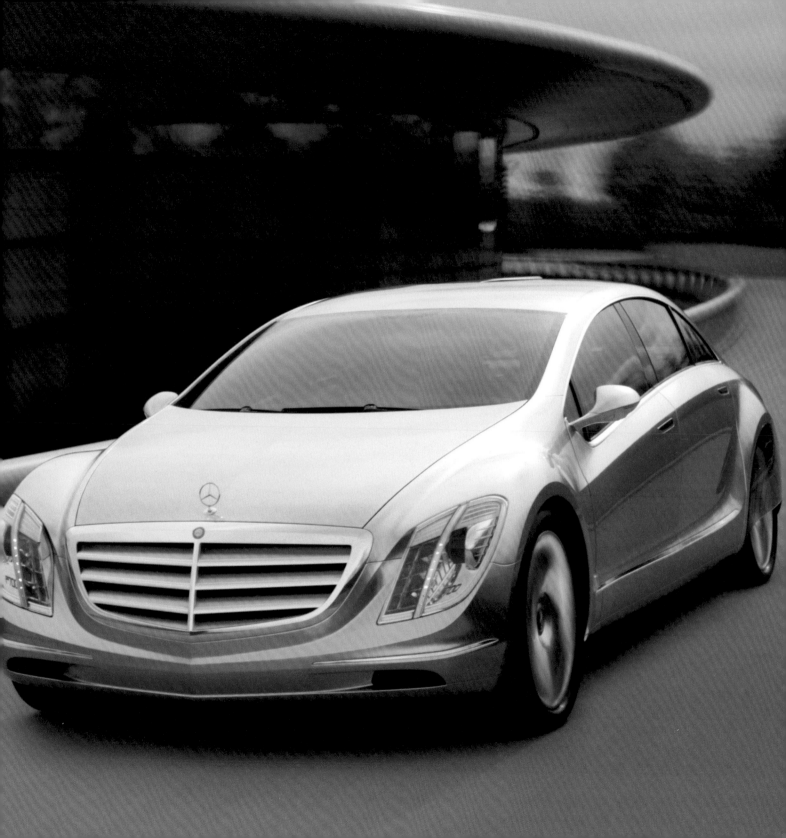

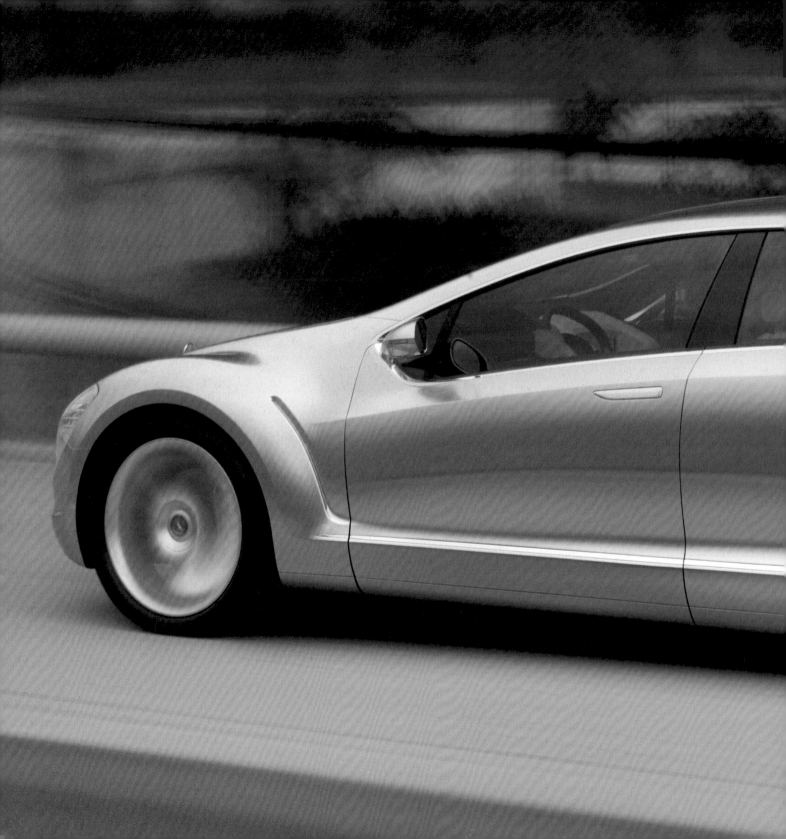

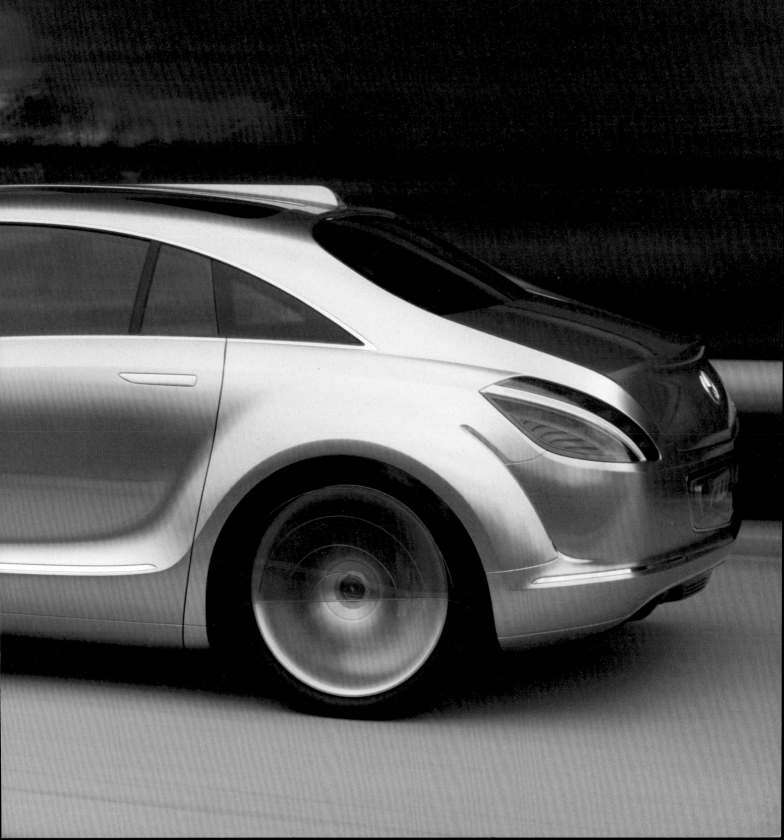

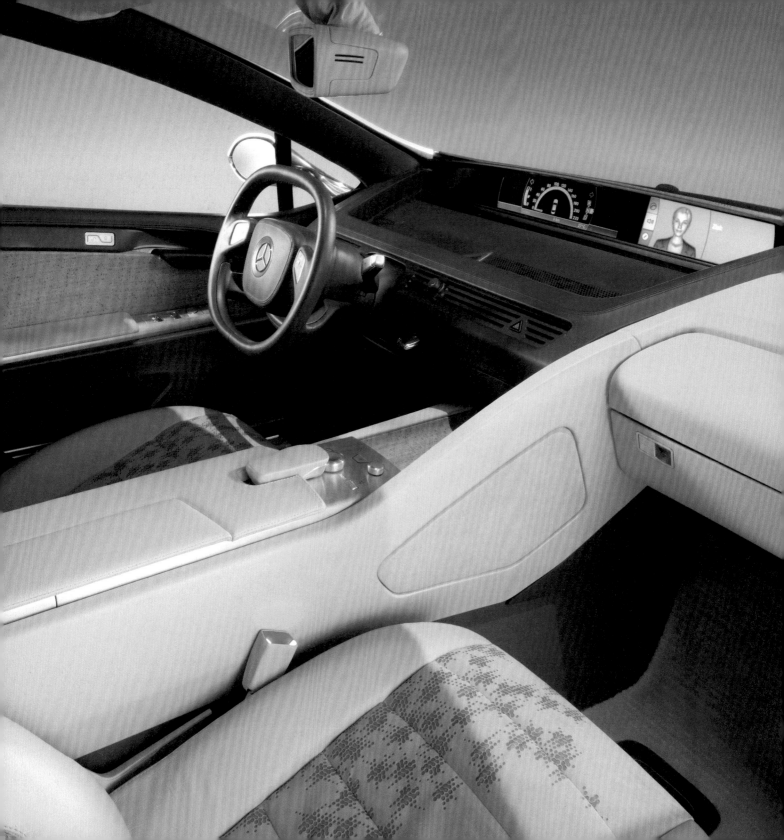

Data and Facts		S 300 Bluetec		
Engine Type	Antriebsart		diesel hybrid	Diesel-Hybrid
Status	Status		2010	
Displacement	Hubraum		2200 cm³	
Output	Leistung		150 kW; 204 HP	PS (diesel)
Fuel Consumption	Verbrauch		43 mpg	5,4 l/100 km
CO₂ Emission	CO₂-Ausstoß		142 g/km	
Cruising Range	Reichweite		1035 mi	1666 km
Acceleration	Beschleunigung		8.4 s (0-60 mph	0-100 km/h)
Max. Speed	Geschwindigkeit		149 mph	240 km/h

Mercedes-Benz S 300 Bluetec Hybrid | Daimler AG

All in One | Alles in einem

www.daimler.com

It will take until 2010, but Mercedes-Benz wants to put an S-Class on the market that unites all of the current series-produced technologies for an especially economical and eco-friendly diesel drive. The S 300 Bluetec Hybrid is driven by an economical four-cylinder diesel, which is combined with an electric motor as a hybrid. This means that the self-igniting diesel engine, which is by nature economical, becomes even more frugal because the engine turns off at the traffic light, the electric motor offers additional driving power, and energy is recovered during braking or coasting. The energy is stored in a lithium-ion battery. Although the diesel hybrid cannot drive without exhaust fumes, a particle filter and the Bluetec System that cuts the nitrogen oxide (NOx) in the exhaust ensure reduced pollutant emissions. As a result, the S 300 Bluetec Hybrid may fulfill the strictest emission standards in the world—such as the planned EU6 standards or the BIN5 standards for the 50 states of the USA.

Es wird noch bis 2010 dauern, doch dann will Mercedes-Benz eine S-Klasse auf den Markt bringen, die alle derzeit in Serie umsetzbaren Techniken für einen besonders sparsamen und umweltfreundlichen Dieselantrieb in sich vereint. Der S 300 Bluetec Hybrid wird von einem sparsamen Vierzylinder-Diesel angetrieben, der als Hybrid um einen Elektromotor ergänzt wird. Das heißt: Der von Haus aus sparsame Selbstzünder wird noch genügsamer, weil beim Ampelstopp der Motor abgeschaltet wird, der Elektromotor zusätzliche Antriebskraft bietet und beim Bremsen oder im Schiebebetrieb Energie zurückgewonnen wird. Die Energie wird in einer Lithium-Ionen-Batterie gespeichert. Ohne Abgase kann der Diesel-Hybrid indes nicht fahren, doch hier sorgen ein Partikelfilter und das Bluetec-System, das die im Abgas enthaltenen Stickoxide (NOx) abbaut, für reduzierte Schadstoffemissionen. Dadurch vermag der S 300 Bluetec Hybrid die weltweit schärfsten Abgasnormen – zum Beispiel die geplante EU6- oder die BIN5-Norm für 50 US-Bundesstaaten – zu erfüllen.

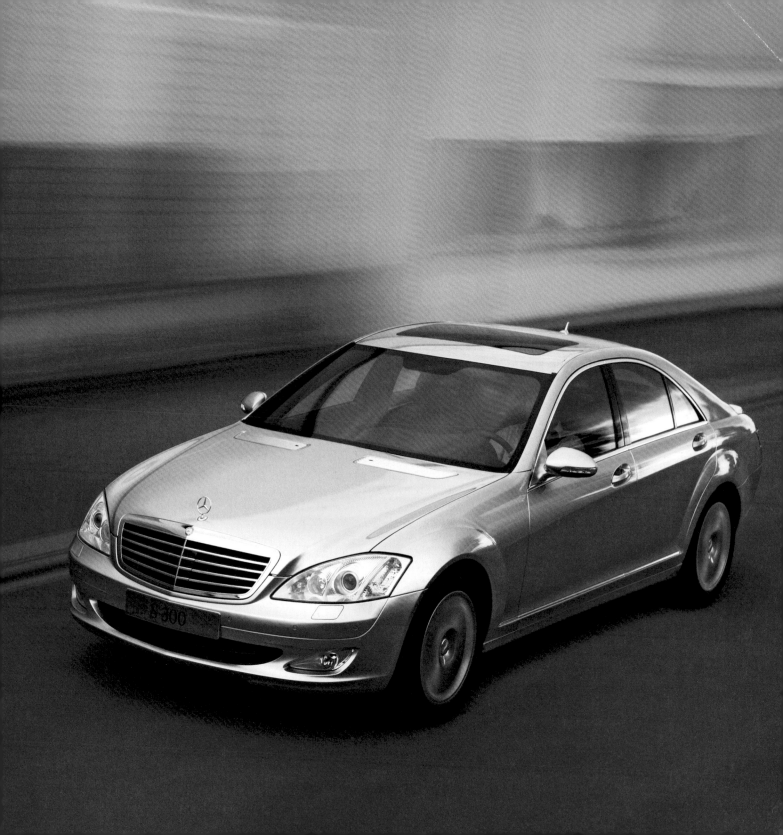

Data and Facts	308 HybridHDi
Engine Type \| Antriebsart	diesel hybrid \| Diesel-Hybrid
Status \| Status	2010
Displacement \| Hubraum	1580 cm³
Output \| Leistung	80 kW; 109 HP \| PS (diesel) 16 kW; 22 HP \| PS (diesel)
Fuel Consumption \| Verbrauch	70 mpg \| 3,4 l/100 km
CO_2 Emission \| CO_2-Ausstoß	90 g/km
Cruising Range \| Reichweite	1096 mi \| 1764 km
Acceleration \| Beschleunigung	12.2 s (0-60 mph \| 0-100 km/h)
Max. Speed \| Geschwindigkeit	no data \| keine Angaben

Peugeot 308 HybridHDi | Automobiles Peugeot

A Lion on a Diet | Ein Löwe auf Diät

www.peugeot.com

Frugality is not necessarily a characteristic of French cuisine. But people in the "Grande Nation" tend to be more reserved when it comes to cars and rely primarily on the economical diesel engines. No wonder that the French brand Peugeot first sets its sights on this principle in the development of alternative drives. The 'lion brand' was the first to introduce a diesel hybrid. An economical diesel engine together with a particle filter in combination with an electric engine are responsible for an especially thrifty consumption and low CO_2 emissions. The diesel engine is being turned off at every stop. When starting, only the electric engine with its 22 HP is running; if necessary, the diesel engine automatically turns on as well. The 308 can drive up to 1.8 miles without emissions by using the electric drive. The nickel-metal hydride battery (Ni-MH) provides a voltage of 200 volts and is housed in the spare-tire recess—which means that no additional space is lost in the trunk. In overrun or when braking, the 308 HybridHDi recovers the movement energy and uses it to charge the batteries. As a result, the consumption of the 308 HybridHDi is at 70 miles per gallon—which corresponds to a CO_2 emission of 90 grams per kilometer. The undemanding French car should be ready to go into production by 2010.

Genügsamkeit ist nicht gerade ein Kennzeichen der französischen Küche. Doch beim Auto ist man in der Grande Nation eher zurückhaltend und setzt vor allem auf die sparsamen Dieselmotoren. Kein Wunder, dass die französische Marke Peugeot bei der Entwicklung alternativer Antriebe zunächst dieses Prinzip ins Visier nimmt. Als erster Hersteller hat die Löwen-Marke einen Diesel-Hybrid vorgestellt, bei dem ein sparsamer Dieselmotor nebst Partikelfilter in Kombination mit einem Elektromotor für besonders niedrigen Verbrauch und geringen CO_2-Ausstoß sorgen soll. Bei jedem Stopp wird der Dieselmotor abgeschaltet. Beim Anfahren arbeitet zunächst nur der 22 PS starke Elektromotor, bei Bedarf schaltet sich der Dieselmotor automatisch zu. Bis zu drei Kilometer kann der 308 emissionsfrei mit Elektroantrieb fahren. Die Nickel-Metallhydrid-Batterie (Ni-MH) liefert 200 Volt Spannung und ist in der Reserveradmulde untergebracht – dadurch geht kein zusätzlicher Platz im Kofferraum verloren. Im Schubbetrieb oder beim Bremsen gewinnt der 308 HybridHDi die Bewegungsenergie zurück und nutzt sie zum Aufladen der Batterien. So soll der 308 HybridHDi nur 3,4 Liter Diesel auf 100 Kilometer verbrauchen – was einem CO_2-Ausstoß von 90 Gramm pro Kilometer entspräche. Bis 2010 soll der genügsame Franzose serienreif sein.

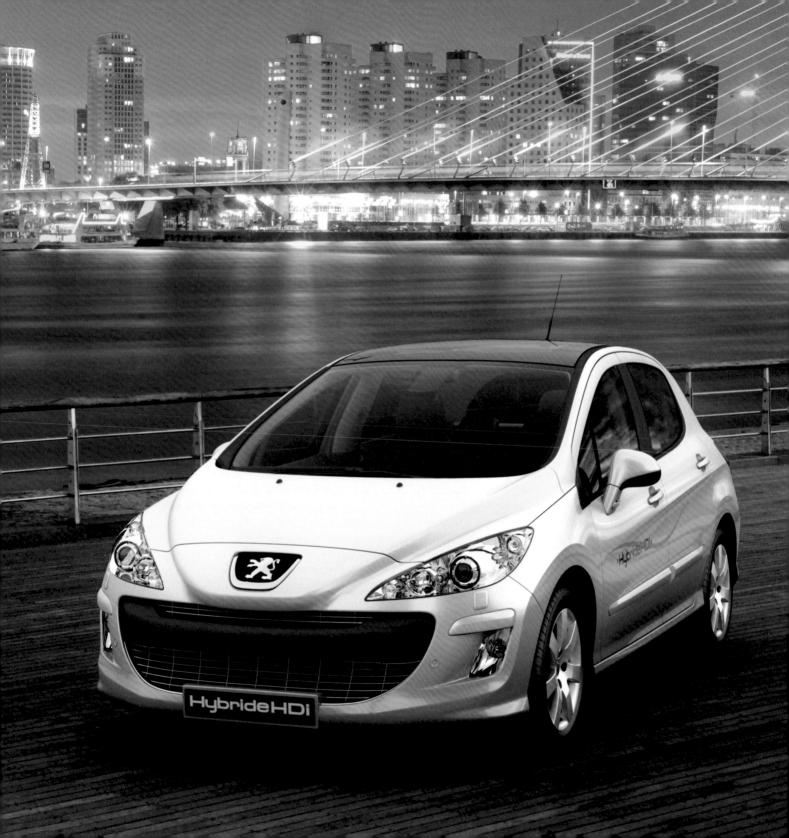

Data and Facts		BioPower 100
Engine Type \| Antriebsart		ethanol drive \| Ethanolantrieb
Status \| Status		concept car
Displacement \| Hubraum		1985 cm³
Output \| Leistung		221 kW; 300 HP \| PS
Fuel Consumption \| Verbrauch		no data \| keine Angaben
CO₂ Emission \| CO₂-Ausstoß		no data \| keine Angaben
Cruising Range \| Reichweite		no data \| keine Angaben
Acceleration \| Beschleunigung		6.6 s (0-60 mph \| 0-100 km/h)
Max. Speed \| Geschwindigkeit		155 mph \| 250 km/h

Saab BioPower 100 | Saab

100-Percent Alcoholic | 100-prozentiger Alkoholiker

www.saab.com

Eco products are available in the supermarket—and sometimes at the gas station. This is the case when bioethanol is pumped instead of gasoline or diesel. The number of gas stations in Europe that offer E85—this fuel consists of 85 percent bioethanol and 15 percent gasoline—is gradually increasing. With its study BioPower 100 Concept based on the 9-5 SportCombi, Saab displayed a variation of a vehicle, which is operated with 100-percent bioethanol (E100) and is almost ready for series production, for the first time at the Geneva Automobile Salon 2007. Bioethanol is produced from useful plants like corn or sugarcane and other forms of biomass. It is considered CO_2 neutral: When it is burned, the same amount of CO_2 is created that had previously been bound by the plant. With this drive, Saab intends to not only emphasize the role of the biogas but also show its power potential. With its 300 HP, the 2.0-liter turbo engine is exactly twice as powerful as the comparable gasoline model. E100 attains a high octane rating of 106 ROZ, which makes a high compression ratio and high supercharging pressure possible. In addition, the E100 has a fuel consumption that is about ten percent lower in comparison to the E85 fuel.

Bio-Artikel gibt es im Supermarkt – und manchmal an der Tankstelle. Dann nämlich, wenn anstelle von Benzin oder Diesel Bio-Ethanol getankt wird. Allmählich nimmt in Europa die Zahl der Tankstellen zu, an denen E85 angeboten wird – dieser Kraftstoff besteht aus 85 Prozent Bio-Ethanol und 15 Prozent Benzin. Saab hat mit der auf dem 9-5 Sport-Combi basierenden Studie BioPower 100 Concept auf dem Genfer Automobilsalon 2007 erstmals eine seriennahe Variante eines Fahrzeugs gezeigt, das mit 100-prozentigem Bio-Ethanol (E100) betrieben wird. Bioethanol wird aus Nutzpflanzen wie Mais oder Zuckerrohr und anderen Formen von Biomasse hergestellt und gilt als CO_2-neutral: Bei seiner Verbrennung entsteht die Menge an CO_2, die zuvor von der Pflanze gebunden wurde. Saab will mit diesem Antrieb nicht nur die Rolle von Bio-Sprit betonen, sondern auch dessen Leistungspotenzial aufzeigen. Denn mit 300 PS ist der 2,0-Liter-Turbomotor genau doppelt so stark wie das vergleichbare Benzin-Modell. E100 erreicht eine hohe Oktanzahl von 106 ROZ, wodurch ein hohes Verdichtungsverhältnis und hoher Ladedruck möglich werden. Außerdem sorgt E100 im Vergleich zum E85-Kraftstoff für einen um etwa zehn Prozent niedrigeren Verbrauch.

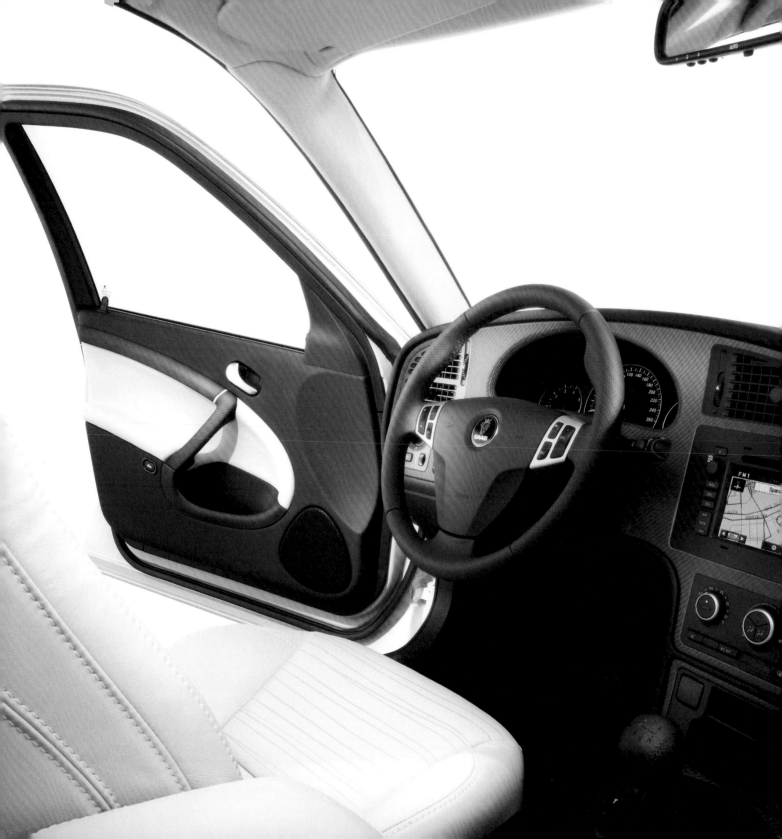

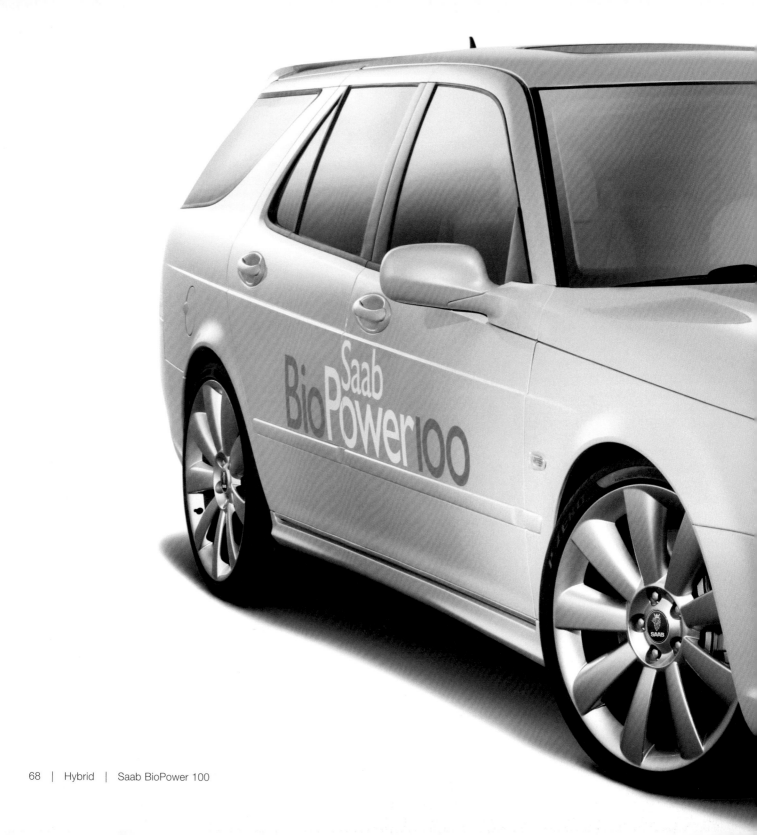

Data and Facts	1/X
Engine Type \| Antriebsart	gasoline hybrid \| Benzin-Hybrid
Status \| Status	concept car
Displacement \| Hubraum	500 cm³
Output \| Leistung	no data \| keine Angaben
Fuel Consumption \| Verbrauch	87 mpg \| 2,7 l/100 km
CO₂ Emission \| CO₂-Ausstoß	no data \| keine Angaben
Cruising Range \| Reichweite	no data \| keine Angaben
Acceleration \| Beschleunigung	no data \| keine Angaben
Max. Speed \| Geschwindigkeit	no data \| keine Angaben

Toyota 1/X | Toyota Motor Corporation

Hybrid with a Diet Program | Hybrid mit Diät-Programm

www.toyota.com

In some diets, the menus are simply cut in half. For the concept car 1/X, Toyota attempts to reduce the gas consumption by 50 percent. The criterion for this is the series version of the Toyota Prius. In order to realize this goal, the engineers have resolutely relied on lightweight construction. Because of the extensive use of carbon-fiber composites in the vehicle structure and essential body parts, it was possible to reduce the weight of the vehicle to 926 pounds—just one-third of the Prius weight. However, the study with a length of 13 feet presented in 2007 in Tokyo has room for four people. Toyota additionally uses the advantages of plug-in hybrid technology in the 1/X by minimizing the combustion engine that belongs to the system through the greater electrical capacity of the drive. As a result, a 500 cubic centimeter two-cylinder is adequate as a supplement to the electric motor in this concept vehicle. The combustion engine can also be operated by a choice of gasoline or bio-ethanol. The drive unit is placed under the back seats to save space.

Bei mancher Diät wird der Speiseplan schlichtweg auf die Hälfte reduziert, Toyota versucht beim Concept-Car 1/X, den Benzinverbrauch um 50 Prozent zu reduzieren. Maßstab dafür ist die Serienversion des Toyota Prius. Um dieses Ziel zu realisieren, setzen die Ingenieure konsequent auf Leichtbau. Durch die weitgehende Verwendung von Kohlefaserverbundstoffen bei der Fahrzeugstruktur und wesentlichen Karosserieteilen ließ sich das Gewicht des Fahrzeugs auf 420 Kilogramm senken – lediglich ein Drittel des Prius. Dennoch bietet die 2007 in Tokio präsentierte Studie auf 3,90 Metern Länge Platz für vier Personen. Beim 1/X nutzt Toyota die Vorteile der Plug-In-Hybridtechnologie weiter aus, indem der zum System gehörende Verbrennungsmotor durch die größere elektrische Kapazität des Antriebs minimiert wird. So genügt dem Konzeptfahrzeug ein 500 Kubikzentimeter großer Zweizylinder als Ergänzung zum Elektromotor. Der Verbrennungsmotor kann zudem wahlweise mit Benzin oder mit Bio-Ethanol betrieben werden. Die Antriebseinheit ist platzsparend unter den Rücksitzen untergebracht.

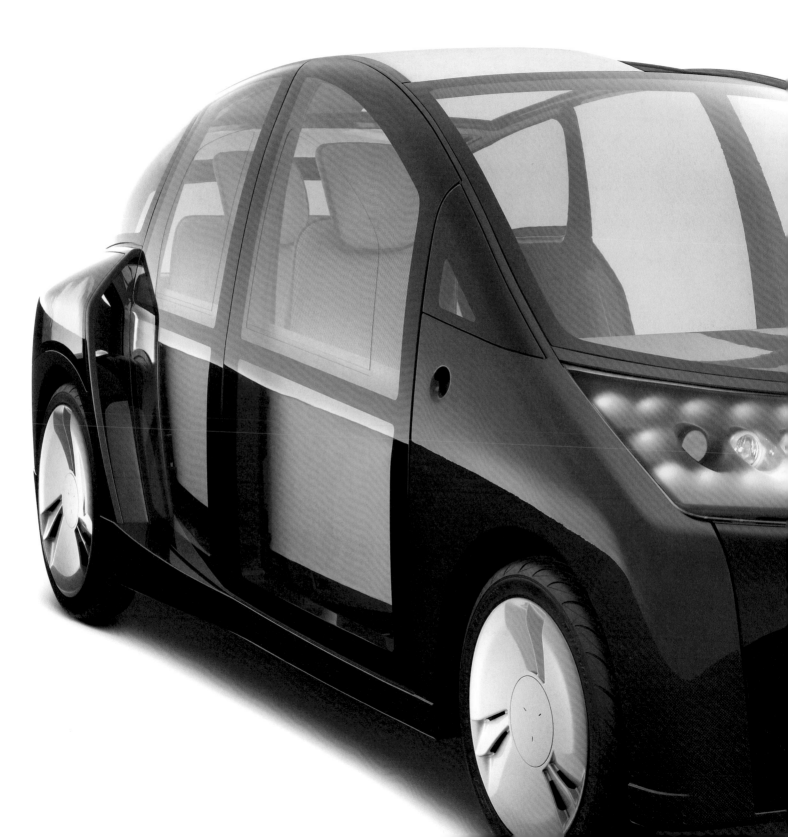

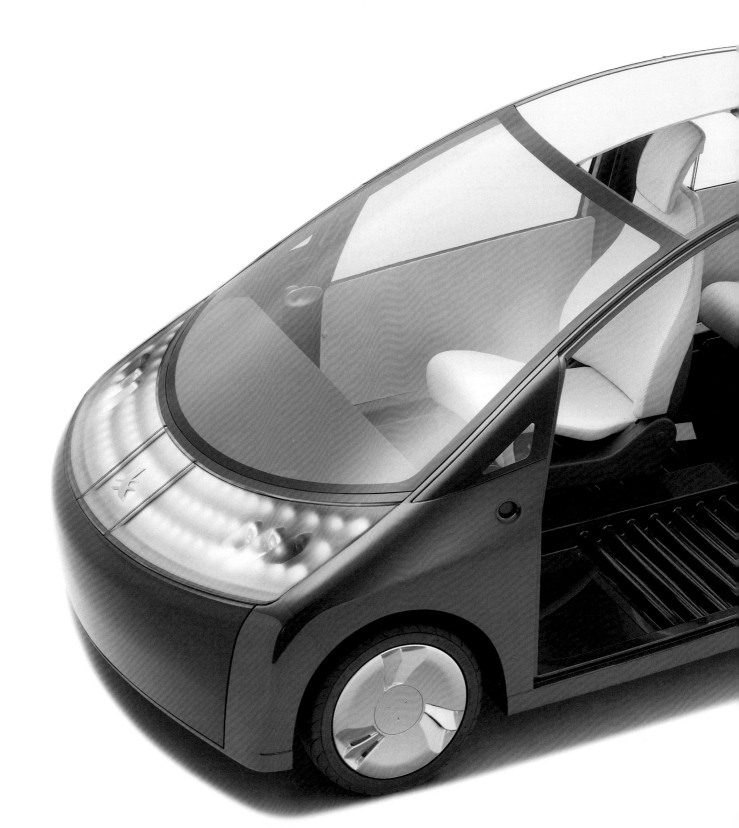

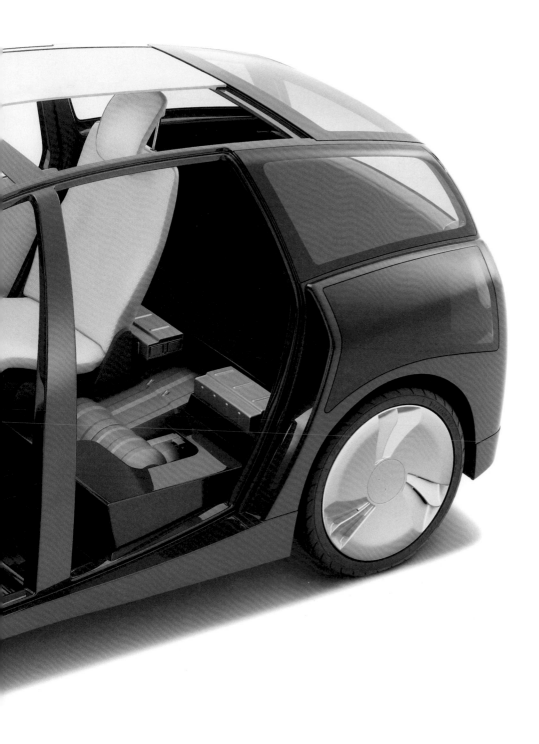

Data and Facts	FT-HS
Engine Type \| Antriebsart	gasoline hybrid \| Benzin-Hybrid
Status \| Status	concept car
Displacement \| Hubraum	3500 cm³
Output \| Leistung	298 kW; 400 HP \| PS (gasoline)
Fuel Consumption \| Verbrauch	no data \| keine Angaben
CO₂ Emission \| CO₂-Ausstoß	no data \| keine Angaben
Cruising Range \| Reichweite	no data \| keine Angaben
Acceleration \| Beschleunigung	no data \| keine Angaben
Max. Speed \| Geschwindigkeit	no data \| keine Angaben

Toyota FT-HS | Toyota Motor Corporation

Hybrid as a Top Athlete | Hybrid als Hochleistungssportler
www.toyota.com

High-performance sports cars and alternative drives don't appear to be a perfect match at first glance. But the Japanese manufacturer Toyota shows a possible approach with the concept car FT-HS. The sports-car study was presented at the beginning of 2007 in Detroit. Its abbreviation stands for the unwieldy name of Future Toyota Hybrid Sports and represents a 2+2-seater with an especially sporty body design. The coupé was created at the Toyota Design Center in Newport Beach, California. With this study, Toyota demonstrates that the hybrid drive, which has already been applied successfully in series production, can definitely also be transferred to a sports car. The coupe is driven by a 3.5-liter V-six-cylinder that is installed in the front of the vehicle and drives the rear wheels. Together with an electric motor, it provides a system capacity of 400 HP. The exclusive character of the study is underscored by the 21-inch tires that are made of carbon.

Hochleistungssportwagen und alternative Antriebe, das scheint auf Anhieb nicht so recht zusammenzupassen. Mit dem Concept-Car FT-HS zeigt der japanische Hersteller Toyota jedoch einen möglichen Weg. Die Anfang 2007 in Detroit präsentierte Sportwagen-Studie, dessen Kürzel für den sperrigen Namen „Future Toyota Hybrid Sports" steht, stellt einen 2+2-Sitzer mit besonders sportlichem Karosseriedesign dar. Entworfen wurde das Coupé im kalifornischen Toyota-Design-Center Newport Beach. Toyota zeigt mit der Studie, dass sich der bereits in Serie bewährte Hybridantrieb durchaus auch auf einen Sportwagen übertragen lässt. Angetrieben wird das Coupé durch einen 3,5 Liter großen V-Sechszylinder, der in der Front des Fahrzeugs eingebaut ist und die Hinterräder antreibt. Gemeinsam mit einem Elektromotor steht eine Systemleistung von 400 PS zur Verfügung. Den exklusiven Charakter der Studie unterstreichen die 21 Zoll großen Räder, die aus Carbon gefertigt sind.

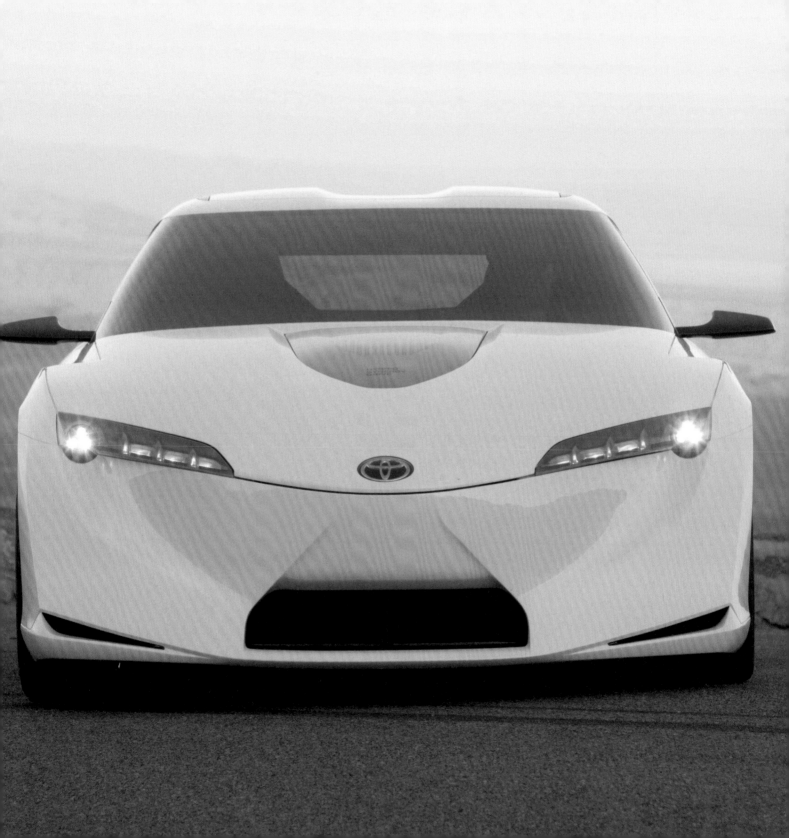

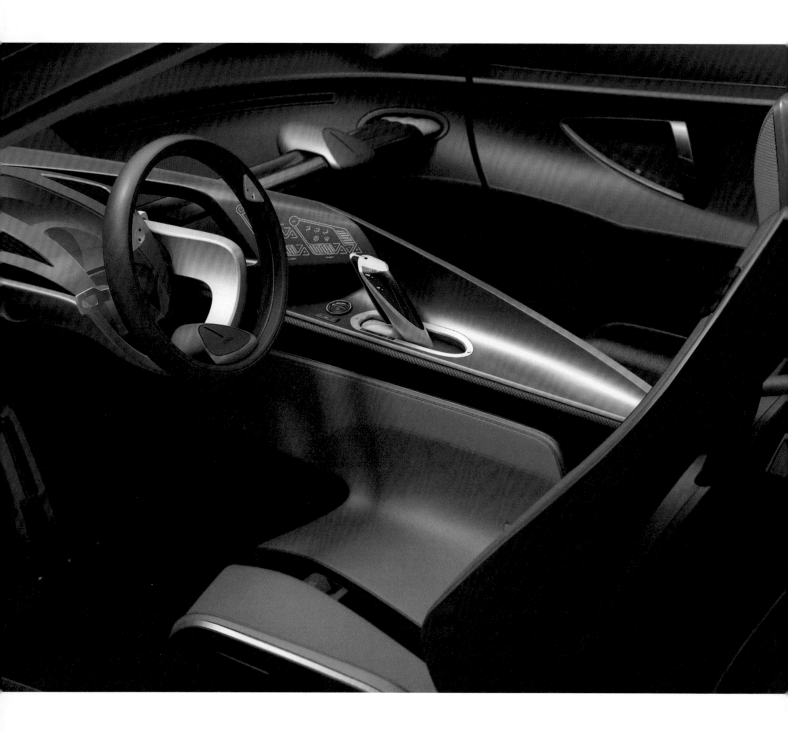

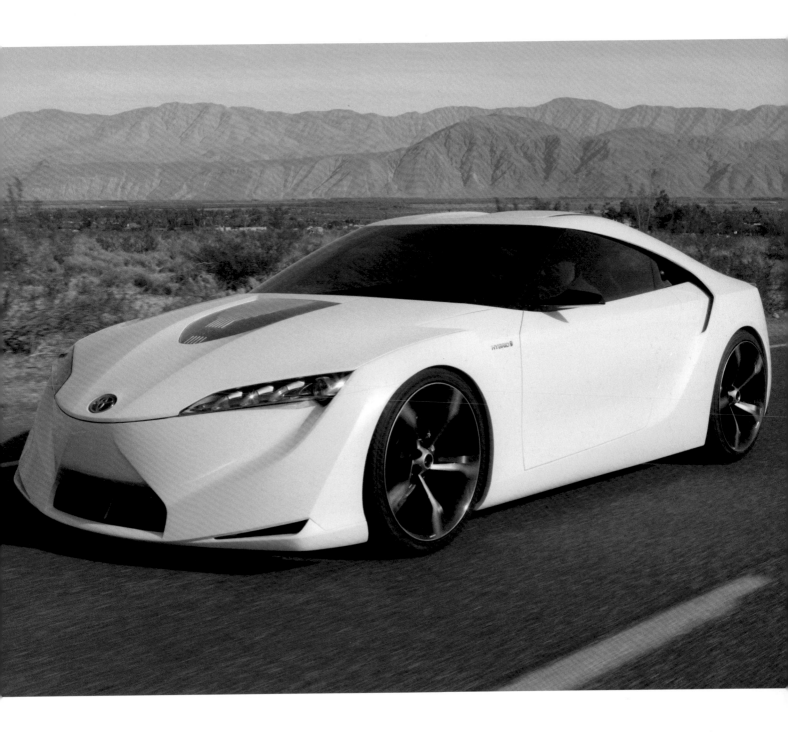

Data and Facts	Hybrid X
Engine Type \| Antriebsart	gasoline hybrid \| Benzin-Hybrid
Status \| Status	concept car
Displacement \| Hubraum	no data \| keine Angaben
Output \| Leistung	no data \| keine Angaben
Fuel Consumption \| Verbrauch	no data \| keine Angaben
CO_2 Emission \| CO_2-Ausstoß	no data \| keine Angaben
Cruising Range \| Reichweite	no data \| keine Angaben
Acceleration \| Beschleunigung	no data \| keine Angaben
Max. Speed \| Geschwindigkeit	no data \| keine Angaben

Toyota Hybrid X | Toyota Motor Corporation
Look at the Future | Blick in die Zukunft
www.toyota.com

Toyota ushered in a new era of vehicle technology more than ten years ago with the hybrid drive. The Japanese manufacturer also wants to maintain this position. At the Geneva Automobile Salon 2007, it presented a concept study with the Hybrid X that introduces a new design language for hybrid vehicles and is simultaneously intended to serve as the technology-bearer for future hybrid models. The Hybrid X, which was designed as an especially roomy and comfortable four-door four-seater, was created at Toyota's European ED² design center. Its location in the south of France is distinct evidence that the brand wants to orient itself to the taste of the European customers. With the Hybrid X, Toyota translates its vision of the eco-friendly car of the future into concrete terms. Even if Toyota has not yet announced the detailed technical data of the concept vehicle, the public should pay attention to the shapes of the Hybrid X. Toyota has unmistakably declared that the design of the Hybrid X will set the tone for the Toyota brand's hybrid models in the future.

Mit dem Hybridantrieb hat Toyota schon mehr als zehn Jahre eine neue Ära der Fahrzeugtechnik eingeläutet. Daran will der japanische Hersteller auch in Zukunft festhalten und präsentierte auf dem Genfer Automobilsalon 2007 mit dem Hybrid X eine Konzeptstudie, die eine neue Designsprache für Hybridfahrzeuge vorstellt und zugleich als Technologieträger für zukünftige Hybridmodelle fungieren soll. Der als besonders geräumiger und komfortabler viertüriger Viersitzer konzipierte Hybrid X entstand in Toyotas europäischem Design-Zentrum ED², das im Süden Frankreichs beheimatet ist – ein deutlicher Beleg dafür, dass sich die Marke am Geschmack europäischer Kunden orientieren will. Mit dem Hybrid X konkretisiert Toyota seine Vision vom umweltfreundlichen Auto der Zukunft. Auch wenn Toyota keine detaillierten technischen Daten des Konzeptfahrzeugs bekannt gibt, sollte man sich die Formen des Hybrid X schon einmal gut merken. Toyota hat unmissverständlich erklärt, dass das Design des Hybrid X in Zukunft die Hybridmodelle der Marke Toyota prägen werde.

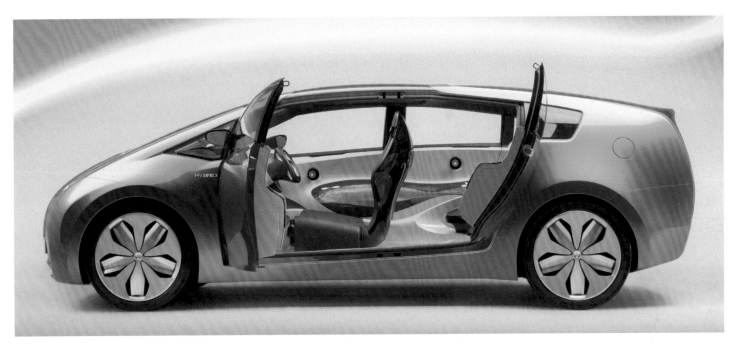

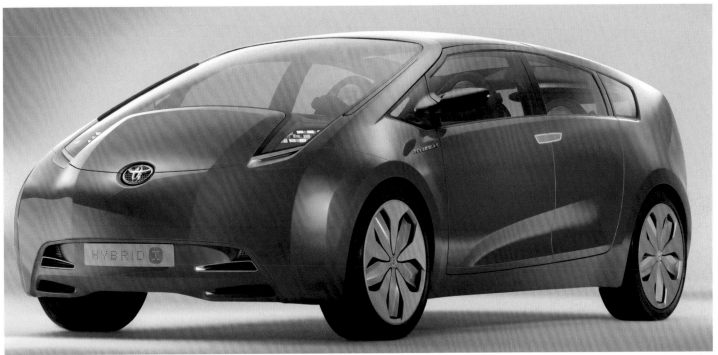

Data and Facts	Prius
Engine Type \| Antriebsart	gasoline hybrid \| Benzin-Hybrid
Status \| Status	1997
Displacement \| Hubraum	1497 cm³
Output \| Leistung	57 kW; 78 HP \| PS (gasoline) 51 kW; 68 HP \| PS (electro)
Fuel Consumption \| Verbrauch	55 mpg \| 4,3 l/100 km
CO₂ Emission \| CO₂-Ausstoß	104 g/km
Cruising Range \| Reichweite	650 mi \| 1046 km
Acceleration \| Beschleunigung	10.9 s (0-60 mph \| 0-100 km/h)
Max. Speed \| Geschwindigkeit	105 mph \| 170 km/h

Toyota Prius | Toyota Motor Corporation

The Trailblazer | Der Vorreiter

www.toyota.com

Although its appearance is as inconspicuous as a good civil servant, the Toyota Prius enjoys a special position: It is the uncrowned king of hybrid vehicles—and an example for all the others who rely on the power of two hearts. The Prius already came onto the market in 1997 in its first generation and was also offered outside of Japan starting in 2000. Although the competition didn't take it seriously for a long time, the Prius set a trend. And it created the basis for its sales success: Toyota now offers the hybrid technology in several production series and has sold more than one million hybrid cars during the past ten years. According to its own statements, Toyota has reduced the CO_2 emissions by 3.5 million tons as a result. Since 2003, the second generation of Prius has been on the market with a body shape that has a distinctly more pleasing and modern look in comparison to its predecessor. With its electric motor, the sedan can be driven in the city with electric drive. Energy is recovered during braking and coasting. Toyota is now working on a plug-in variation of the Prius, which can be charged at an outlet. When driven just electrically, this version reaches a top speed of 60 mph and has a range 8 miles.

In seinem Auftritt ist er unscheinbar wie ein braver Beamter, doch der Toyota Prius genießt eine Sonderstellung: Er ist der ungekrönte König der Hybridfahrzeuge – und ein Vorbild für alle anderen, die auf die Kraft der zwei Herzen setzen. Denn in seiner ersten Generation kam der Prius bereits 1997 auf den Markt und wurde ab 2000 auch außerhalb Japans angeboten. Von der Konkurrenz lange nicht ernst genommen, hat der Prius einen Trend gesetzt. Und die Basis für einen Verkaufserfolg gelegt: Toyota bietet die Hybridtechnik inzwischen in mehreren Baureihen an und hat in den vergangenen zehn Jahren mehr als eine Million Hybrid-Autos verkauft. Nach eigenen Angaben hat Toyota dadurch den CO_2-Ausstoß um 3,5 Millionen Tonnen reduziert. Seit 2003 ist die zweite Generation des Prius auf dem Markt, deren Karosserieformen im Vergleich zum Vorgänger deutlich gefälliger und moderner wirken. Mit ihrem Elektromotor vermag die Limousine in der Stadt mit Elektroantrieb zu fahren. Beim Bremsen und im Schiebebetrieb wird Energie zurückgewonnen. Toyota arbeitet zwischenzeitlich an einer Plug-in-Variante des Prius, die an der Steckdose aufgeladen werden kann. Rein elektrisch bewegt, erreicht diese Version eine Spitzengeschwindigkeit von 100 km/h und schafft eine Strecke von rund 13 Kilometern.

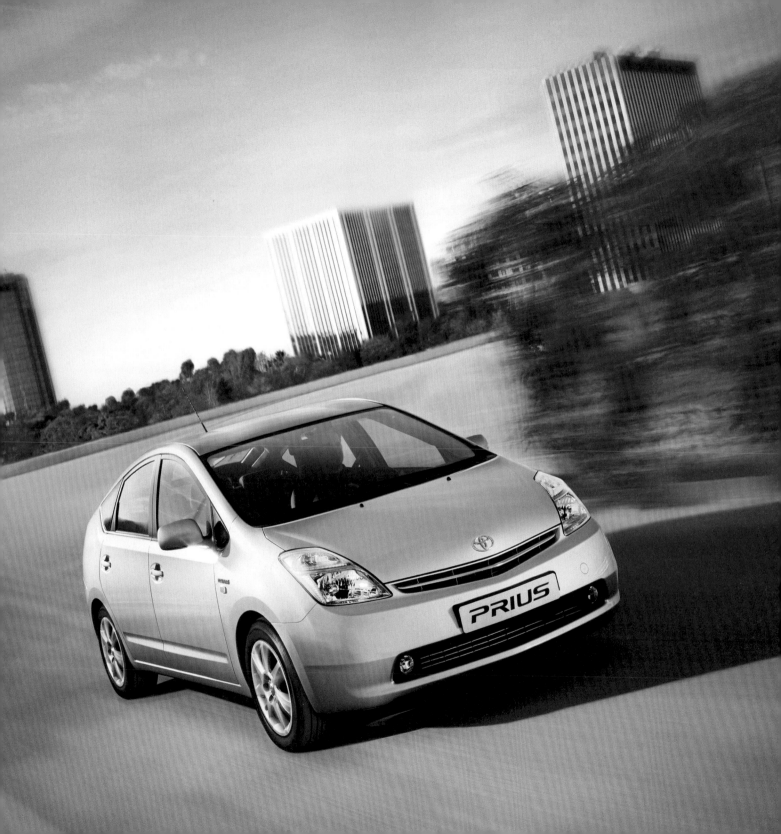

Data and Facts		Space Up! Blue
Engine Type \| Antriebsart		hydrogen fuel cell \| Brennstoffzelle
Status \| Status		concept car
Displacement \| Hubraum		-
Output \| Leistung		45 kW; 61 HP \| PS (electro)
Fuel Consumption \| Verbrauch		no data \| keine Angaben
CO₂ Emission \| CO₂-Ausstoß		0 g/km
Cruising Range \| Reichweite		217 mi \| 350 km
Acceleration \| Beschleunigung		no data \| keine Angaben
Max. Speed \| Geschwindigkeit		74 mph \| 120 km/h

VW Space Up! Blue | Volkswagen AG

Trip into the Blue | Fahrt ins Blaue

www.volkswagen.com

VW has introduced a visionary family of small cars under the name of Space Up! As a part of this, the Space Up! Blue plays the role of the eco-friendly angel: It drives completely without a combustion engine; instead, it has a 61 HP electric motor in the rear. This is fed by twelve lithium-ion batteries that are arranged under the rear seat and can be charged via outlets. If the energy supply runs out while traveling, a high-temperature fuel cell located in the front of the car is activated. While the power of the batteries is enough for 62 miles, the fuel cell expands the range for another 155 miles. In addition, a large solar panel on the roof can feed the vehicle batteries with up to 150 watts. According to VW, the high-temperature fuel cell, in which electrical energy is produced from hydrogen, has the advantage of being distinctly lighter and more suitable for everyday use than other fuel cells and is less expensive to produce. In addition to its modern technology, the Space Up! Blue with its length of 12 feet is very much reminiscent of the past. Not only its rear-engine concept, but also its design philosophy is an homage on the Samba Bus, which was also popular and almost legendary in the USA.

Unter dem Namen Space Up! hat VW eine visionäre Kleinwagen-Familie vorgestellt. Der Space Up! Blue spielt dabei die Rolle des Umweltengels: Er fährt gänzlich ohne Verbrennungsmotor, sondern besitzt im Heck einen 61 PS starken Elektromotor. Dieser wird aus zwölf Lithium-Ionen-Batterien gespeist, die unter der Rückbank angeordnet sind und via Steckdose aufgeladen werden können. Geht unterwegs der Energievorrat zur Neige, wird eine im Vorderwagen untergebrachte Hochtemperatur-Brennstoffzelle aktiv. Während die Kraft der Batterien für 100 Kilometer Fahrstrecke reicht, erweitert die Brennstoffzelle die Reichweite um weitere 250 Kilometer. Zusätzlich kann ein großes Solarpanel auf dem Dach bis zu 150 Watt in die Fahrzeugbatterie einspeisen. Die Hochtemperatur-Brennstoffzelle, in der aus Wasserstoff elektrische Energie erzeugt wird, birgt laut VW den Vorteil, dass sie deutlich leichter und alltagstauglicher als andere Brennstoffzellen sei und sich günstiger herstellen lassen soll. Neben seiner modernen Technik beweist der 3,68 Meter lange Space Up! Blue durchaus Sinn für Vergangenes. Denn er ist nicht nur durch sein Heckmotorkonzept, sondern auch in seiner Designphilosophie eine Hommage an den auch in den USA beliebten, geradezu legendären Samba Bus.

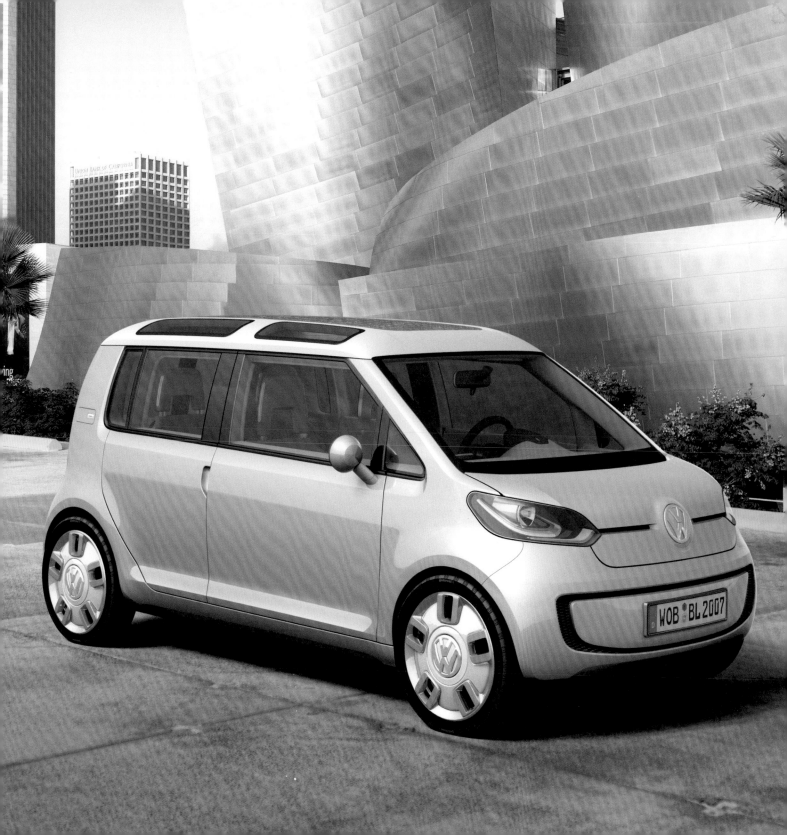

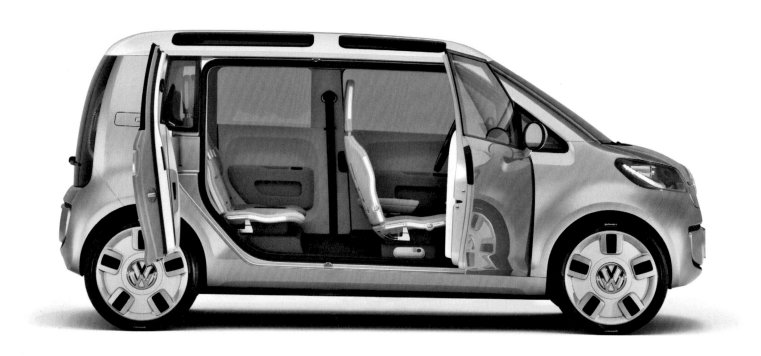

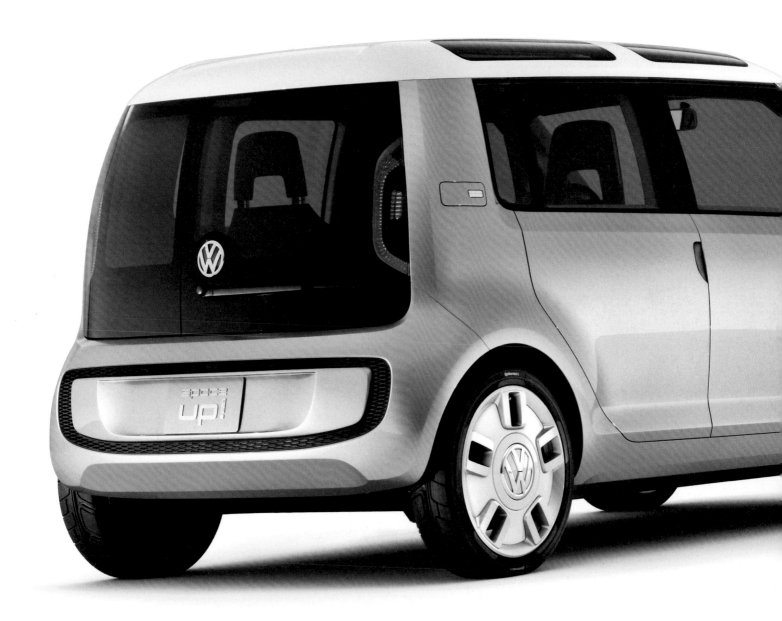

Data and Facts	Karma
Engine Type \| Antriebsart	electric drive with gasoline engine Elektroantrieb mit Benzinmotor
Status \| Status	2009
Displacement \| Hubraum	no data \| keine Angaben
Output \| Leistung	no data \| keine Angaben
Fuel Consumption \| Verbrauch	no data \| keine Angaben
CO₂ Emission \| CO₂-Ausstoß	no data \| keine Angaben
Cruising Range \| Reichweite	621 mi \| 1000 km
Acceleration \| Beschleunigung	6 s (0-60 mph \| 0-100 km/h)
Max. Speed \| Geschwindigkeit	125 mph \| 200 km/h

Fisker Karma | Fisker Automotive Inc.

Racy and Classy | Rasse und Klasse

www.fiskerautomotive.com

The American manufacturer Fisker is one of the exotics among car builders. The company from Irvine/California produces conventional high HP sports cars. But with an elegant sedan that has hybrid drive named Karma, the manufacturer founded by the Danish designer Henrik Fisker is taking new paths. The intention is for the four-door car, which is distinguished by forms that are equally elegant and powerful, to be available with a gasoline engine, which produces electricity for the electric motor. The sedan was scheduled to celebrate its premiere in January 2008 at the Detroit Auto Show and is to be launched on the market at the end of 2009. The batteries of the hybrid sedan can be charged through a conventional outlet. The company is also planning a carport with solar cells that produces electricity for the batteries. Solar cells for the roof of the vehicle have also been announced. One battery charge should take the sedan 50 miles. In developing the car, Fisker has been working with Quantum Technologies, a provider for vehicles with hydrogen-fuel cells and hydrogen internal combustion engines, as well as fuel and energy-storage processes.

Der US-amerikanische Hersteller Fisker gehört zu den Exoten unter den Autobauern. Das Unternehmen aus Irvine/California produziert gewöhnlich PS-starke Sportwagen. Doch mit einer eleganten Limousine mit Hybridantrieb namens Karma, beschreitet die von dem dänischen Designer Henrik Fisker gegründete Manufaktur neue Wege. Der Viertürer, der sich durch ebenso elegante wie kraftvolle Formen auszeichnet, soll mit einem Benzinmotor ausgestattet sein, der Strom für den Elektromotor liefert. Ende 2009 soll die Limousine, die auf der Detroit Auto Show im Januar 2008 ihre Premiere feierte, auf den Markt kommen. Die Batterien der Hybrid-Limousine können über eine konventionelle Steckdose aufgeladen werden. Geplant ist auch ein Carport mit Solarzellen, die den Strom für die Batterien liefern. Ebenso sind Solarzellen für das Fahrzeugdach angekündigt. Mit einer Batterieladung soll die Limousine 80 Kilometer weit kommen. Bei der Entwicklung des Fahrzeugs arbeitet Fisker mit Quantum Technologies zusammen, einem Anbieter für Fahrzeuge mit Wasserstoff-Brennstoffzellen und Wasserstoff-Verbrennungsmotoren sowie Kraftstoff- und Energie-Speicherverfahren.

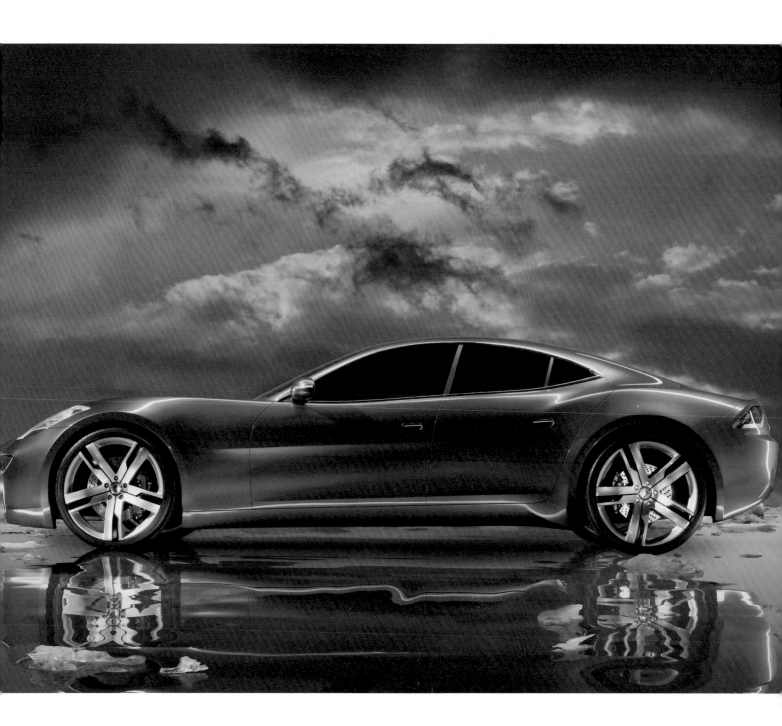

Data and Facts		Type-1
Engine Type \| Antriebsart		electro \| Elektro
Status \| Status		end of 2008
Displacement \| Hubraum		-
Output \| Leistung		10 kW; 13 HP \| PS
Fuel Consumption \| Verbrauch		294 mpg \| 0,8 l/100 km (Hybridversion)
CO₂ Emission \| CO₂-Ausstoß		0 g/km (Electroversion)
Cruising Range \| Reichweite		118 mi \| 190 km (Electroversion)
Acceleration \| Beschleunigung		10 s (0-60 mph \| 0-100 km/h)
Max. Speed \| Geschwindigkeit		140 mph \| 225 km/h

Aptera Typ-1 | Aptera Motors

Encounters of a Special Kind | Begegnung der besonderen Art
www.aptera.com

It seems very much like a scene from a science-fiction film when the Aptera Typ-1 appears. With its flat and wide body, the bizarre vehicle looks like a strange insect that just came from another world on its three legs. The two front wheels of the electric car are aerodynamically fully covered, and three passengers can enter through the two big gull-wing doors. The rear just has one wheel, which is driven by a belt—no wonder that the Aptera is registered as a motorcycle in the USA, its home country. The Californian manufacturer intends to produce the eco-friendly three-wheel vehicle beginning in October 2008. Two variations are planned: an all-electric version with an electric motor, powered exclusively by batteries charged at an outlet, and a plug-in electric hybrid version. The latter has a small gas engine that produces additional electrical energy when necessary, increasing the range of the rolling UFO.

Es mutet durchaus wie eine Szene in einem Science-Fiction-Film an, wenn der Aptera Typ-1 in Erscheinung tritt. Mit seiner flachen und breiten Karosserie erscheint das skurrile Fahrzeug wie ein fremdartiges Insekt, das auf seinen drei Beinen geradewegs aus einer anderen Welt zu kommen scheint. Die beiden Vorderräder des Elektromobils sind aerodynamisch voll verkleidet, der Einstieg für die drei Passagiere erfolgt über zwei große Flügeltüren. Am Heck ist nur ein einzelnes Rad platziert, das über einen Riemen angetrieben wird – kein Wunder, dass der Aptera in seinem Heimatland USA eine Zulassung als Motorrad besitzt. Der kalifornische Hersteller will das umweltfreundliche Dreirad ab Oktober 2008 produzieren. Geplant sind zwei Varianten: eine Elektroversion, deren Elektromotor ausschließlich aus mehreren über die Steckdose aufladbaren Batterien gespeist wird, und eine Plug-In Hybridversion. Dort erzeugt ein kleiner Benzinmotor bei Bedarf zusätzliche elektrische Energie und erhöht somit die Reichweite des fahrenden Ufos.

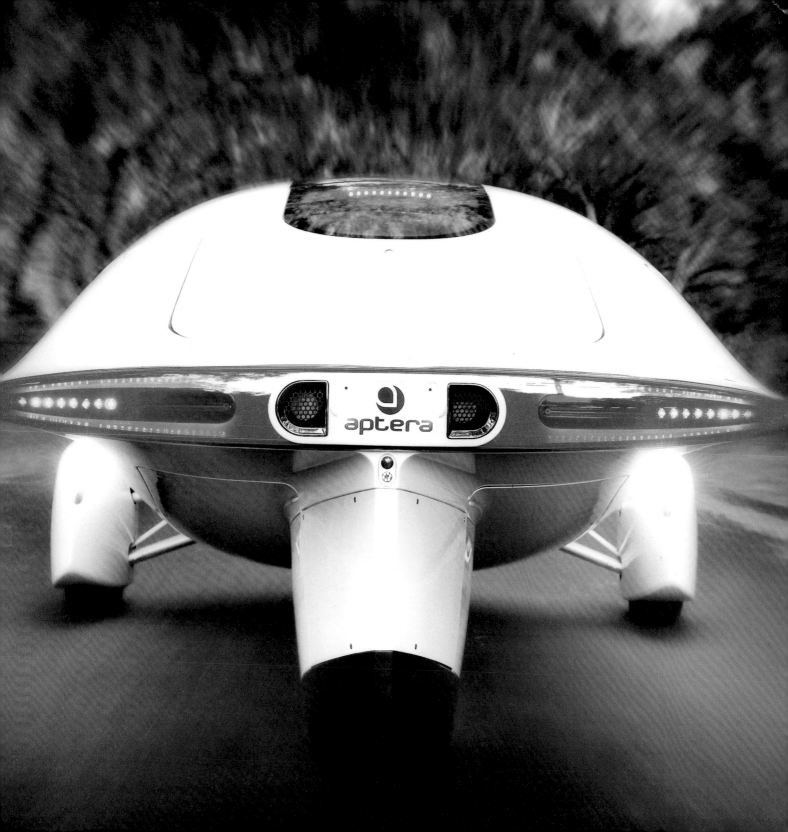

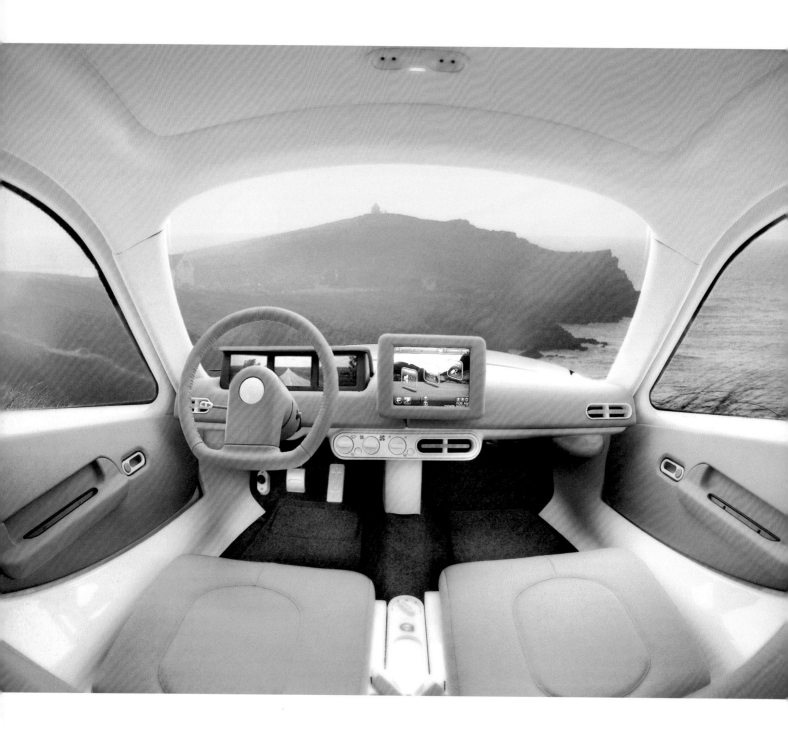

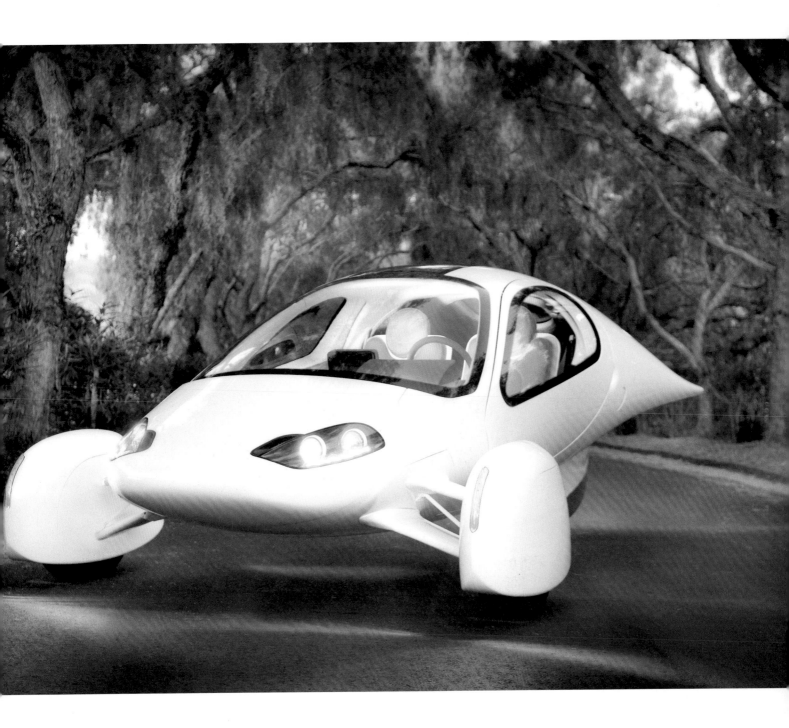

Data and Facts	Volt
Engine Type \| Antriebsart	electric drive with gasoline engine Elektroantrieb mit Benzinmotor
Status \| Status	concept car
Displacement \| Hubraum	1000 cm³
Output \| Leistung	120 kW; 160 HP \| PS
Fuel Consumption \| Verbrauch	50 mpg \| 4,7 l/100 km
CO₂ Emission \| CO₂-Ausstoß	0 g/km
Cruising Range \| Reichweite	40 mi \| 64 km (elektro)
Acceleration \| Beschleunigung	8.5 s (0-60 mph \| 0-100 km/h)
Max. Speed \| Geschwindigkeit	119 mph \| 192 km/h

Chevrolet Volt | General Motors

A Volt for Every Situation | Ein Volt für alle Fälle

www.gm.com

The name says it all: The Chevrolet Volt drives alone with the help of electric energy and does not emit any type of pollutants, at least not directly. The concept car presented in 2007 is the first vehicle to be developed on the basis of the new E-Flex System by GM. Its lithium-ion battery can be charged within six hours by connecting it to a customary outlet (USA: 110 V). If the energy supply runs out during the drive, a gasoline engine on board produces additional electricity to increase the range. This is a small three-cylinder turbo engine with 1.0 liter cubic capacity that works with a constant rotational speed and serves only to create electricity. It can be operated with gasoline or E85, a mixture of 85 percent ethanol and 15 percent gasoline. When the engine must be used to produce electricity over longer distances, Chevrolet quotes a consumption of 50 miles per gallon. This increases its range up to 640 miles. For a daily road performance of 62 miles Chevrolet cites a consumption of 0.42 gallons - whereas up to 40 miles can be achieved with electricity from the outlet. Despite all of its frugality, the Volt looks like a classic sports car.

Der Name ist Programm: Der Chevrolet Volt fährt allein mit Hilfe von elektrischer Energie und stößt somit zumindest unmittelbar keinerlei Schadstoffe aus. Das 2007 präsentierte Concept-Car ist das erste Fahrzeug, das auf Basis des neuen E-Flex-Systems von GM entwickelt wurde. Seine Lithium-Ionen-Batterie kann durch Anschluss an eine gewöhnliche Steckdose (USA: 110 V) innerhalb von sechs Stunden aufgeladen werden. Geht der Energievorrat während der Fahrt zur Neige, erzeugt ein Benzinmotor an Bord zusätzlich Strom, um die Reichweite zu erhöhen. Dabei handelt es sich um einen kleinen Dreizylinder-Turbomotor mit 1,0 Liter Hubraum, der mit konstanter Drehzahl arbeitet und allein der Stromerzeugung dient. Er kann mit Benzin oder E85, einer Mischung aus 85 Prozent Ethanol und 15 Prozent Benzin, betrieben werden. Wenn der Motor über längere Strecken zur Stromerzeugung genutzt werden muss, gibt Chevrolet einen Verbrauch von 4,7 Liter pro 100 Kilometer an. Dabei erhöht sich die Reichweite auf bis zu 1030 Kilometer. Bei einer täglichen Fahrleistung von rund 100 Kilometern, die größtenteils mit Strom aus der Steckdose absolviert werden kann, nennt Chevrolet einen Verbrauch von nur 1,6 Litern. Bei aller Genügsamkeit erinnert der Volt äußerlich an einen klassischen Sportwagen.

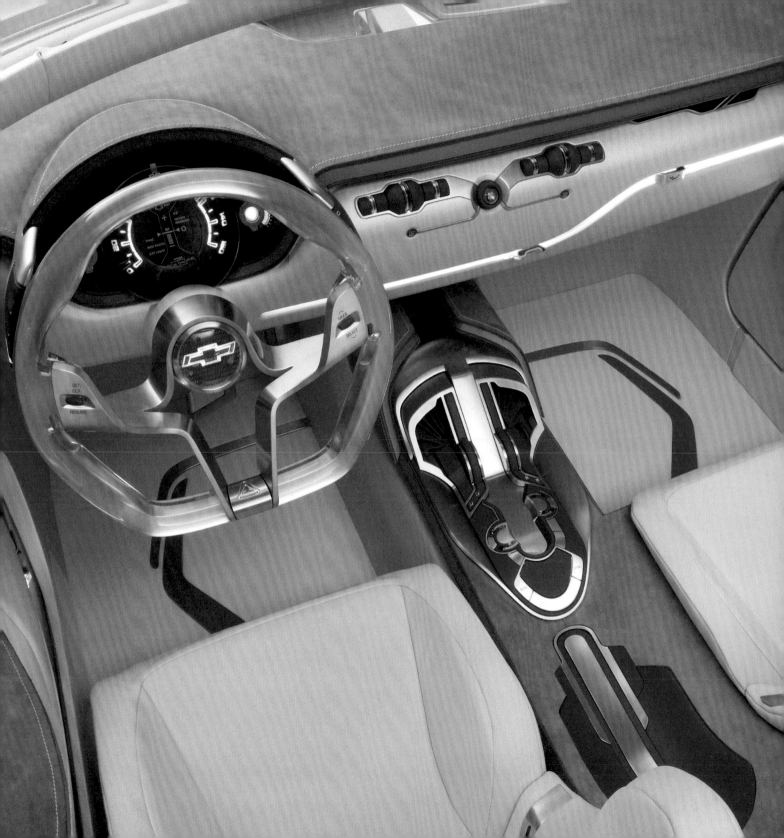

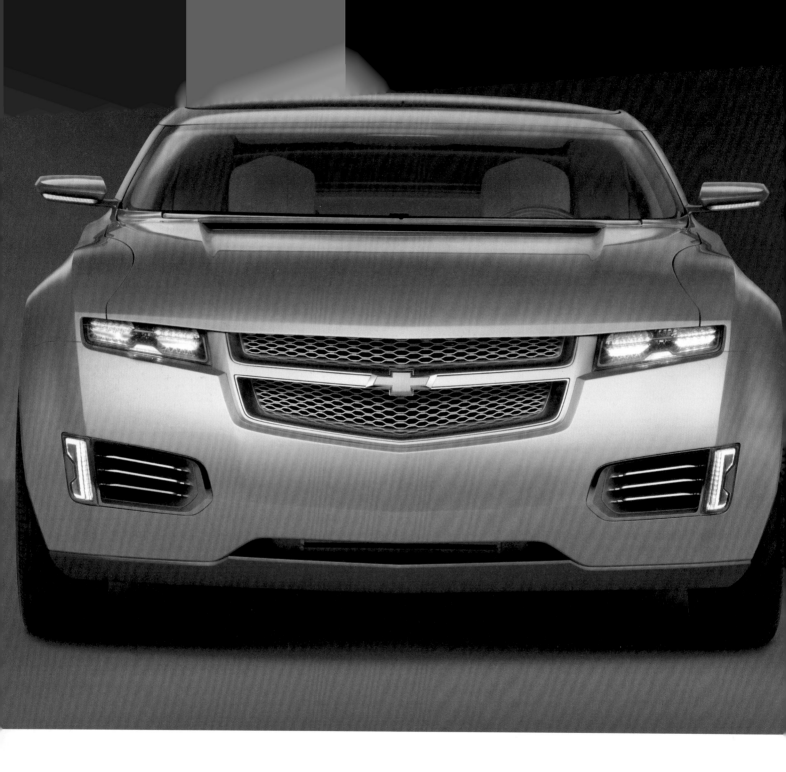

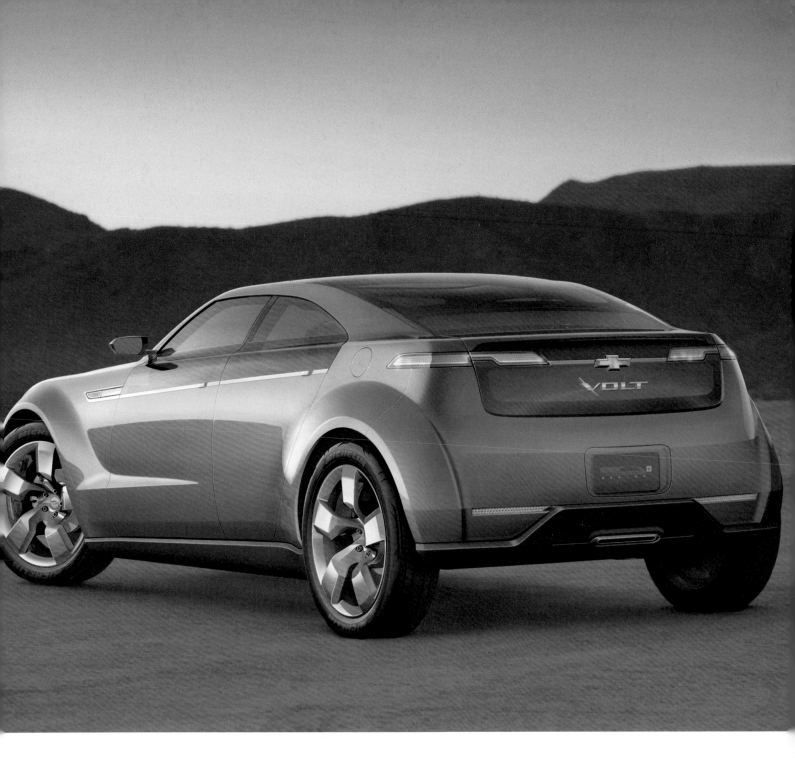

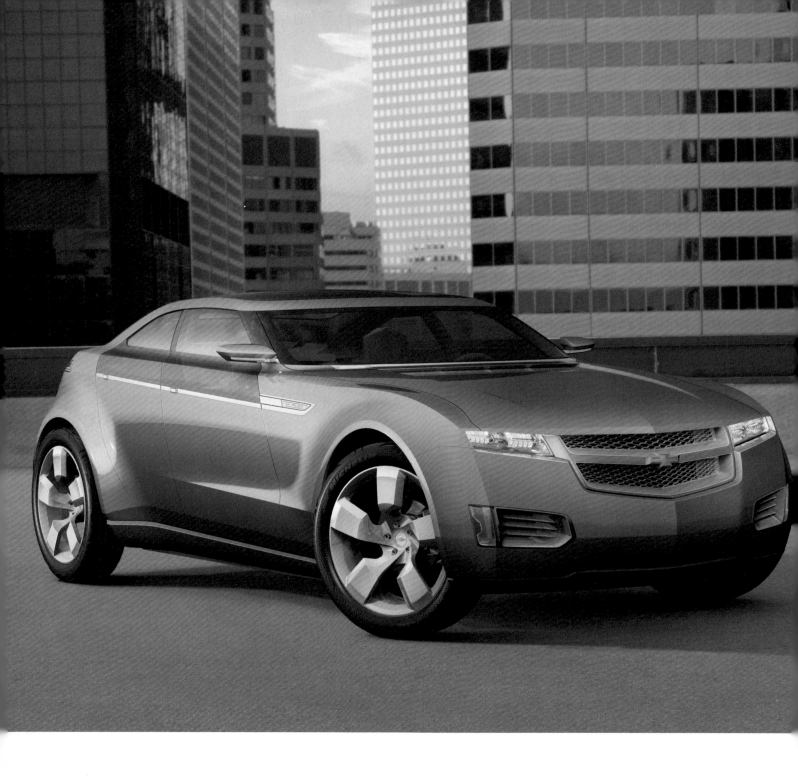

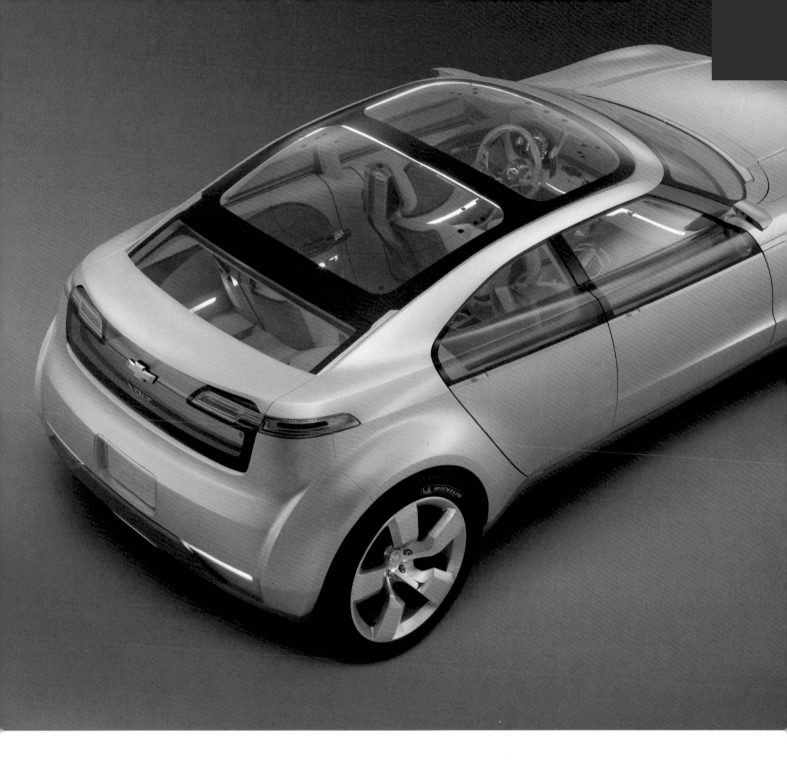

Data and Facts		T600
Engine Type \| Antriebsart		electric drive \| Elektroantrieb
Status \| Status		2005
Displacement \| Hubraum		-
Output \| Leistung		no data \| keine Angaben
Fuel Consumption \| Verbrauch		-
CO₂ Emission \| CO₂-Ausstoß		0 g/km
Cruising Range \| Reichweite		155 mi \| 250 km
Acceleration \| Beschleunigung		4 s (0-60 mph \| 0-100 km/h)
Max. Speed \| Geschwindigkeit		149 mph \| 241 km/h

Tango T600 | Commuter Cars

Slim Look | Dünn gemacht

www.commutercars.com

The Tango T600's length of 8.43 feet is not unusual—the German Smart Fortwo is also in the class of two-and-a-half meters (8.2 feet). But the Tango dances in a league of its own in terms of the width. The American small car is barely 99 centimeters (39 inch) wide. As a result, two passengers sit one behind the other instead of next to each other. In turn, the Tango offers completely new perspectives when it comes to parking. If the parking spaces are wide enough, the builders believe that this quirky vehicle might even find a little room between two other parked cars. And if the dimensions of this two-seater are unusual, its drive is also special. Two electric motors on the rear axle with a maximal torque of a breathtaking 1,355 Nm propel the small car with its carbon-fiber passenger cabin forward. So the small car, which has a total weight of about 3,086 pounds because of its 992-pounds battery pack, can actually reach 149 mph according to data from the manufacturer, Commuter Cars of Spokane, Washington. So it can certainly reach the next outlet to recharge the battery in plenty of time.

Mit seiner Länge von 2,57 Metern hat der Tango T600 kein außergewöhnliches Maß – auch der deutsche Smart Fortwo spielt in der Zweieinhalb-Meter-Klasse. Bei der Breite tanzt der Tango jedoch in einer eigenen Liga. Gerade mal 99 Zentimeter ist der amerikanische Kleinwagen breit. Daher müssen zwei Passagiere nicht nebeneinander, sondern hintereinander Platz nehmen. Dafür bietet der Tango aber völlig neue Perspektiven beim Parken. Sind die Parklücken breit genug, könnte das skurrile Gefährt nach Meinung seiner Erbauer sogar zwischen zwei parkenden Autos noch ein Plätzchen finden. So außergewöhnlich die Abmessungen des Zweisitzers sind, so speziell ist auch sein Antrieb. Zwei Elektromotoren an der Hinterachse mit einem maximalen Drehmoment von atemberaubenden 1.355 Nm katapultieren den Kleinwagen, dessen Fahrgastzelle aus Kohlefaser besteht, nach vorn. So soll der Kleinwagen, der es wegen des 450 Kilogramm schweren Batteriepacks auf rund 1400 Kilogramm Gesamtgewicht bringt, laut Angaben des Hersteller Commuter Cars aus Spokane im US-Staat Washington gut 240 km/h schnell sein. Damit ist die nächste Steckdose zum Aufladen der Akkus sicherlich schnell genug erreicht.

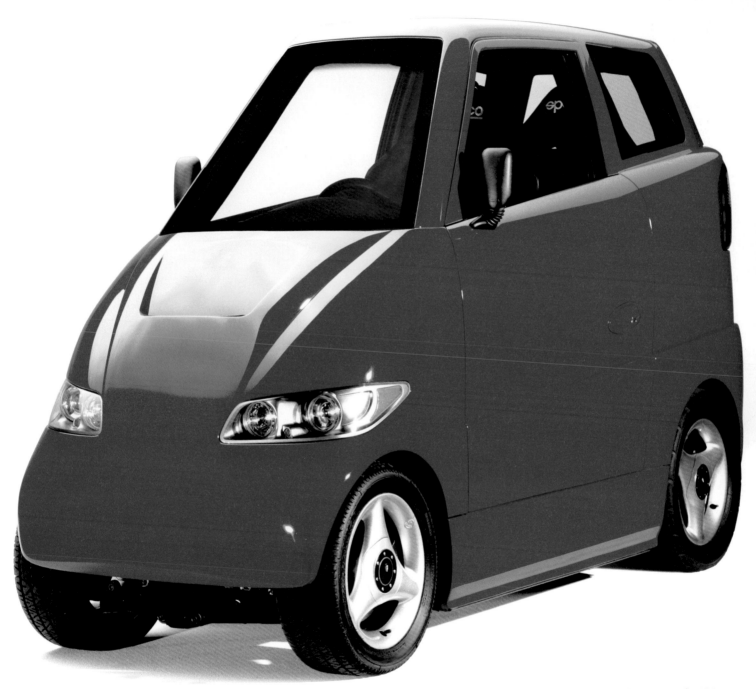

Data and Facts		Mixim	
Engine Type \| Antriebsart		electric drive \| Elektroantrieb	
Status \| Status		concept car	
Displacement \| Hubraum		-	
Output \| Leistung		no data \| keine Angaben	
Fuel Consumption \| Verbrauch		-	
CO₂ Emission \| CO₂-Ausstoß		0 g/km	
Cruising Range \| Reichweite		no data \| keine Angaben	
Acceleration \| Beschleunigung		no data \| keine Angaben	
Max. Speed \| Geschwindigkeit		no data \| keine Angaben	

Nissan Mixim | Nissan Motor Co., Ltd.

For the Kids | Für die Kids

www.nissan.co.jp

With the concept car Mixim, Nissan presented the vision of a car for the generation of computer kids in 2007 at the Frankfurt's IAA. Above all, the orientation toward this clientele is documented in the interior. The 12.14 feet long study offers three seats here—a centrally arranged driver's seat, as well as two other seats that can easily be shifted. The design of the steering wheel and the control buttons are oriented on computer games that are very familiar to the younger generation. The chassis form of the Mixim looks very dynamic, almost aggressive. The windshield, which is rounded like a helmet visor, contributes toward the profile that dominates the study. Triangular side windows, the flowing roofline, and the sharply cut-off back create a dynamic seldom seen in an electric car. Two electric engines serve as the drive. One of the engines drives the front wheels, while the second drives the rear wheels. This makes the Mixim with its low height of 4.6 feet and weight of 2,094 pounds into a flawless, emission-free four-wheeler.

Die Vision eines Autos für die Generation der Computer-Kids hat Nissan mit dem 2007 auf der IAA in Frankfurt gezeigten Concept-Car Mixim präsentiert. Die Orientierung auf diese Klientel dokumentiert sich vor allem im Innenraum. Dort bietet die 3,70 Meter lange Studie drei Sitzplätze – einen zentral angeordneten Fahrersitz sowie zwei weitere, leicht versetzte Plätze. Das Design des Lenkrads und der Steuertasten orientiert sich an Computerspielen, mit denen die Jugendlichen bestens vertraut sind. Die Karosserieformen des Mixim wirken sehr dynamisch, fast schon aggressiv. Dazu trägt auch die wie ein Helmvisier abgerundete Windschutzscheibe bei, die das Profil der Studie dominiert. Dreieckige Seitenscheiben, die fließende Dachlinie und das scharf abgeschnittene Heck schaffen eine von einem Elektroauto selten gekannte Dynamik. Als Antrieb dienen zwei Elektromotoren, wobei ein Motor die Vorder-, der zweite die Hinterräder antreibt – was den nur 1,40 Meter hohen und 950 Kilogramm leichten Mixim zum lupenreinen, abgasfreien Allrader macht.

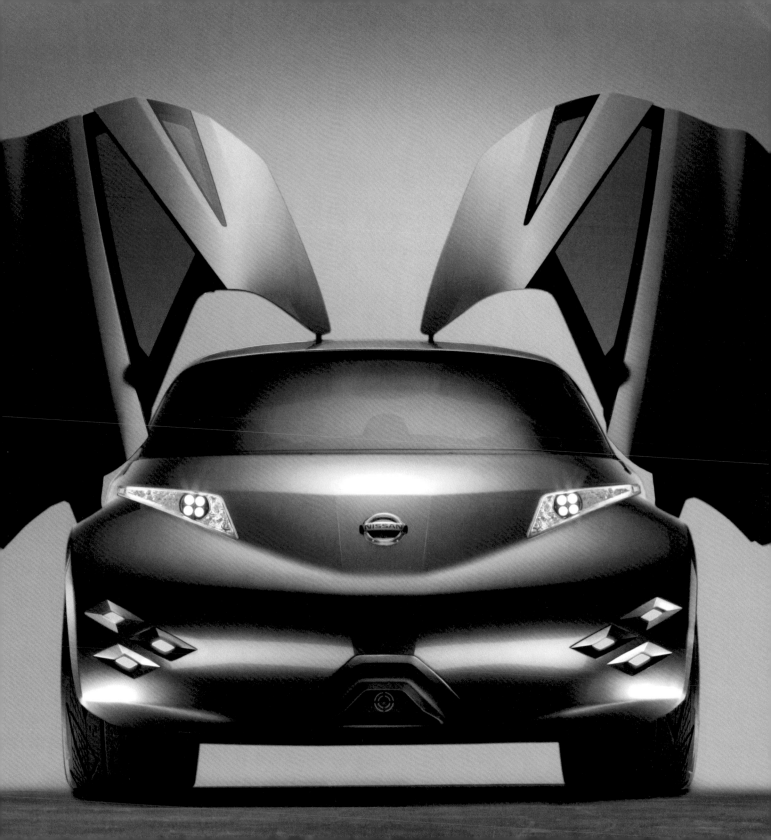

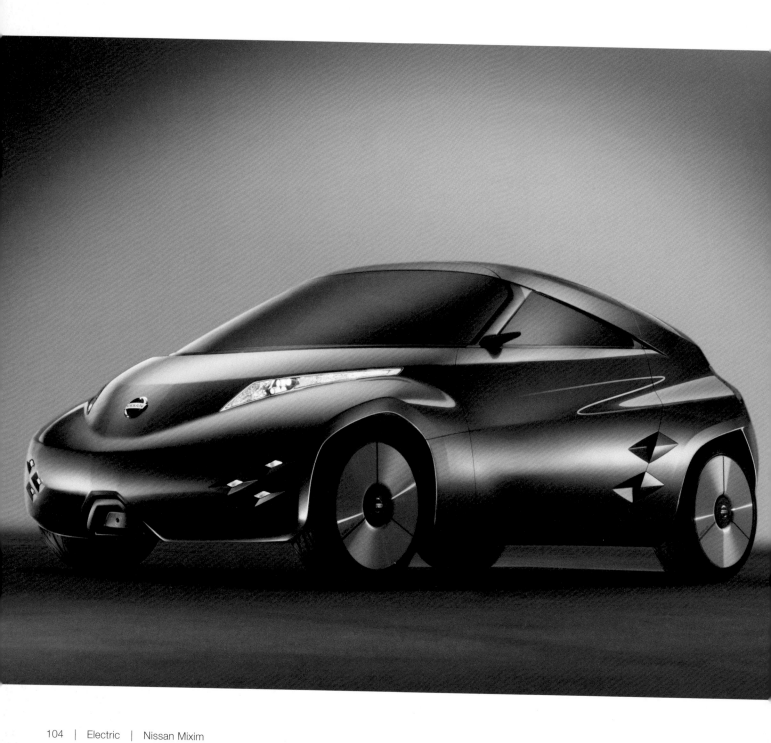

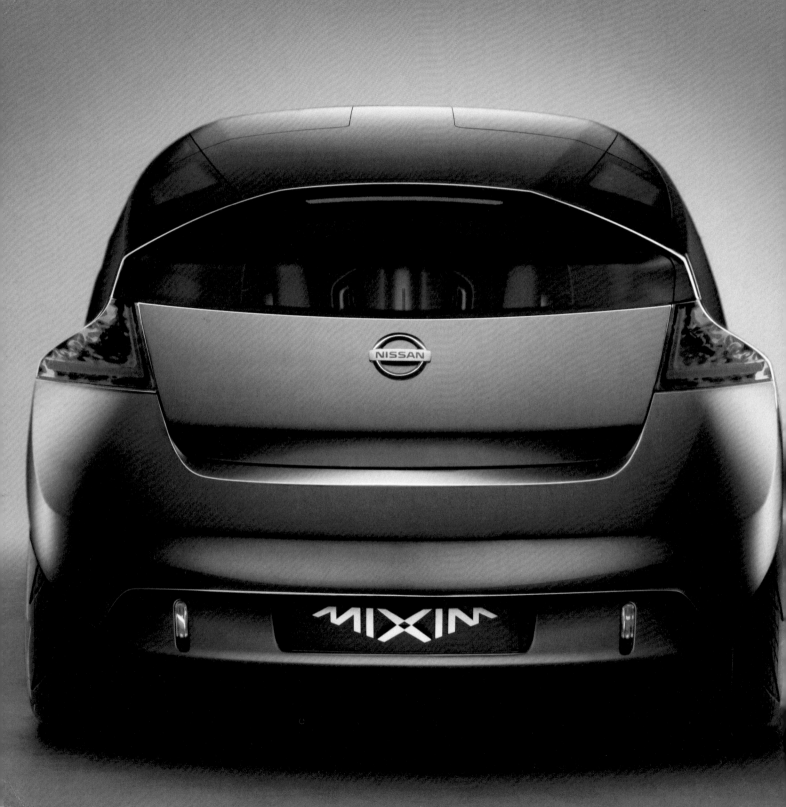

Data and Facts	Pivo 2
Engine Type \| Antriebsart	electric drive \| Elektroantrieb
Status \| Status	concept car
Displacement \| Hubraum	-
Output \| Leistung	no data \| keine Angaben
Fuel Consumption \| Verbrauch	-
CO_2 Emission \| CO_2-Ausstoß	0 g/km
Cruising Range \| Reichweite	no data \| keine Angaben
Acceleration \| Beschleunigung	no data \| keine Angaben
Max. Speed \| Geschwindigkeit	no data \| keine Angaben

Nissan Pivo 2 | Nissan Motor Co., Ltd.

Same Front and Back | Vorne wie hinten

www.nissan.co.jp

At first glance, the Nissan Pivo looks like a toy car. However, the unconventional concept car with the small wheels that are flared like little feet conceals sophisticated technology on the inside. Nissan already presented the Pivo in 2005 at the Tokyo Motor Show; two years later, the advanced Pivo 2 followed. The city flea of just 8.53 feet in length primarily stands out because of its ball-shaped cabin that offers three seats and is mounted in a completely revolvable manner on the frame. Turning or driving in reverse is no longer necessary. Instead, the cockpit is simply turned in the desired direction. Cameras in the A-pillars transmit their pictures to monitors on the inside. Additional lenses on the nose and back capture the entire surroundings of the Pivo and assemble it into a 360-degree picture. In addition, the Pivo 2 has a robot assistant on board that serves as a mediator between the car and the human being. Through changes in facial expression, it analyzes the driver's frame of mind and can actively start communication. The Pivo 2 is driven by electric wheel-hub engines. Since all four engines can be activated individually, the city flea can move sideways like a crab, if necessary—a big advantage when heading for narrow parking spaces.

Auf den ersten Blick mutet der Nissan Pivo wie ein Spielzeugauto an. Doch das eigenwillige Concept-Car mit dem kleinen, wie kleine Füßchen ausgestellten Rädern verbirgt in seinem Innern anspruchsvolle Technik. Bereits 2005 hat Nissan auf der Tokio Motor Show erstmals den Pivo präsentiert, zwei Jahre später folgte der weiter entwickelte Pivo 2. Der nur 2,6 Meter lange Cityfloh fällt vor allem durch seine kugelförmige Kabine auf, die drei Sitzplätze bietet und komplett drehbar auf dem Fahrgestell gelagert ist. Wenden oder rückwärts fahren ist nicht mehr nötig. Es reicht vielmehr, die Kanzel in die gewünschte Richtung zu drehen. Kameras in den A-Säulen übertragen ihre Bilder auf Bildschirme auf der Innenseite. Weitere Objektive an Bug und Heck fangen die gesamte Umgebung des Pivo ein und setzen diese zu einem 360-Grad-Bild zusammen. Der Pivo 2 hat zudem einen Roboterassistenten an Bord, der als Vermittler zwischen Auto und Mensch dient. Mittels Gesichtserkennung erfasst er die Gemütsverfassung des Fahrers und kann aktiv eine Kommunikation starten. Angetrieben wird der Pivo 2 von Elektro-Radnabenmotoren. Da alle vier Motoren einzeln aktivierbar sind, kann sich der Cityfloh bei Bedarf wie ein Krebs seitlich bewegen – ein großer Vorteil beim Ansteuern enger Parklücken.

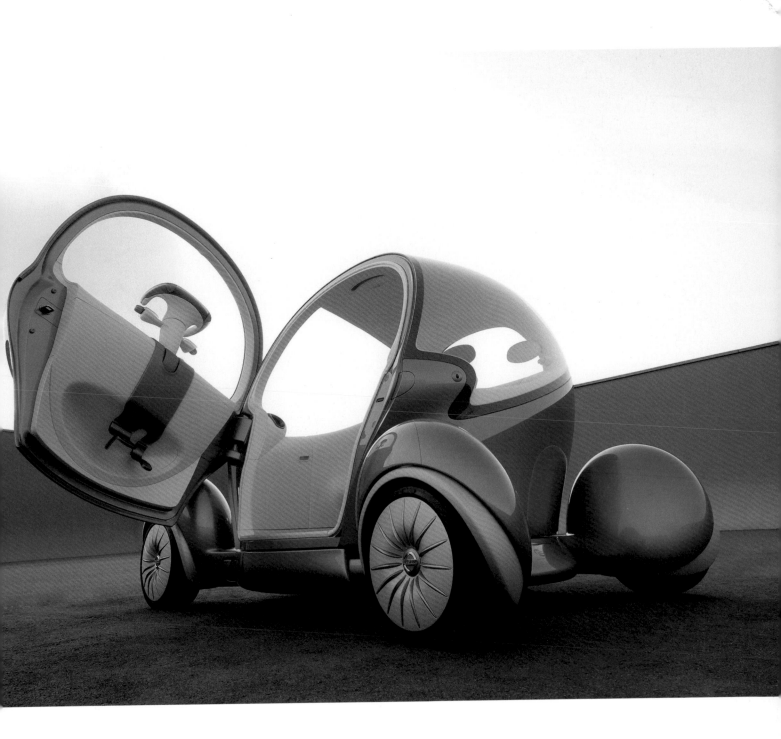

01 | Playful design of the Pivo 2 with a rotating cabin

Verspieltes Design des Pivo 2 mit drehbarer Kabine

01

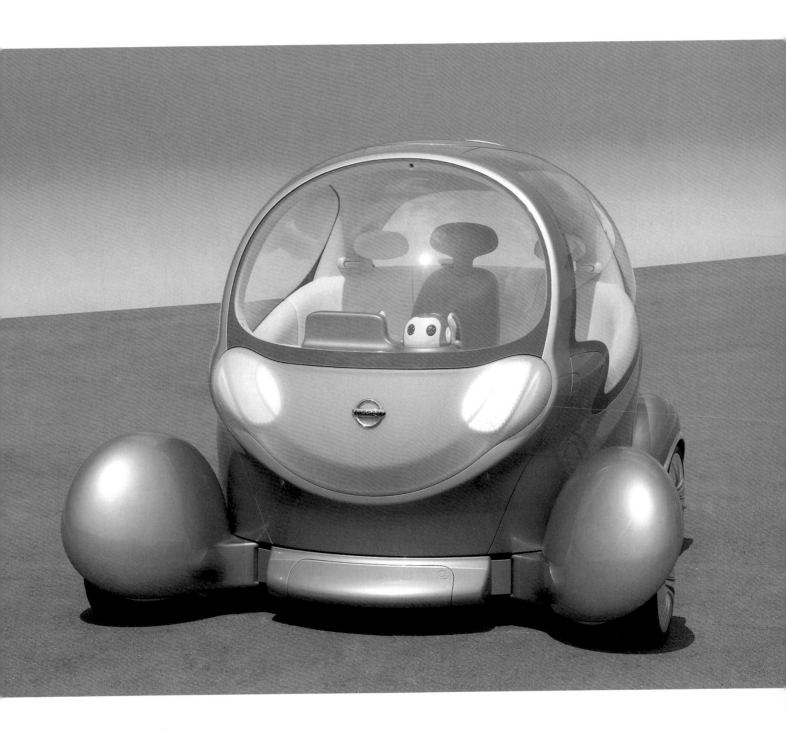

Data and Facts	ed	mhd
Engine Type \| Antriebsart	electric drive \| Elektroantrieb	gasoline hybrid \| Benzin-Hybrid
Status \| Status	2007	2007
Displacement \| Hubraum	-	999 cm³
Output \| Leistung	30 kW; 41 HP \| PS	52 kW; 71 HP \| PS
Fuel Consumption \| Verbrauch	-	55 mpg \| 4,3 l/100 km
CO₂ Emission \| CO₂ Ausstoß	0 g/km	103 g/km
Cruising Range \| Reichweite	71 mi \| 115 km	476 mi \| 767 km
Acceleration \| Beschleunigung	no data \| keine Angaben	13.3 s (0-60 mph \| 0-100 km/h)
Max. Speed \| Geschwindigkeit	70 mph \| 112 km/h	90 mph \| 145 km/h

Smart Fortwo ed & mhd | Daimler AG
Two Midgets Strive for the Top | Zwei Zwerge wollen hoch hinaus
www.smart.com

With a total length of just 8.85 feet, the Smart Fortwo is one of the smallest vehicles available. The two-seater now wants to score points with regard to environmental protection by using various technologies. The Smart with a complete electric drive is being tested in the trial period while a version with the start-stop system is already on the market as a micro hybrid. Within the scope of a pilot project in Great Britain, about 100 Smart Fortwo ed (electric drive) were offered to selected customers as leasing vehicles. This model is driven by a 41-HP electric motor. The energy costs are reportedly just one-third of the conventional gasoline drive. There is an additional advantage of the electric drive especially for British customers: The Smart Fortwo ed is exempt from the city toll in London. The Smart Fortwo mhd (micro hybrid drive) has already gone into series production. The gasoline engine is linked with a start-stop function here. When braking, the engine turns off at a speed of 5 mph. As soon as the driver removes the foot from the brake pedal, the engine starts again automatically. This reportedly reduces the fuel consumption by eight percent; in city traffic, Smart believes that a reduction of 19 percent is even possible.

Mit nur 2,70 Meter Gesamtlänge gehört der Smart Fortwo zu den kleinsten überhaupt erhältlichen Fahrzeugen. Der Zweisitzer will nun in Sachen Umweltschutz mit unterschiedlichen Techniken punkten. In einer Testphase wird der Smart mit reinem Elektroantrieb erprobt, während eine Version mit Start/Stopp-System als Micro-Hybrid schon auf dem Markt ist. Im Rahmen eines Pilotprojekts in Großbritannien wurden rund 100 Smart Fortwo ed (electric drive) ausgewählten Kunden als Leasingfahrzeuge angeboten. Dieses Modell wird von einem 41 PS starken Elektromotor angetrieben. Dadurch sollen die Energiekosten nur ein Drittel der Kosten bei konventionellem Benzinantrieb betragen. Ein weiterer Vorteil des Elektroantriebs speziell für die britischen Kunden: Der Smart Fortwo ed ist in London von der City-Maut befreit. Bereits in Serie ist der Smart Fortwo mhd (micro hybrid drive) erhältlich. Hier ist der Benzinmotor mit einer Start/Stopp-Funktion gekoppelt. Beim Bremsen schaltet der Motor bei einer Geschwindigkeit von 8 km/h ab. Sobald der Fahrer den Fuß vom Bremspedal nimmt, startet der Motor automatisch wieder. Dadurch soll der Kraftstoffverbrauch durchschnittlich um acht Prozent reduziert werden, im Stadtverkehr hält Smart sogar eine Reduzierung um 19 Prozent für möglich.

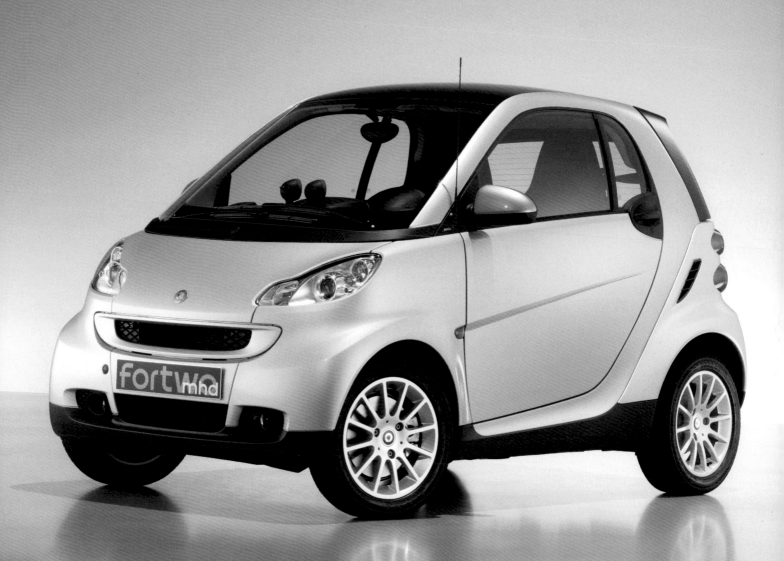

Data and Facts	Roadster
Engine Type \| Antriebsart	electric drive \| Elektroantrieb
Status \| Status	2008
Displacement \| Hubraum	-
Output \| Leistung	185 kW; 248 HP \| PS
Fuel Consumption \| Verbrauch	-
CO₂ Emission \| CO₂-Ausstoß	0 g/km
Cruising Range \| Reichweite	221 mi \| 356 km
Acceleration \| Beschleunigung	< 4 s (0-60 mph \| 0-100 km/h)
Max. Speed \| Geschwindigkeit	125 mph \| 200 km/h

Tesla Roadster | Tesla Motors

With the Power of the Laptop | Mit der Kraft der Laptops
www.teslamotors.com

With much commitment, the US company Tesla Motors has developed a two-seat sports car that is driven solely by electrical energy and still offers the road performance that its exterior promises. The Tesla Roadster has an ultra-powerful electric drive with 248 HP—a performance that a small sports car with conventional drive could also be proud of. In the selection of the energy storage, the engineers have also taken advantage of a technology that has already been used successfully in a completely different area. Lithium-ion batteries, as are customarily employed in laptops, serve to store the energy. Not less than 6,831 pieces of these energy-storage devices are concealed in the open sports car. The battery pack weighs a total of 990 pounds, which contributes considerably to the more than 2,700 pounds of the Tesla Roadster's total weight. That the emission-free sports car knows how to enthuse drivers with its high-performance body shape is no coincidence—Lotus, the British sports-car manufacturer provided support in its development.

Mit großem Engagement hat das US-Unternehmen Tesla Motors einen zweisitzigen Sportwagen entwickelt, der allein mit elektrischer Energie angetrieben wird und dennoch mit Fahrleistungen aufwartet, die sein Äußeres erwarten lassen. Der Tesla Roadster verfügt über einen bärenstarken Elektroantrieb mit 248 PS – eine Leistung, die auch einem kleinen Sportwagen mit konventionellem Antrieb gut zu Gesicht stehen würde. Bei der Wahl des Energiespeichers haben sich die Ingenieure einer Technik bedient, die in einem ganz anderen Bereich erfolgreich eingesetzt wird. Als Kräftespeicher dienen Lithium-Ionen-Akkus, wie sie gewöhnlich in Laptops zum Einsatz kommen. Nicht weniger als 6831 Stück dieser Energiespeicher verbergen sich in dem offenen Sportwagen. Der Akku-Pack bringt insgesamt 450 Kilogramm auf die Waage, was einen erheblichen Anteil an den gut 1225 Kilogramm Gesamtgewicht des Tesla Roadsters ausmacht. Dass der abgasfreie Sportwagen auch durch rassige Karosserieformen zu begeistern weiß, ist kein Zufall – bei seiner Entwicklung leistete die britische Sportwagenschmiede Lotus Schützenhilfe.

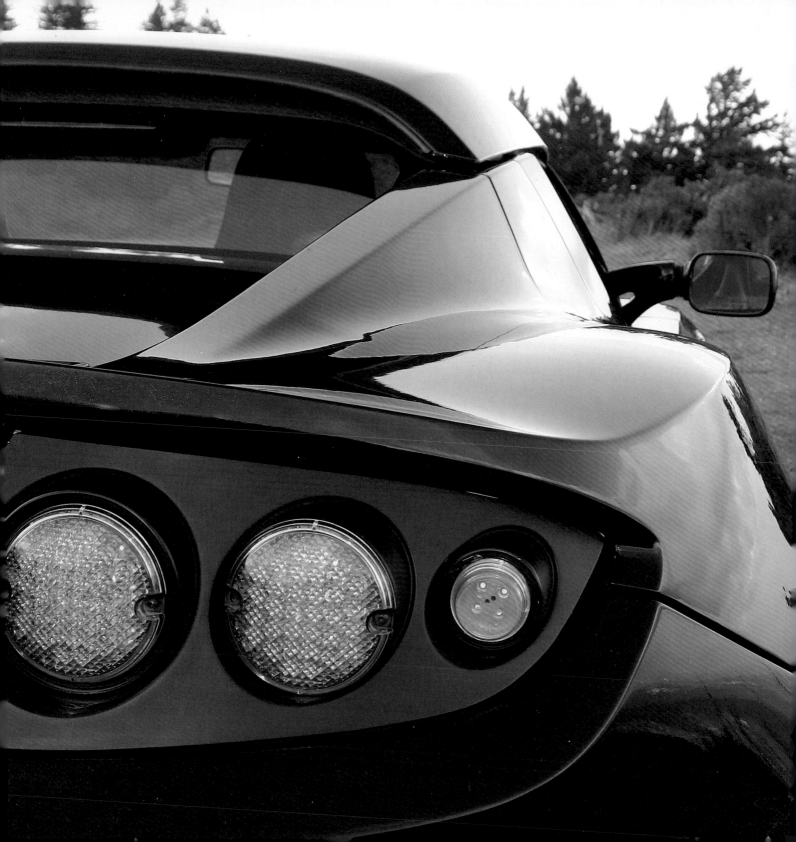

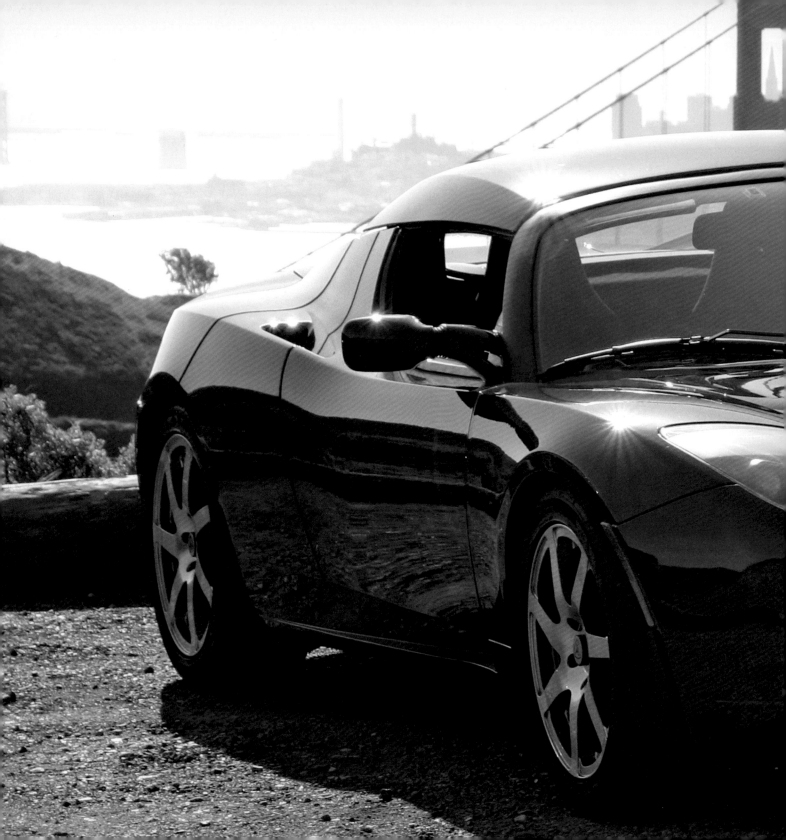

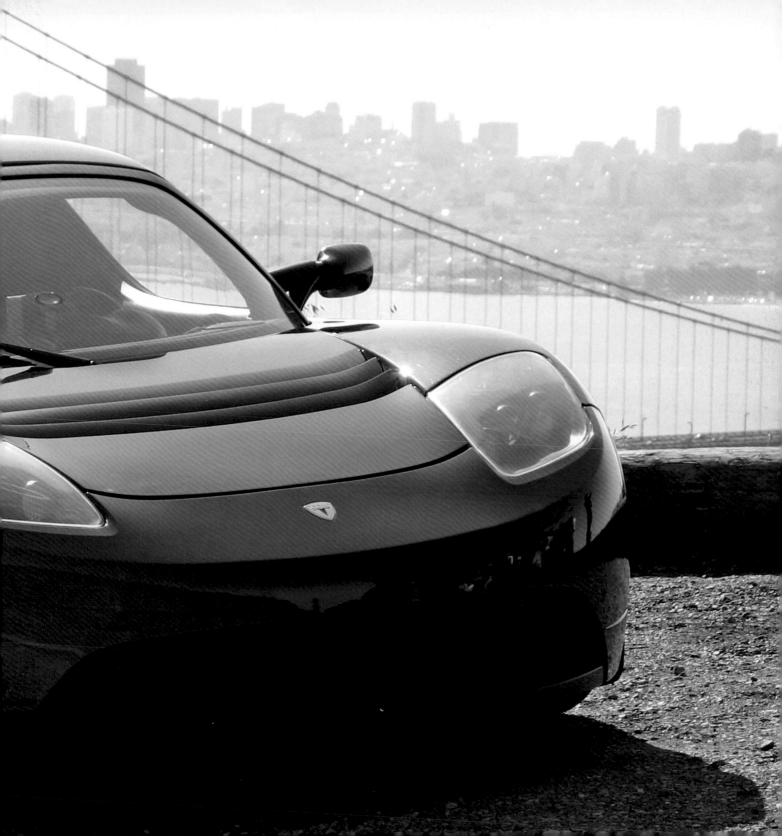

Data and Facts	G4e Concept
Engine Type \| Antriebsart	electric drive \| Elektroantrieb
Status \| Status	concept car
Displacement \| Hubraum	-
Output \| Leistung	no data \| keine Angaben
Fuel Consumption \| Verbrauch	-
CO₂ Emission \| CO₂-Ausstoß	0 g/km
Cruising Range \| Reichweite	124 mi \| 200 km
Acceleration \| Beschleunigung	no data \| keine Angaben
Max. Speed \| Geschwindigkeit	no data \| keine Angaben

Subaru G4e Concept | Fuji Heavy Industries Ltd.

Little Roamer | Kleiner Stromer

www.subaru-global.com

Even the little guys can be very green. The Subaru G4e Concept documents this not only with the color of its body, but also through its technological internal workings. With this concept car, the Japanese manufacturer has put a futuristic, eco-friendly electric vehicle on its wheels. Despite its compact dimensions, the G4e Concept offers room for five passengers. The batteries are located under the car floor so that they take up as little space as possible in the interior. Through the use of top-performance lithium-ion batteries and the lightweight construction of the vehicle, Subaru calculates a distance of 124 miles per battery charge. The futuristic design of the interior provides space for a continuous front seat and a large, central display that leads to a centrally positioned touchscreen operation panel. The trapezoid-shaped steering wheel with integrated function keys also deviates considerably from conventional designs. Whether this little roamer will ever go into series production still remains to be seen.

Auch die Kleinen können ganz schön grün sein. Der Subaru G4e Concept dokumentiert dies nicht nur durch seine Karosseriefarbe, sondern auch durch sein technisches Innenleben. Mit diesem Concept-Car hat der japanische Hersteller ein futuristisches, umweltfreundliches Elektrofahrzeug auf die Räder gestellt. Der G4e Concept bietet trotz seiner kompakten Abmessungen Platz für fünf Passagiere. Die Batterien befinden sich unter dem Wagenboden, so dass im Innenraum möglichst wenig Platz verloren geht. Durch den Einsatz von Hochleistungs-Lithium-Ionen-Batterien und die Leichtbauweise des Fahrzeugs kalkuliert Subaru eine Reichweite von 200 Kilometer pro Batterieladung. Das futuristisch gezeichnete Interieur beherbergt eine durchgehende Frontsitzbank und ein großes, zentrales Display, das in eine mittig angeordnete Touchscreen-Bediensäule mündet. Auch das trapezförmige Lenkrad mit integrierten Funktionstasten weicht stark von einer konventionellen Formgebung ab. Ob der kleine Stromer jemals in Serie geht, ist offen.

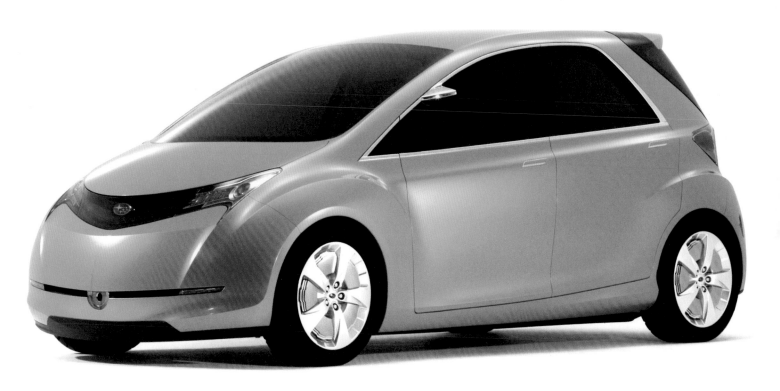

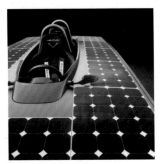

Data and Facts		Astrolab	
Engine Type	Antriebsart	electric drive	Elektroantrieb
Status	Status	concept car	
Displacement	Hubraum	-	
Output	Leistung	16 kW; 21 HP	PS (electro)
Fuel Consumption	Verbrauch	-	
CO₂ Emission	CO₂-Ausstoß	0 g/km	
Cruising Range	Reichweite	68 mi	110 km
Acceleration	Beschleunigung	no data	keine Angaben
Max. Speed	Geschwindigkeit	74 mph	120 km/h

Venturi Astrolab | Venturi Automobiles

Power from the Sun | Kraft aus der Sonne

www.venturi.fr

The Monegasque manufacturer Venturi built high-power sports cars in the 1990s, but has dedicated itself to future-oriented vehicle concepts in the meantime. One example of this is the Astrolab, which looks like a moon vehicle on the outside and is driven by an electric motor. The open two-seater receives its energy through large-area photovoltaic solar cells that cover a surface of 38.7 square feet on the filigree body. The solar cells charge the liquid-cooled nickel-metal hybrid batteries that are intended to provide power for the mobile sunbed over a distance of up to 11 miles. Like a race car, the Astrolab has a carbon-fiber body that is not just extremely stabile but also very light: The concept car, which is fueled by the power of the sun, weighs only 617 pounds. Very narrow 17-tires guarantee low rolling friction, which increases the range.

Der monegassische Hersteller Venturi baute in den neunziger Jahren leistungsstarke Sportwagen, hat sich aber längst zukunftsorientierten Fahrzeugkonzepten verschrieben. Ein Beispiel dafür ist der Astrolab, der äußerlich wie ein Mondfahrzeug erscheint und der von einem Elektromotor angetrieben wird. Seine Energie bezieht der offene Zweisitzer durch großflächige Photovoltaik-Solarzellen, die auf der filigranen Karosserie eine Fläche von 3,6 Quadratmetern belegen. Die Solarzellen laden die flüssigkeitsgekühlten Nickel-Metallhybrid-Batterien auf, die der fahrbaren Sonnenbank Kraft für eine bis zu 18 Kilometer lange Fahrstrecke geben sollen. Wie bei einem Rennwagen besitzt der Astrolab ein Kohlefaser-Chassis, das nicht nur extrem stabil, sondern auch sehr leicht ist: Das Concept-Car, das die Kraft der Sonne tankt, bringt gerade mal 280 Kilogramm auf die Waage. Sehr schmale 17-Reifen garantieren für geringen Rollwiderstand, was der Reichweite zugute kommt.

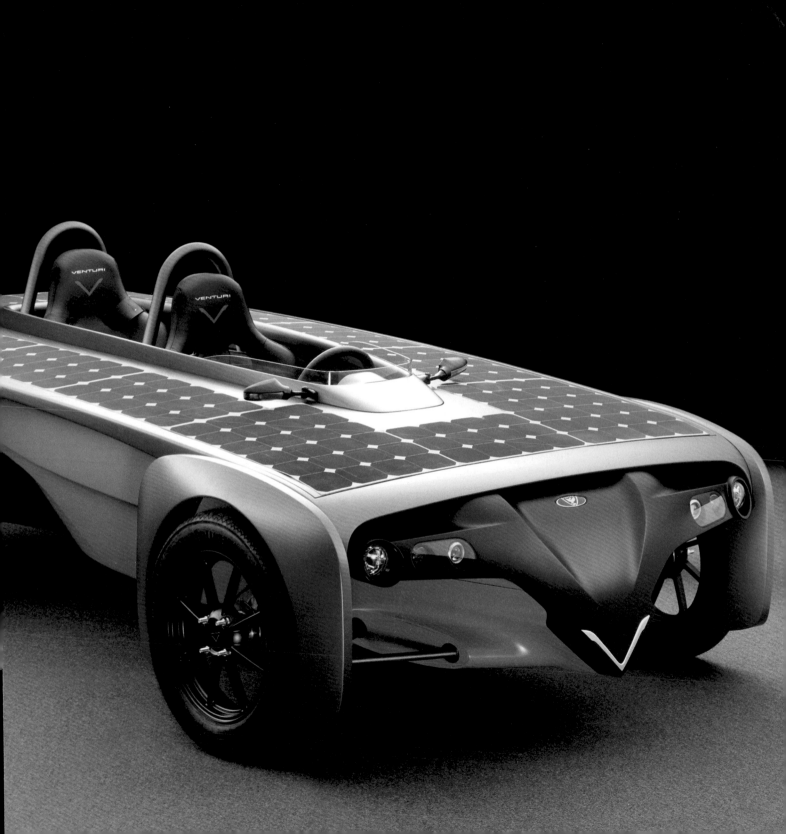

Data and Facts	Eclectic
Engine Type \| Antriebsart	electric drive \| Elektroantrieb
Status \| Status	2008
Displacement \| Hubraum	-
Output \| Leistung	11 kW; 15 HP \| PS
Fuel Consumption \| Verbrauch	-
CO₂ Emission \| CO₂-Ausstoß	0 g/km
Cruising Range \| Reichweite	31 mi \| 50 km
Acceleration \| Beschleunigung	no data \| keine Angaben
Max. Speed \| Geschwindigkeit	31 mph \| 50 km/h

Venturi Eclectic | Venturi Automobiles

Independent Car | Autonomes Automobil

www.venturi.fr

Driving without the need for fuels like oil and gas, or power plants—this ideal has been realized with the Eclectic by the limited-series manufacturer Venturi, which is based in Monaco. This vehicle, which was presented for the first time at the Paris Automobile Salon 2006, looks more like a golf cart and can also only be driven in good weather because of its open, three-seat style. For a good reason: The electric motor of the Eclectic is fed by solar cells that are distributed over a surface of 27 square feet on the roof of the quirky vehicle. Venturi wants to use long non-operation periods during parking for charging the battery. In addition, a wind wheel is intended to provide energy. When using only the power of the sun, the Eclectic reportedly can achieve a distance of seven kilometers. When the wind is blowing, the 771-pounds vehicle can travel another 9.3 miles. Up to 31 miles are possible with electricity from the outlet. Eclectic is planned for a limited series of 200 vehicles in 2008.

Fahren, ohne dass dazu Kraftstoff wie Öl, Gas oder Kraftwerke nötig sind – dieses Ideal hat der in Monaco beheimatete Kleinserienhersteller Venturi mit dem Eclectic realisiert. Das auf dem Pariser Automobilsalon 2006 erstmals präsentierte Fahrzeug mutet optisch eher wie ein Golf-Car an und ist mit seiner offenen, dreisitzigen Karosserie auch nur für Fahrten bei schönem Wetter geeignet. Aus gutem Grund: Der Elektromotor des Eclectic wird aus Solarzellen gespeist, die sich über eine Fläche von 2,5 Quadratmetern über das Dach des skurrilen Fahrzeugs verteilen. Venturi will damit lange Standzeiten beim Parken für das Aufladen der Akkus nutzen. Darüber hinaus soll ein Windrad für Energie sorgen. Allein mit Sonnenkraft soll der Eclectic eine Reichweite von sieben Kilometern erreichen. Wenn der Wind bläst, kommt das 350 Kilogramm schwere Fahrzeug 15 Kilometer weiter. Mit Strom aus der Steckdose sind bis zu 50 Kilometer möglich. Vom Eclectic soll 2008 eine Kleinserie von 200 Fahrzeugen aufgelegt werden.

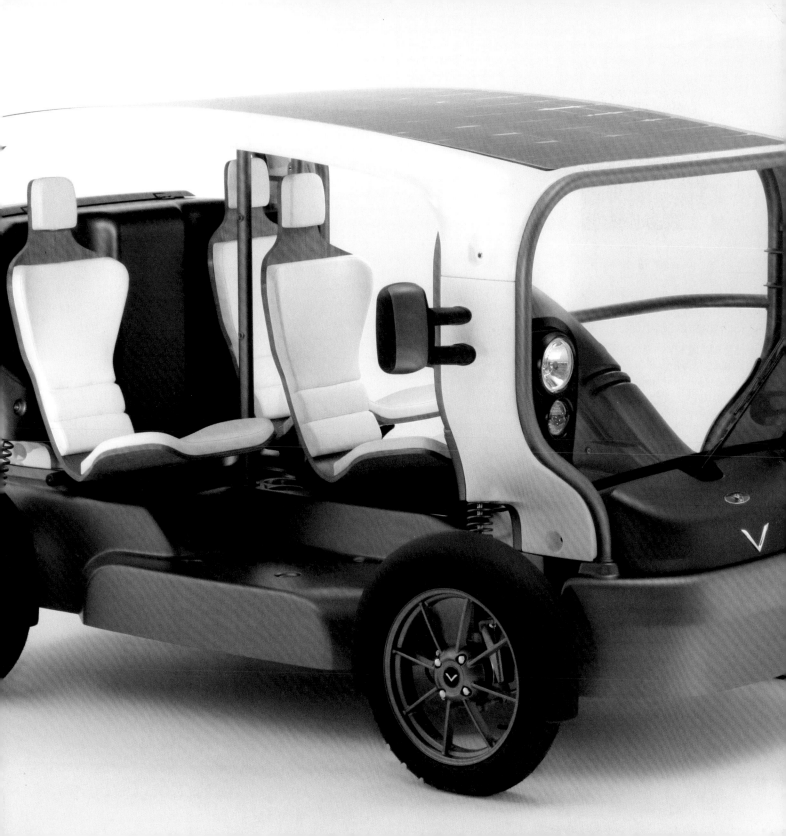

Data and Facts	Fetish
Engine Type \| Antriebsart	electric drive \| Elektroantrieb
Status \| Status	small series \| Kleinserie
Displacement \| Hubraum	-
Output \| Leistung	180 kW; 241 HP \| PS
Fuel Consumption \| Verbrauch	-
CO_2 Emission \| CO_2-Ausstoß	0 g/km
Cruising Range \| Reichweite	155 mi \| 250 km
Acceleration \| Beschleunigung	< 5 s (0-60 mph \| 0-100 km/h)
Max. Speed \| Geschwindigkeit	no data \| keine Angaben

Venturi Fetish | Venturi Automobiles

Fine Selection | Feine Auslese

www.venturi.fr

The small Monegasque company Venturi already displayed the little Fetish at the Paris Automobile Salon in 2004. It presented a sports car with super-racy shapes on the one hand and an emission-free electric drive on the other. The Fetish has been modified in the meantime. The energy is supplied by the powerful and liquid-cooled lithium-ion battery, which is about 30 percent lighter than the battery that was previously used. A fast charge of the battery takes an hour, but the normal charge cycle requires three hours. Venturi specifies a battery life of ten years for the energy storage system. The drive of the sporty two-seater is powered by an electric motor with 241 HP and 220 Nm torque, which literally has an easy job with the Fetish: Thanks to a modern carbon-fiber body, the sporty fellow weighs only 2,160 pounds. The arrangement of the mid-engine also corresponds to the classic racecar concept. Venturi has planned an extremely exclusive production of just 25 units for the Fetish. It can be made to order by hand within four months.

Bereits 2004 hatte das kleine monegassische Unternehmen Venturi auf dem Pariser Automobilsalon den Fetish gezeigt und damit einen Sportwagen präsentiert, der einerseits überaus rassige Formen, andererseits aber einen abgasfreien Elektroantrieb besitzt. Inzwischen wurde der Fetish überarbeitet. Die Energie liefern leistungsstarke und flüssigkeitsgekühlte Lithium-Ionen-Akkus, die im Vergleich zu den zuvor verwendeten Akkus um 30 Prozent leichter sind. Eine Schnellladung des Akkus erfolgt in einer Stunde, der normale Ladezyklus in drei Stunden. Venturi nennt eine Lebensdauer der Energiespeicher von zehn Jahren. Der Antrieb des sportlichen Zweisitzers erfolgt über einen Elektromotor mit 241 PS und 220 Nm Drehmoment, der mit dem Fetish buchstäblich leichtes Spiel hat: Dank eines modernen Kohlefaser-Chassis ist der Sportler nur 980 Kilogramm schwer. Auch die Mittelmotoranordnung entspricht dem klassischen Rennwagenkonzept. Venturi hat für den Fetish eine äußerst exklusive Auflage von nur 25 Einheiten vorgesehen. Er wird auf Bestellung in Handarbeit innerhalb von vier Monaten gebaut.

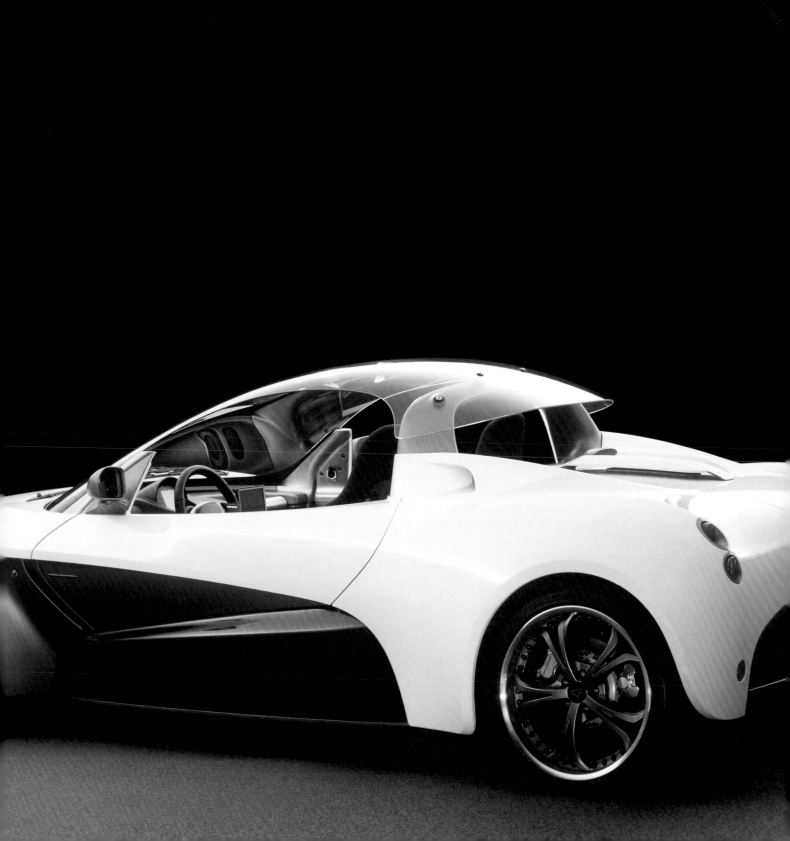

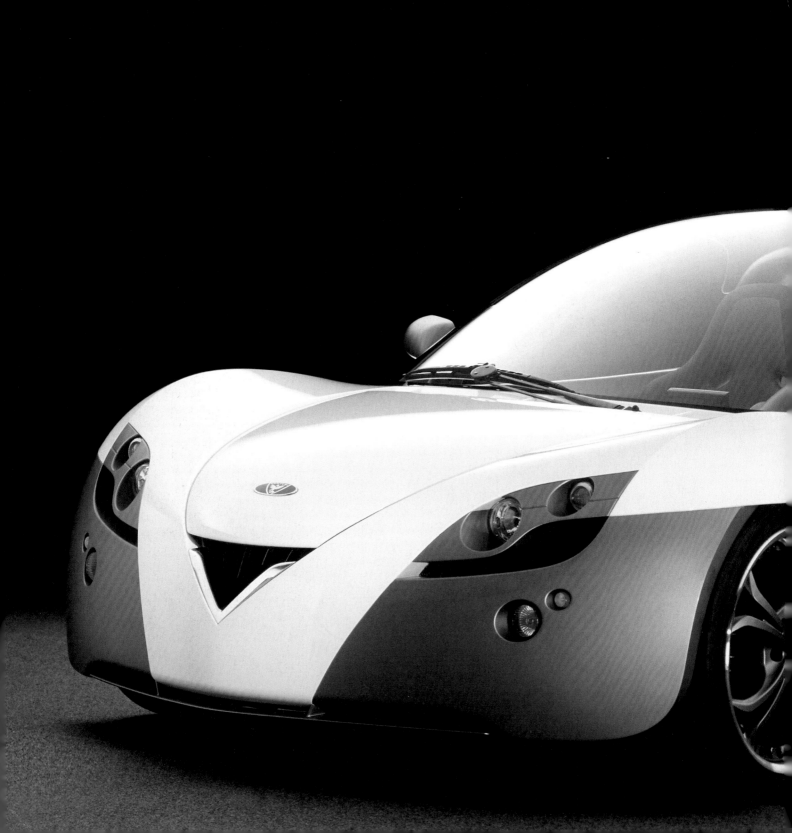

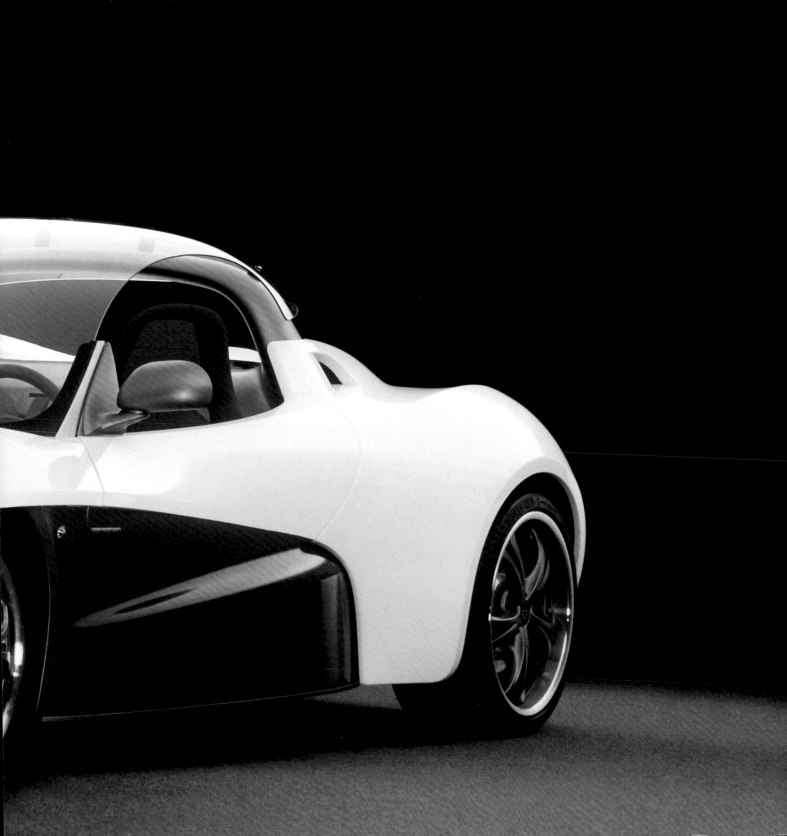

Data and Facts	Flextreme
Engine Type \| Antriebsart	electric drive with diesel engine Elektroantrieb mit Dieselmotor
Status \| Status	concept car
Displacement \| Hubraum	1300 cm³ (diesel)
Output \| Leistung	120 kW; 163 HP \| PS (electro)
Fuel Consumption \| Verbrauch	no data \| keine Angaben
CO₂ Emission \| CO₂-Ausstoß	< 40 g/km
Cruising Range \| Reichweite	34 mi \| 55 km; 444 mi with diesel engine \| 715 km mit Dieselmotor
Acceleration \| Beschleunigung	9,5 s (0-60 mph \| 0-100 km/h)
Max. Speed \| Geschwindigkeit	99 mph \| 160 km/h

Opel Flextreme | Adam Opel AG

On Two and Four Wheels | Auf zwei und vier Rädern

www.opel.com

Opel and the parent company General Motors (GM) are intensely pushing the development of alternative drives—and at the same time offer surprise s in the form of creative ideas. In addition to driving distances of u p to 34 miles without emissions through its electric propulsion, the Op el Flextreme concept car presented at the IAA 2007 also offers optional m obility on two wheels: The study's additional underfloor trunk FlexLoad provides space for two Segway PT personal transporters. They can be used to make the route from the parking lot to the office or for shopping even easier. The electric scooters can also be used in zones where cars are not permitted to drive and offer up to 23.6 miles of clean transportation. The Opel Flextreme is also suited for longer trips. A 1.3-liter diesel engine motor produces electricity via a generator, for electric propulsion when the energy supply runs out in the lithium-ion battery. The combustion engine always runs in the optimal speed range and only produces a low level of pollutant emissions. As an alternative, the battery of the Opel Flextreme can also be charged in around three hours at a standard electrical socket.

Opel und der Mutterkonzern General Motors (GM) treiben die Entwicklung alternativer Antriebe kräftig voran – und überraschen gleichzeitig auch noch mit kreativen Ideen. Denn die auf der IAA 2007 präsentierte Studie Opel Flextreme vermag mit ihrem Elektroantrieb nicht nur Strecken von bis zu 55 Kilometer abgasfrei zu fahren, sondern bietet auch optionale Fortbewegung auf zwei Rädern: In dem zusätzlichen Unterflur-Gepäckraum FlexLoad beherbergt die Studie zwei Segway-PT Personentransporter, die bei Bedarf den Weg vom Parkplatz zum Büro oder zum Einkauf noch bequemer machen. Die Elektroroller können in Zonen benutzt werden, in denen Autos nicht fahren dürfen und bieten bis zu 38 Kilometer saubere Fortbewegung. Der Opel Flextreme ist indes auch für größere Fahrten geeignet. Über einen Generator produziert ein 1,3 Liter-Dieselmotor dann Strom für den Elektroantrieb, wenn der Energievorrat in der Lithium-Ionen-Batterie zur Neige geht. Der Verbrennungsmotor läuft stets im optimalen Drehzahlbereich und gibt dadurch nur geringe Schadstoffemissionen ab. Alternativ kann der Akku des Opel Flextreme auch in rund drei Stunden an einer Steckdose aufgeladen werden.

01 | Switch to two wheels: Segway scooter in the trunk of the Flextreme

Umstieg auf zwei Räder: Segway-Roller im Kofferraum des Flextreme

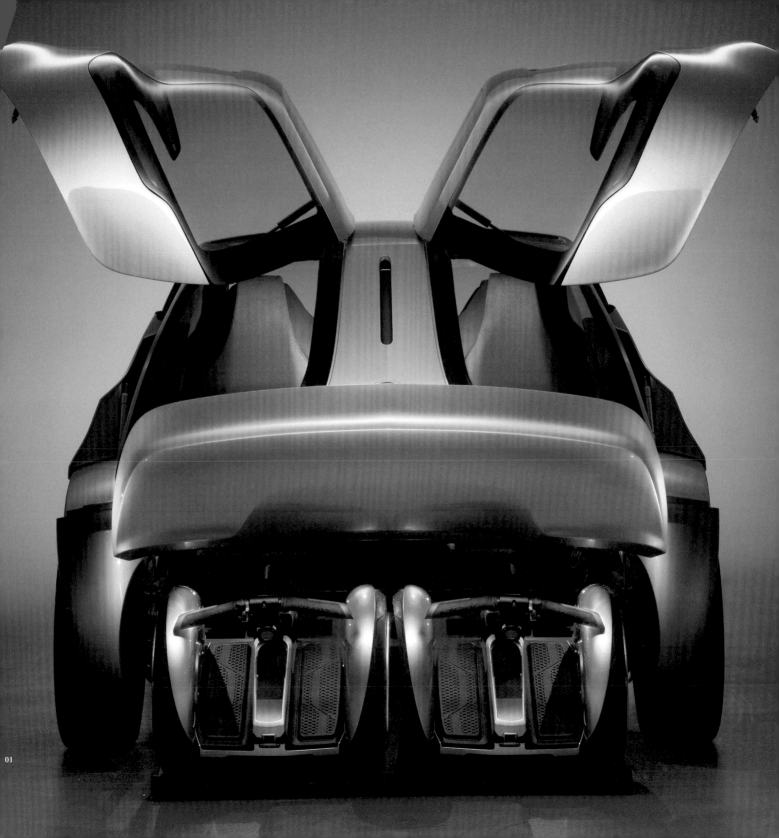

01

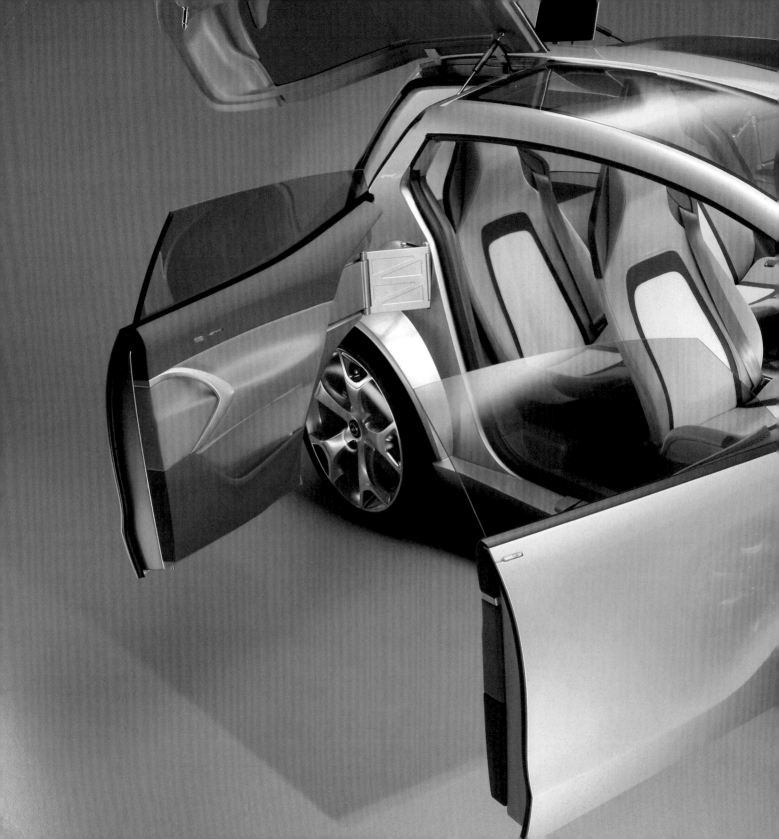

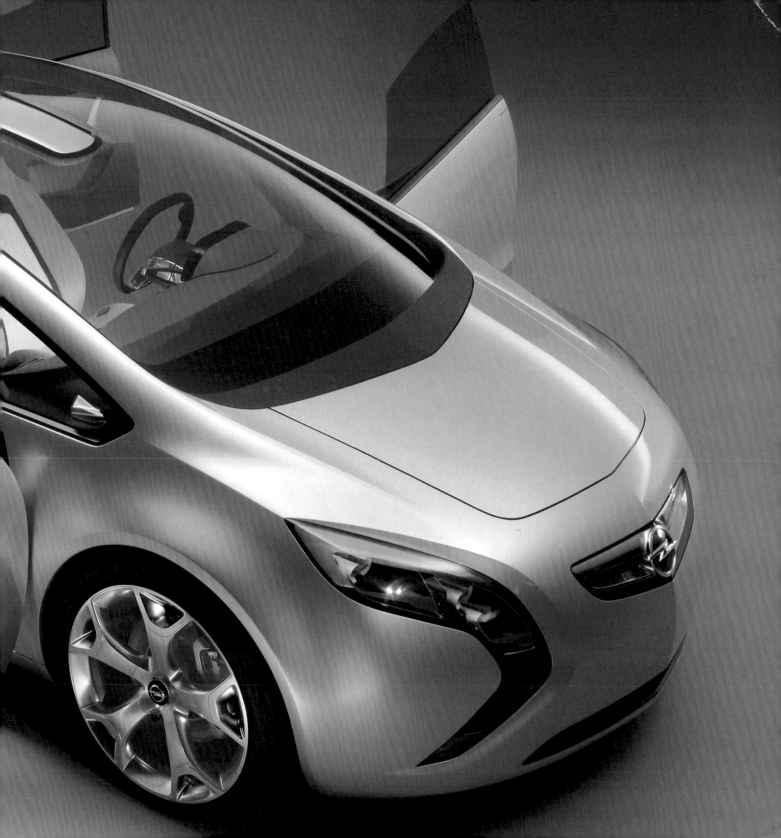

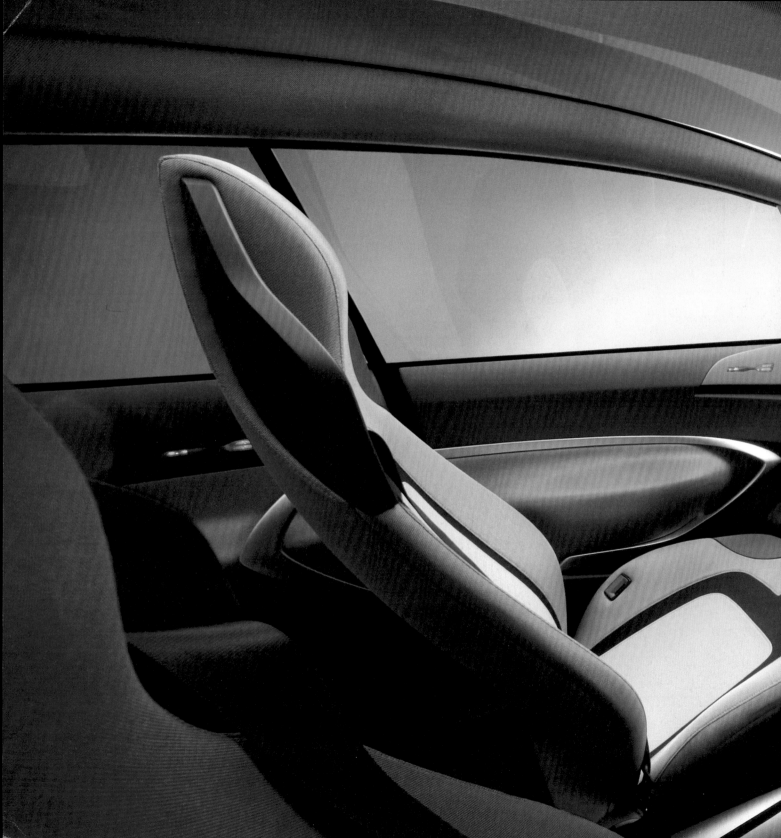

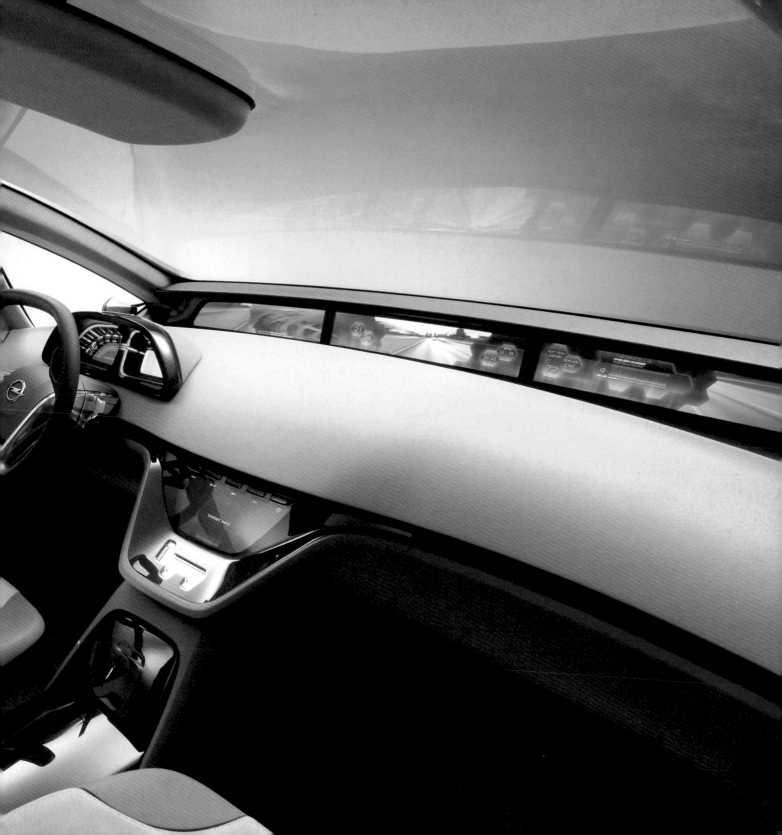

Data and Facts	C30 ReCharge
Engine Type \| Antriebsart	electric drive with bioethanol engine Elektroantrieb mit Bioethanol-Motor
Status \| Status	concept car
Displacement \| Hubraum	1600 cm³ (bioethanol)
Output \| Leistung	no data \| keine Angaben
Fuel Consumption \| Verbrauch	123 mpg \| 1,9 l/100 km
CO₂ Emission \| CO₂-Ausstoß	no data \| keine Angaben
Cruising Range \| Reichweite	62 mi \| 100 km
Acceleration \| Beschleunigung	9 s (0-60 mph \| 0-100 km/h)
Max. Speed \| Geschwindigkeit	no data \| keine Angaben

Volvo C30 ReCharge Concept | Volvo
Power in the Wheel | Die Kraft im Rad
www.volvo.com

The Volvo C30 ReCharge Concept, which the Swedish manufacturer presented at the IAA 2007 in Frankfurt, has no less than five engines on board. The solution to the puzzle: The concept car is driven by four wheel-hub engines. These electric engines are installed directly in the wheels. They get their energy from a lithium-polymer battery that can be charged at an outlet. The energy storage makes a distance of 60 miles possible. Once the power source has been used up, the fifth engine comes into play: a four-cylinder combustion engine that solely serves the purpose of recharging the batteries—it does not drive the car itself. The 1.6-liter engine can be operated with eco-friendly bio-ethanol. When operated just electrically, the running costs are about 80 percent below those of a comparable gasoline model. Since the FlexiFuel engine solely drives the APU (Auxiliary Power Unit) generator, it can run in an economical operating range with low CO₂ emissions. It starts automatically as soon as 70 percent of the battery capacity has been used up. According to the data from Volvo, less than 2.8 liters of gasoline are required for a distance of 93 miles after the battery capacity has been exhausted. This corresponds with an effective consumption of 123 miles per gallon. One full charging cycle lasts three hours; one hour is enough for an additional distance of 31 miles. The C30 ReCharge Concept was developed at the Swedish manufacturer's think tank in the Californian town of Camarillo.

Nicht weniger als fünf Motoren hat der Volvo C30 ReCharge Concept an Bord, den der schwedische Hersteller auf der IAA 2007 in Frankfurt präsentierte. Des Rätsels Lösung: Das Concept-Car wird von vier Radnabenmotoren angetrieben. Diese Elektromotoren sind direkt in den Rädern untergebracht. Ihre Energie beziehen sie von einer Lithium-Polymer-Batterie, die sich an der Steckdose aufladen lässt. Der Energiespeicher ermöglicht 100 Kilometer Reichweite. Ist die Stromquelle versiegt, kommt der fünfte Motor zum Einsatz: ein Vierzylinder-Verbrennungsmotor dient aber lediglich dazu, die Batterie wieder aufzuladen – den Wagen selbst treibt er nicht an. Der 1,6-Liter Motor kann mit umweltfreundlichem Bio-Ethanol betrieben werden. Beim reinen Elektrobetrieb liegen die Betriebskosten rund 80 Prozent unter denen eines vergleichbaren Benzinmodells. Da der FlexiFuel-Motor ausschließlich den APU-Generator (Auxiliary Power Unit) antreibt, kann er in einem verbrauchsgünstigen Betriebsbereich mit niedrigem CO₂-Ausstoß laufen. Er startet automatisch, sobald 70 Prozent der Batteriekapazität aufgebraucht sind. Nach Angaben von Volvo würden nach dem Ausschöpfen der Batteriekapazität für eine 150-Kilometer-Strecke weniger als 2,8 Liter Benzin benötigt, was einem Effektivverbrauch von 1,9 Litern pro 100 Kilometer entspräche. Ein voller Ladezyklus dauert drei Stunden, eine Stunde reicht für weitere 50 Kilometer Fahrstrecke. Entwickelt wurde der C30 ReCharge Concept in der Denkfabrik des schwedischen Herstellers im kalifornischen Camarillo.

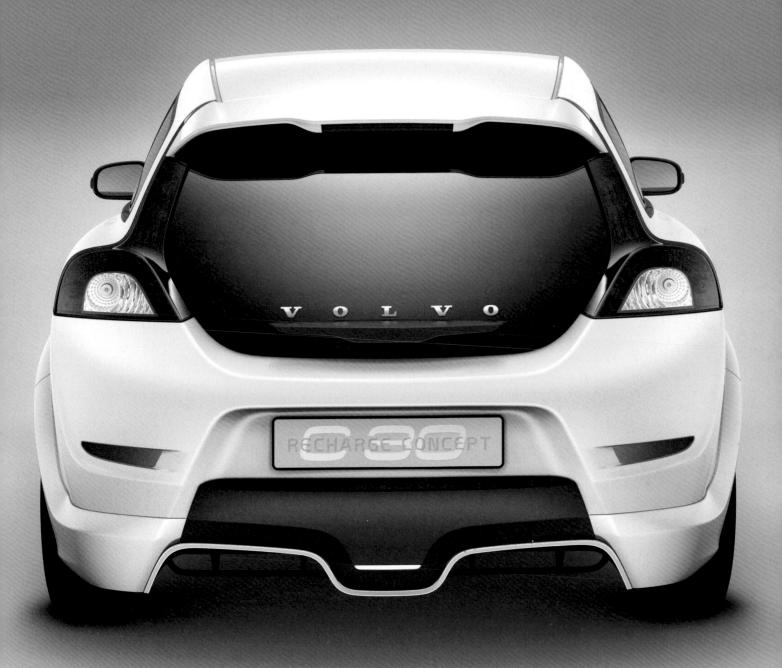

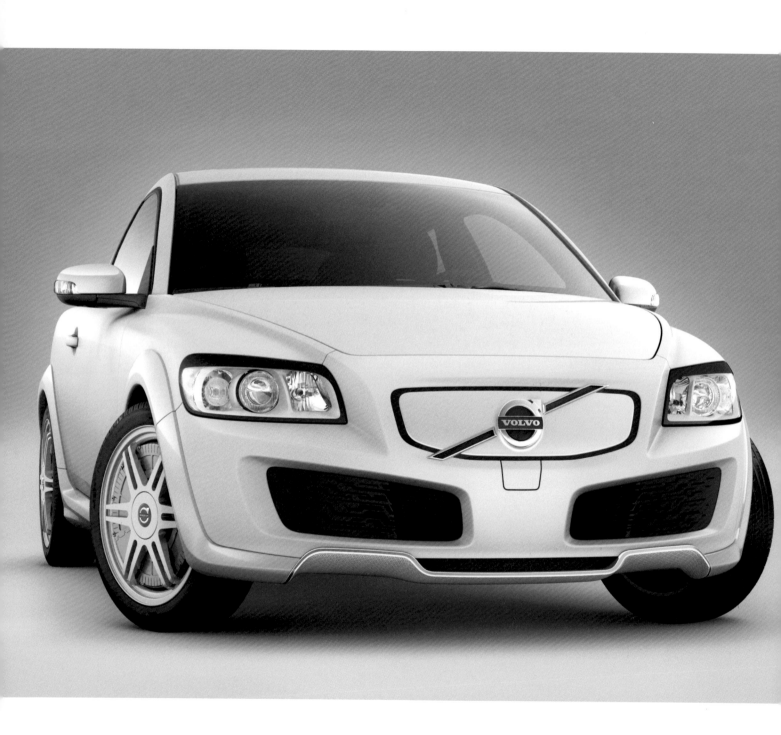

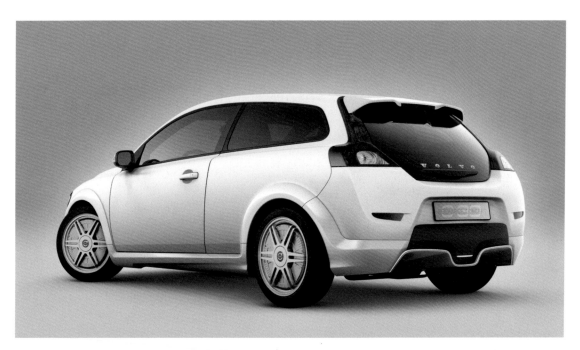

Data and Facts		TH!NK city
Engine Type \| Antriebsart		eletric drive \| Elektroantrieb
Status \| Status		2007
Displacement \| Hubraum		-
Output \| Leistung		28 kW; 40 HP \| PS
Fuel Consumption \| Verbrauch		-
CO₂ Emission \| CO₂-Ausstoß		0 g/km
Cruising Range \| Reichweite		111 mi \| 180 km
Acceleration \| Beschleunigung		6.5 s (0-60 mph \| 0-100 km/h)
Max. Speed \| Geschwindigkeit		62 mph \| 100 km/h

TH!NK city | Think

High-Voltage Viking | Wikinger unter Strom
www.think.no

Norway is not exactly famous for building cars. However, the Scandinavian nation has produced an innovative electric vehicle whose name alone makes people stop and think. The innovative company had previously worked with Ford. After the separation from the US company in 2002 and economic difficulties, the Norwegians developed the small car that they call TH!NK city, which is recommended as an eco-friendly and emission-free town car. The launch of its series production was in fall 2007, with the intention of selling the car starting in spring 2008. The small electromobile should be able to travel 111 miles with one battery charge and produce energy costs in the amount of three to five dollars per 62 miles. After the start of the series, Think wants to produce 3,500 units of the vehicle per year, later 7,000 per year. The company entered into a cooperation with the US manufacturer Tesla Motors, which has developed a battery-driven sports car.

Als Land des Automobilbaus lässt sich Norwegen nicht gerade bezeichnen. Doch aus der skandinavischen Nation kommt ein innovatives Elektrofahrzeug, das schon durch seinen Namen zum Nachdenken anregt. Das innovative Unternehmen hatte zwischenzeitlich mit Ford zusammengearbeitet. Nach der Trennung von dem US-Konzern im Jahr 2002 und wirtschaftlichen Schwierigkeiten haben die Norweger den TH!NK city genannten Kleinwagen entwickelt, der sich als umweltfreundliches und abgasfreies Stadtauto empfiehlt. Der Start der Serienproduktion war im Herbst 2007, ab Frühling 2008 soll das Auto verkauft werden. Das kleine Elektromobil soll mit einer Batterieladung 180 Kilometern weit kommen und dabei Stromkosten in Höhe von zwei bis drei Euro pro 100 Kilometer produzieren. Think will nach dem Serienstart 3500 Einheiten des Fahrzeugs pro Jahr produzieren, später bis zu 7000 pro Jahr. Das Unternehmen ist eine Kooperation mit dem US-Hersteller Tesla Motors eingegangen, der einen batteriebetriebenen Sportwagen entwickelt hat.

Data and Facts	Hydrogen 7
Engine Type \| Antriebsart	hydrogen combustion engine \| Wasserstoffverbrennungsmotor
Status \| Status	production vehicle \| Serienfahrzeug
Displacement \| Hubraum	5972 cm³
Output \| Leistung	191 kW; 260 HP \| PS
Fuel Consumption \| Verbrauch	8 lb/60 mi \| 3,6 kg/100 km (H₂) 17 mpg \| 13,9 l/100 km (gasoline),
CO₂ Emission \| CO₂-Ausstoß	5 g/km (H₂) , 332 g/km (gasoline)
Cruising Range \| Reichweite	435 mi \| 700 km
Acceleration \| Beschleunigung	7.6 s (0-60 mph \| 0-100 km/h)
Max. Speed \| Geschwindigkeit	143 mph \| 230 km/h

BMW Hydrogen 7 | BMW AG

Luxury without Emissions | Luxus ohne Emissionen

www.bmw.com

BMW with its Hydrogen 7 made significant progress toward the ideal vision of solely emitting steam through the exhaust pipe when driving. With this model, the Bavarian manufacturer has presented the first luxury sedan for everyday operation that is powered by hydrogen. A fleet of Hydrogen 7 is already on the streets for daily use by customers. The hydrogen BMW is powered by a bivalent twelve-cylinder combustion engine. That means: The largely conventional engine works with both hydrogen and normal gasoline. There is no delay and no tangible change in the road performance when switching from hydrogen to gasoline operation. The hydrogen tank, which holds eight kilograms, permits a distance of 125 miles. Another 310 miles are possible with the gasoline operation. That is increasing the actual cruising range, because there are almost hardly any hydrogen filling stations at this point. Another technical challenge arises because the ultra-low refrigerated liquid hydrogen evaporates over time and the tank empties during long lasting parking as a result.

Der schönen Vision, beim Autofahren lediglich Wasserdampf durch den Auspuff entweichen zu lassen, ist BMW mit dem Hydrogen 7 ein großes Stück näher gekommen. Der bayrische Hersteller hat mit diesem Modell die weltweit erste mit Wasserstoff angetriebene Luxuslimousine für den Alltagsbetrieb vorgestellt. Derzeit ist bereits eine Flotte des Hydrogen 7 mit den Kunden im Alltagseinsatz auf den Straßen unterwegs. Angetrieben wird der Wasserstoff-BMW von einem bivalenten Zwölfzylinder-Verbrennungsmotor. Das heißt: Das weitgehend konventionelle Triebwerk arbeitet sowohl mit Wasserstoff als auch mit herkömmlichem Benzin. Das Umschalten vom Wasserstoff-Betrieb auf den Benzin-Betrieb erfolgt verzögerungsfrei und ohne Veränderung im Fahrverhalten. Der acht Kilogramm fassende Wasserstofftank erlaubt eine Reichweite von 200 Kilometern, zusätzlich sind 500 Kilometer im Benzinbetrieb möglich. Das erhöht die tatsächliche Reichweite, denn bislang gibt es kaum Wasserstofftankstellen. Eine weitere technische Herausforderung ergibt sich dadurch, dass der tiefkalte flüssige Wasserstoff mit der Zeit verdampft und sich der Tank somit beim längeren Parken entleert.

Data and Facts	Equinox Fuel Cell
Engine Type \| Antriebsart	hydrogen fuel cell \| Brennstoffzelle
Status \| Status	small series \| Kleinserie (2007)
Displacement \| Hubraum	-
Output \| Leistung	73 kW; 100 HP \| PS
Fuel Consumption \| Verbrauch	no data \| keine Angaben
CO_2 Emission \| CO_2-Ausstoß	0 g/km
Cruising Range \| Reichweite	198 mi \| 320 km
Acceleration \| Beschleunigung	12 s (0-60 mph \| 0-100 km/h)
Max. Speed \| Geschwindigkeit	99 mph \| 160 km/h

Chevrolet Equinox Fuel Cell | General Motors

A Big Car Speeds It Up with Steam | Ein Großer macht (Wasser-)Dampf

www.gm.com

The Chevrolet Equinox Fuel Cell is far more than just a concept car. The SUV with eco-friendly fuel-cell drive is already in the practical test phase. Since fall 2007, a number of vehicles are being driven on a daily basis in the USA, and General Motors wants to increase this to a fleet of 100 vehicles throughout the world. The two-ton SUV, which uses no gasoline and has no exhaust fumes except for steam, is also set to prove its suitability for everyday use in Germany. GM has already introduced the European version of the Chevrolet Equinox Fuel Cell under the model name of HydroGen4. The vehicle is powered by a 100-HP electric motor. The fuel cell produces an output of up to 125 HP on its own, which is accumulated in the storage batteries and made available to the electric motor. The Equinox Fuel Cell can also be started and operated at temperatures below freezing—which represents a considerable innovation compared to the preceding generation and means an important step in the direction of suitability for everyday use.

Weit mehr als nur ein Concept-Car ist der Chevrolet Equinox Fuel Cell. Der SUV mit umweltfreundlichem Brennstoffzellenantrieb befindet sich bereits in der praktischen Erprobung. Seit Herbst 2007 sind mehrere Fahrzeuge in den USA im Alltagseinsatz, General Motors will weltweit eine Flotte von 100 Fahrzeugen aufbauen. Seine Alltagstauglichkeit soll der zwei Tonnen schwere SUV, der kein Benzin verbraucht und außer Wasserdampf keine Abgase ausstößt, auch in Deutschland unter Beweis stellen. GM hat unter der Typbezeichnung HydroGen4 bereits die europäische Version des Chevrolet Equinox Fuel Cell vorgestellt. Angetrieben wird das Fahrzeug von einem 100 PS starken Elektromotor. Die Brennstoffzelle selbst produziert eine Leistung von bis zu 125 PS, die in Akkus gespeichert und dem Elektromotor zur Verfügung gestellt wird. Der Equinox Fuel Cell lässt sich auch bei Temperaturen unter dem Gefrierpunkt starten und betreiben – dies stellt eine wesentliche Neuerung gegenüber der Vorgängergeneration dar und bedeutet einen wichtigen Schritt in Richtung Alltagstauglichkeit.

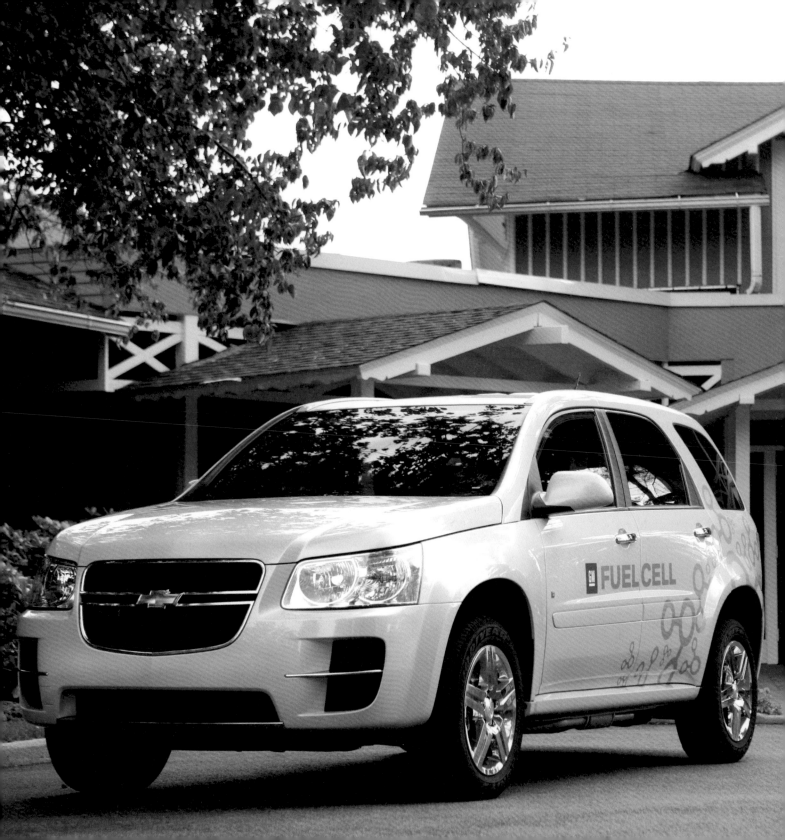

Data and Facts	Airstream Concept
Engine Type \| Antriebsart	hydrogen fuel cell \| Brennstoffzelle
Status \| Status	concept car
Displacement \| Hubraum	-
Output \| Leistung	no data \| keine Angaben
Fuel Consumption \| Verbrauch	no data \| keine Angaben
CO₂ Emission \| CO₂-Ausstoß	0 g/km
Cruising Range \| Reichweite	304 mi \| 490 km
Acceleration \| Beschleunigung	no data \| keine Angaben
Max. Speed \| Geschwindigkeit	no data \| keine Angaben

Ford Airstream Concept | Ford Motor Company

Camper, Spaceship, Car of the Future | Wohnwagen, Raumschiff, Zukunftsauto
www.ford.com

The legendary Airstream caravan has a cult status, and not just among fans of design. The silvery shining mobiles also provided the name for an innovative concept car that Ford presented at the Detroit Motor Show in 2007. It is intended to offer a stylistic outlook of the future in the crossover segment. Ford calls the study a Crossover Utility Vehicle (CUV). Its creators also allowed themselves to be inspired by space travel in its design. While the driver enters on the left side of the vehicle through a normal door, the right side has a large clamshell door that opens upward. The interior also has a futuristic design. The driver and passenger sit on swiveling bucket seats; the passenger area has a lounge atmosphere. The drive for the study developed jointly by Ford and Airstream is a fuel cell. According to statements by Ford, the hydrogen unit is only about half as heavy as customary units and is convincing because of the almost unlimited suitability for everyday use with half the costs. For example, the fuel cell of the Ford Airstream Concept also operates at temperatures below freezing without any restrictions. The Airstream drives about 24 miles with battery power. If the battery charge runs out, the fuel cell delivers new energy for the distance of another 280 miles.

Nicht nur unter Design-Liebhabern genießen die legendären Airstream-Wohnanhänger Kultstatus. Die silbern glänzenden Mobile waren auch Namenspatron für ein innovatives Concept-Car, das Ford 2007 auf der Detroit Motor Show vorstellte. Es soll stilistisch einen Ausblick auf die Zukunft des Crossover-Segments bieten. Ford bezeichnet die Studie als Crossover Utility Vehicle (CUV). Bei seinem Design ließen sich die Gestalter auch von der Raumfahrt inspirieren. Während der Fahrer auf der linken Fahrzeugseite durch eine gewöhnliche Tür einsteigt, befindet sich auf der rechten Seite eine große Flügeltür, die nach oben klappt. Futuristisch gestaltet sich auch der Innenraum. Fahrer und Beifahrer nehmen auf drehbaren Schalensitzen Platz, im Passagierbereich herrscht Lounge-Atmosphäre. Als Antrieb dient der von Ford und Airstream gemeinsam entwickelten Studie eine Brennstoffzelle. Das Wasserstoff-Aggregat ist nach Ford-Angaben nur rund halb so schwer wie gewöhnliche Einheiten und überzeugt bei der Hälfte der Kosten mit nahezu uneingeschränkter Alltagstauglichkeit. So funktioniert die Brennstoffzelle des Ford Airstream Concept beispielsweise auch bei Temperaturen unterhalb des Gefrierpunkts ohne Einschränkungen. Mit Batteriekraft fährt der Airstream etwa 40 Kilometer weit. Geht die Akkuladung zur Neige, liefert die Brennstoffzelle neue Energie für weitere 450 Kilometer Fahrstrecke.

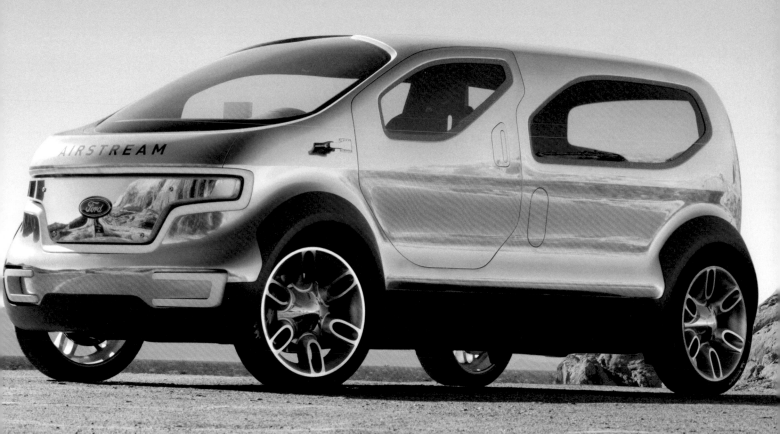

Data and Facts	FCX Clarity
Engine Type \| Antriebsart	hydrogen fuel cell \| Brennstoffzelle
Status \| Status	2008 (Testing phase)
Displacement \| Hubraum	-
Output \| Leistung	100 kW; 136 HP \| PS
Fuel Consumption \| Verbrauch	no data \| keine Angaben
CO_2 Emission \| CO_2-Ausstoß	0 g/km
Cruising Range \| Reichweite	267 mi \| 430 km
Acceleration \| Beschleunigung	no data \| keine Angaben
Max. Speed \| Geschwindigkeit	100 mph \| 160 km/h

Honda FCX Clarity | Honda

The Future Is Here | Zukunft in der Gegenwart
www.honda.com

While some manufacturers are still researching fuel cells, you can already drive them at Honda. Beginning in summer 2008, the Japanese manufacturer wants to market the FCX Clarity, an emission-free fuel-cell vehicle to a limited extent in California. This means: The first built cars ought to be tested in everyday life through a leasing agreement. The FCX with its futuristic design is 15.9 feet long and has a fuel-cell drive that equals the performance standard of an European medium-sized car with 136 HP. The heart of the FCX is a new fuel-cell platform that has clearly undergone advanced development in compactness, efficiency, and endurance. Hydrogen from the tank and oxygen from the surrounding air react inside of it.The energy that is released is transformed into electrical current for driving the vehicle. Morever, kinetic energy is recovered when braking the vehicle and stored in the lithium-ion battery pack together with the excess energy from the fuel cell. If necessary, this energy can also be retrieved in addition to the energy from the fuel cell. Only water is emitted into the atmosphere through the exhaust pipe of the FCX. The FCX Clarity also demonstrates its environmental consciousness in the seat cushions and door panelling. They are made of Honda Bio-Fabric, a newly developed plant material.

Während manche Hersteller noch an der Brennstoffzelle forschen, kann man sie bei Honda schon fahren. Ab Sommer 2008 will der japanische Hersteller den FCX Clarity, ein emissionsfreies Brennstoffzellenfahrzeug, in begrenztem Umfang in Kalifornien vermarkten. Das heißt: Die ersten gebauten Fahrzeuge sollen über einen Leasing-Vertrag im Alltag getestet werden. Der futuristisch gestaltete, 4,84 Meter lange FCX verfügt über einen Brennstoffzellenantrieb, der mit 136 PS auf dem Leistungsniveau einer europäischen Mittelklasse-Limousine liegt. Herzstück des FCX ist eine neue Brennstoffzellenplattform, die in Kompaktheit, Effizienz und Ausdauer deutlich weiterentwickelt wurde. In ihr reagieren Wasserstoff aus dem Tank und Sauerstoff aus der Umgebungsluft. Die dabei freigesetzte Energie wird in elektrischen Strom zum Antrieb des Fahrzeugs umgewandelt. Überdies wird beim Abbremsen des Fahrzeugs kinetische Energie zurückgewonnen und zusammen mit überschüssiger Energie aus der Brennstoffzelle im Lithium-Ionen-Akkupack gespeichert. Diese Energie kann bei Bedarf zusätzlich zur Energie aus der Brennstoffzelle abgerufen werden. Durch den Auspuff des FCX gelangt lediglich Wasser in die Atmosphäre. Umweltbewusst zeigt sich der FCX Clarity auch bei Sitzpolster und Türverkleidungen. Sie sind aus Honda Bio-Fabric gefertigt, einem neu entwickelten pflanzlichen Material.

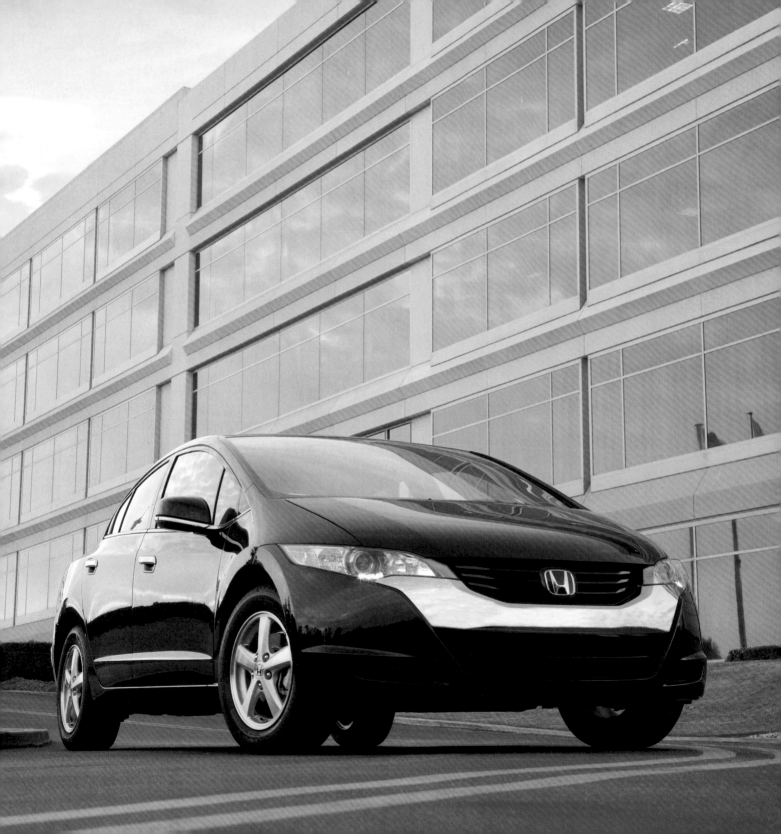

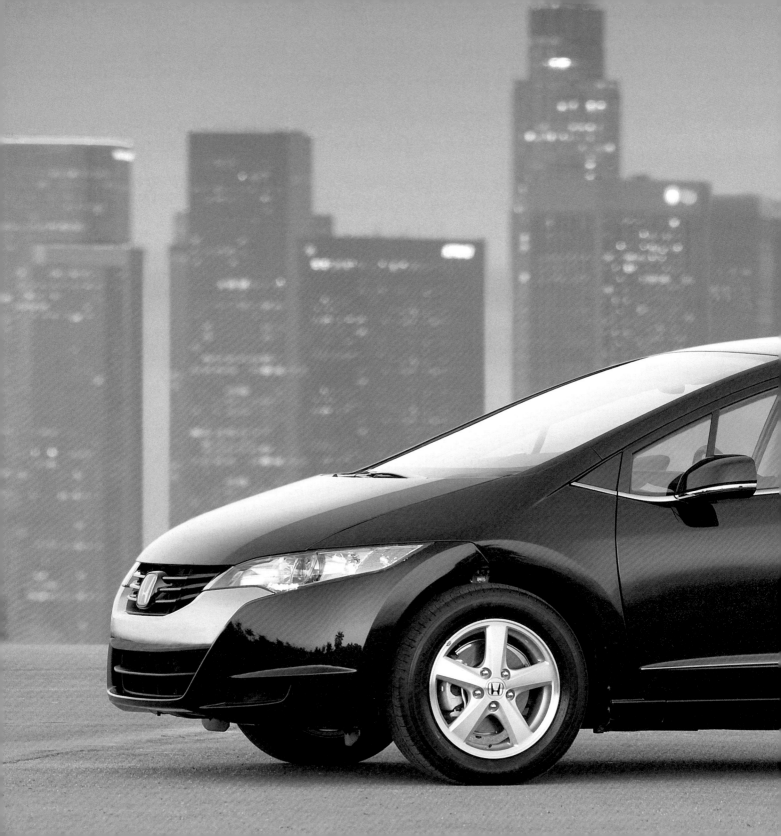

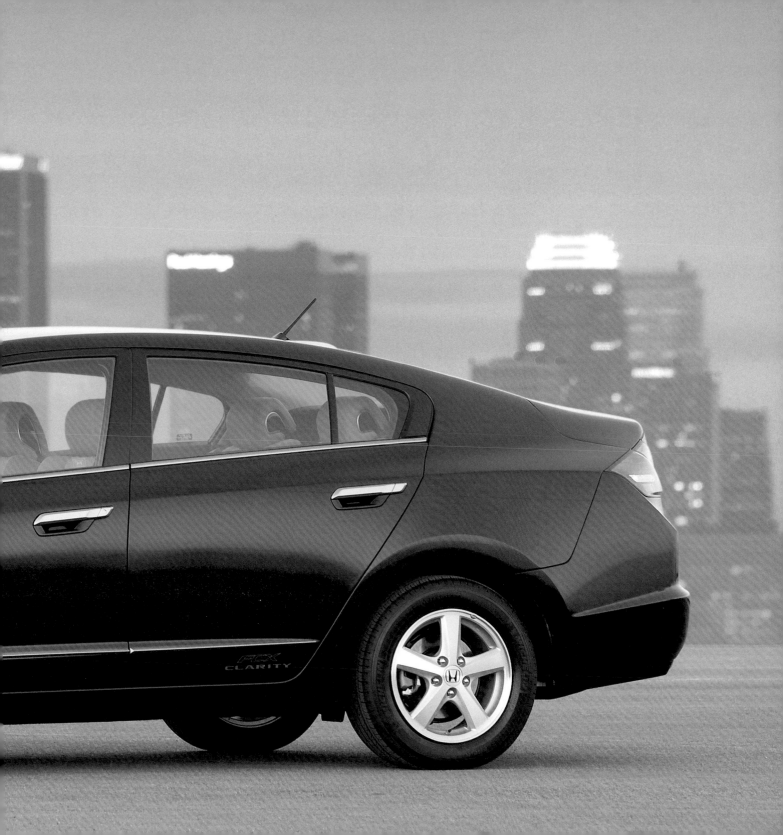

Data and Facts	B-Class Fuel Cell
Engine Type \| Antriebsart	hydrogen fuel cell \| Brennstoffzelle
Status \| Status	2010
Displacement \| Hubraum	-
Output \| Leistung	100 kW; 136 HP \| PS
Fuel Consumption \| Verbrauch	no data \| keine Angaben
CO$_2$ Emission \| CO$_2$-Ausstoß	0 g/km
Cruising Range \| Reichweite	71 mi \| 115 km
Acceleration \| Beschleunigung	no data \| keine Angaben
Max. Speed \| Geschwindigkeit	no data \| keine Angaben

Mercedes-Benz B-Class Fuel Cell | Daimler AG

All Clear for the Premiere | Start frei zur Premiere

www.daimler.com

Mercedes-Benz has long researched the development of the fuel cell: In 1994, the company introduced the first fuel-cell vehicle in the world. Although the innovative technology had to originally be housed in a transporter, they succeeded in placing the fuel cell next to all of the aggregates in an A-Class in 2002. Extensive driver tests with this model are allowing the date for series production to get closer. In 2010, Mercedes wants to put the larger B-Class on the market in a small series with an emission-free fuel-cell drive. The reaction of hydrogen and oxygen results only in steam, which escapes through the exhaust pipe into the atmosphere. Mercedes-Benz presented the current and optimized fuel-cell system in 2005 in the research vehicle F 600 Hygenius. This very compact fuel cell works considerably more efficiently than the previous generations. The newly designed stack is about 40 percent smaller and develops 30 percent more power with 16 percent less consumption. The electric motor built for the B-Class develops 136 HP and a maximum torque of 320 newton-meters. This means that the B-Class F-Cell enables performances that are above the level of a two-liter gasoline-driven car.

Schon lange forscht Mercedes-Benz an der Entwicklung der Brennstoffzelle: 1994 stellte der Konzern das erste Brennstoffzellenfahrzeug der Welt vor. Musste die innovative Technik zuerst in einem Transporter untergebracht werden, gelang es 2002, die Brennstoffzelle nebst aller Aggregate in einer A-Klasse zu platzieren. Ausführliche Fahrerprobungen mit diesem Modell lassen die Serienfertigung näher rücken. 2010 will Mercedes die größere B-Klasse in einer Kleinserie mit einem emissionsfreien Brennstoffzellenantrieb auf den Markt bringen. Durch die Reaktion von Wasserstoff und Sauerstoff entsteht lediglich Wasserdampf, der durch den Auspuff in die Atmosphäre entweicht. Das aktuelle und optimierte Brennstoffzellen-System hatte Mercedes-Benz 2005 im Forschungsfahrzeug F 600 Hygenius vorgestellt. Diese sehr kompakte Brennstoffzelle arbeitet wesentlich effizienter als vorherige Generationen. Der neu konzipierte „Stack" ist rund 40 Prozent kleiner und entwickelt 30 Prozent mehr Leistung bei 16 Prozent weniger Verbrauch. Der für die B-Klasse vorgesehene Elektromotor entwickelt 136 PS und ein maximales Drehmoment von 320 Newtonmetern. Damit erfüllt die B-Klasse F-Cell Leistungen, die über dem Niveau eines Zweiliter-Benziners liegen.

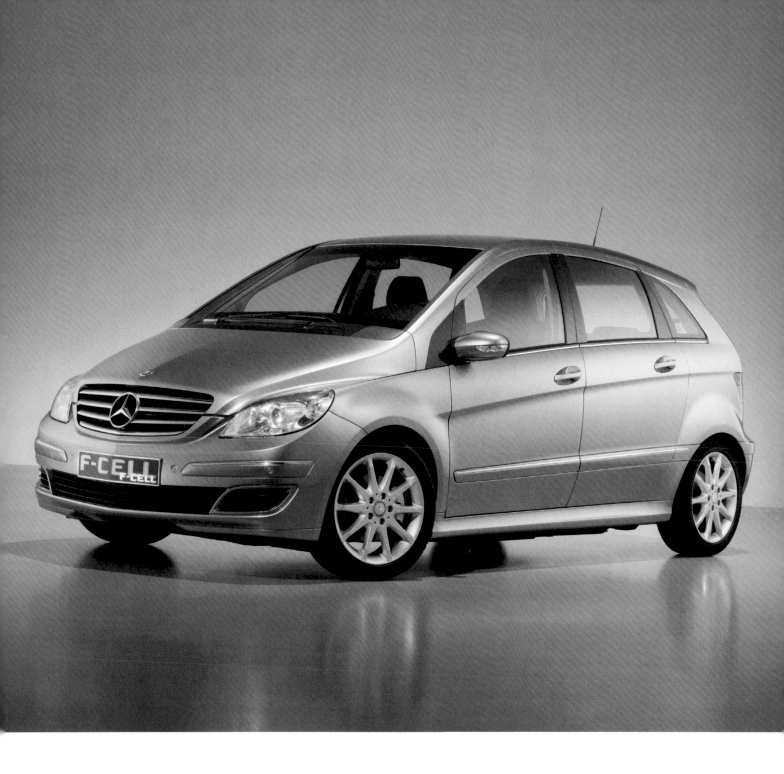

Data and Facts	207 Epure
Engine Type \| Antriebsart	hydrogen fuel cell \| Brennstoffzelle
Status \| Status	concept car
Displacement \| Hubraum	-
Output \| Leistung	20 kW; 27 HP \| PS (hydrogen) 40 kW; 54 HP \| PS (electro)
Fuel Consumption \| Verbrauch	no data \| keine Angaben
CO_2 Emission \| CO_2-Ausstoß	0 g/km
Cruising Range \| Reichweite	217 mi \| 350 km
Acceleration \| Beschleunigung	no data \| keine Angaben
Max. Speed \| Geschwindigkeit	80 mph \| 130 km/h

Peugeot 207 Epure | Automobiles Peugeot

Open and Wonderful | Offen und herrlich

www.peugeot.com

Anyone who drives a convertible wants to enjoy the outdoors—at best without any bothersome exhaust fumes. The Peugeot 207 Epure, which was presented in fall 2006 at the Mondial de l'Automobile in Paris, shows how this can be done. The concept car designed in radiant mother-of-pearl white is driven by an electric motor that draws its energy from a fuel cell. This concept requires only hydrogen and oxygen for energy production. Instead of exhaust fumes, it produces steam. The 207 Epure uses a type of fuel-cell generation oriented toward compactness and efficiency that was developed in France. It is powered by 27 HP and offers an efficiency that is higher than 50 percent—a modern combustion engine only manages 25 to 30 percent. The hydrogen required for operation is stored in five tanks, each of which with a volume of 3.9 gallons. They are arranged in the trunk. The two seats have been kept in the back, as well as the space in the trunk for the collapsible soft top of the coupé convertible. The hydrogen helps the 207 achieve a range of 217 miles. The electric motor produces 54 HP and can offer a peak performance of 94 HP for a short time—which is certainly enough for a fast and, above all, emission-free ride in a convertible. With its electro-hydraulic convertible roof, the Peugeot 207 CC has already found its way into series production—but consumers are still waiting for the launch of fuel-cell series production.

Wer Cabrio fährt, will die Natur genießen—und das am besten ohne störende Abgase. Wie sich dies realisieren ließe, zeigt der im Herbst 2006 auf dem Mondial de l'Automobile in Paris präsentierte Peugeot 207 Epure. Das in strahlendem Perlmuttweiß gestaltete Concept-Car wird von einem Elektromotor angetrieben, der seine Energie aus einer Brennstoffzelle bezieht. Bei diesem Konzept werden lediglich Wasserstoff und Sauerstoff zur Energiegewinnung benötigt, statt Abgasen entsteht Wasserdampf. Beim 207 Epure kommt eine in Frankreich entwickelte Brennstoffzellengeneration zum Einsatz, die auf Kompaktheit und Effizienz ausgerichtet ist. Sie leistet 27 PS und bietet einen Wirkungsgrad von über 50 Prozent—ein moderner Verbrennungsmotor bringt es nur auf 25 bis 30 Prozent. Der für den Betrieb notwendige Wasserstoff befindet sich in fünf Tanks mit je 15 Liter Volumen, die im Kofferraum angeordnet sind. So bleiben die beiden Sitzplätze im Fond ebenso erhalten wie der Platz im Kofferraum für das zusammenklappbare Faltdach des Coupé-Cabrios. Der Wasserstoff verhilft dem 207 Epure zu einer Reichweite von 350 Kilometern. Der Elektromotor leistet 54 PS und kann kurzzeitig eine Spitzenleistung von 94 PS zur Verfügung stellen—allemal genug für eine flotte und vor allem emissionsfreie Cabriofahrt. Mit seinem elektrohydraulischen Klappdach hat der Peugeot 207 CC schon den Weg in die Serie gefunden—jetzt fehlt nur noch der Serienstart der Brennstoffzelle.

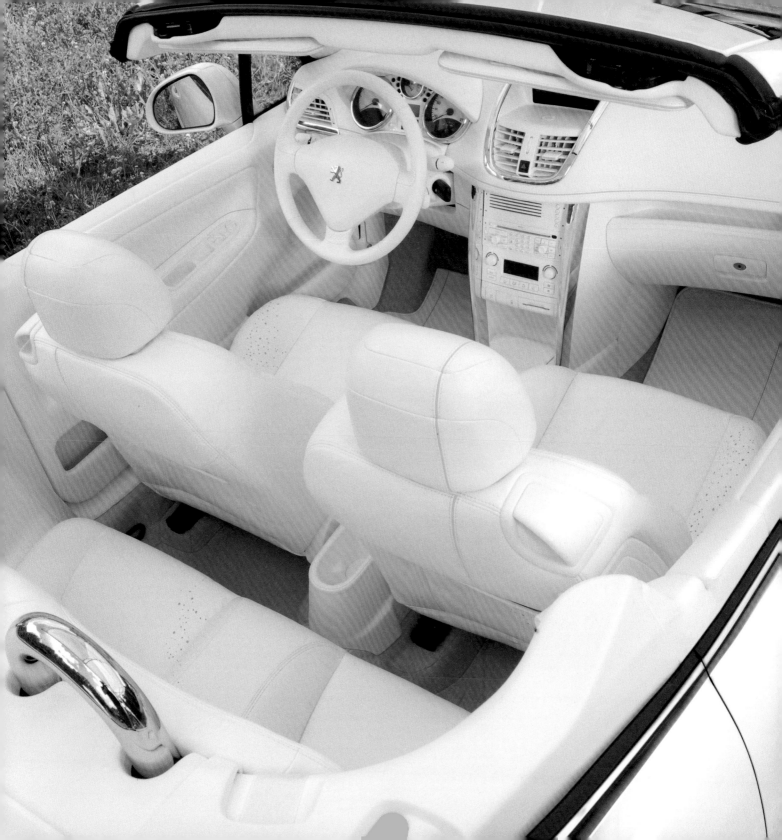

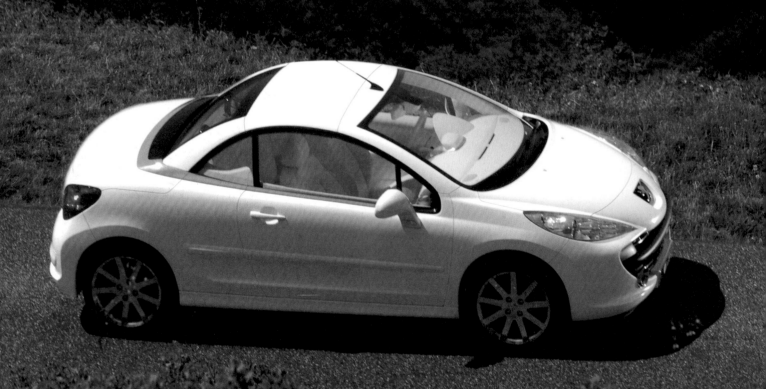

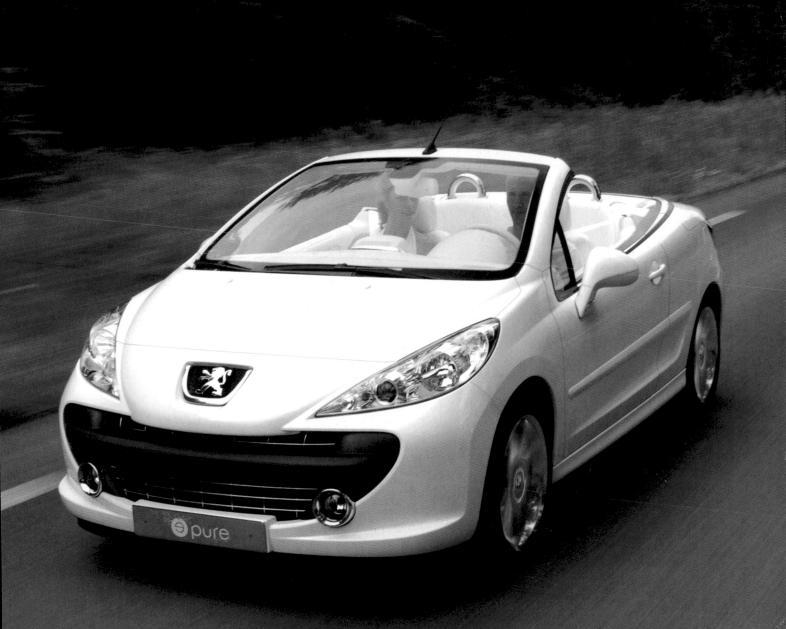

Data and Facts	LS	GT
Engine Type \| Antriebsart	diesel engine \| Dieselmotor	diesel engine \| Dieselmotor
Status \| Status	2010	2010
Displacement \| Hubraum	no data \| keine Angaben	no data \| keine Angaben
Output \| Leistung	15 kW; 20 HP \| PS	36 kW; 50 HP \| PS
Fuel Consumption \| Verbrauch	> 117 mpg \| < 2,0 l/100 km	> 78 mpg \| < 3,0 l/100 km
CO_2 Emission \| CO_2-Ausstoß	< 50 g/km	no data \| keine Angaben
Cruising Range \| Reichweite	> 621 mi \| > 1000 km (20 l Tank)	> 435 mi \| > 700 km (20 l Tank)
Acceleration \| Beschleunigung	16 s (0-60 mph \| 0-100 km/h)	10 s (0-60 mph \| 0-100 km/h)
Max. Speed \| Geschwindigkeit	100 mph \| 160 km/h	125 mph \| 200 km/h

Loremo LS & GT | Loremo AG

Light-Weight | Leicht-Gewicht

www.loremo.com

The discovery is not new, but it appears to have been pushed into the background in the activities of some automobile developers: A good amount of fuel can be saved even without complicated technology if the weight of the car is kept as low as possible. The Loremo follows this simple logic. The miracle of economy from Germany weighs in less than 1.323 pounds. With a two-cylinder turbo-diesel engine that has just 20 HP, the Loremo LS has a fuel consumption of 117 miles per gallon. Those who would like a sportier road performance can decide on the more powerful Loremo GT with three cylinders and 50 HP that reportedly makes the 2+2-seater faster than 125 mph. The light-weight with its length of 12.5 feet and height of just 3.7 feet has an unusual entry. There are no side doors; instead, the entire front part with its windshield and hood must be folded forward. The two seats in the back are arranged to face away from the direction of travel. This principle is intended to not only offer more safety in case of an accident, but also allows a coupé shape with a dramatically dropping roofline.

Die Erkenntnis ist nicht neu, aber sie scheint bei manchen Autoentwicklern in den Hintergrund des Wirkens gerückt: Auch ohne aufwändige Technik lässt sich dadurch viel Kraftstoff sparen, wenn man das Gewicht des Autos möglichst niedrig hält. Dieser simplen Logik folgt der Loremo. Das Sparwunder aus Deutschland bringt weniger als 600 Kilogramm auf die Waage, und mit einem nur 20 PS starken Zweizylinder-Turbodieselmotor soll der Loremo LS weniger als zwei Liter Diesel auf 100 Kilometer verbrauchen. Wer etwas sportlichere Fahrleistungen mag, kann sich für den stärkeren Loremo GT mit drei Zylindern und 50 PS entscheiden, der den 2+2-Sitzer sogar 200 km/h schnell machen soll. Das 3,80 Meter lange und nur 1,14 Meter hohe Leichtgewicht bietet einen außergewöhnlichen Einstieg. Seitliche Türen sind keine vorhanden, statt dessen muss die komplette Frontpartie mit Windschutzscheibe und Haube nach vorne geklappt werden. Die beiden Sitze im Fond sind entgegen der Fahrtrichtung angeordnet. Dieses Prinzip soll bei einem Unfall nicht nur mehr Sicherheit bieten, sondern ermöglicht auch eine Coupé-Form mit stark abfallender Dachlinie.

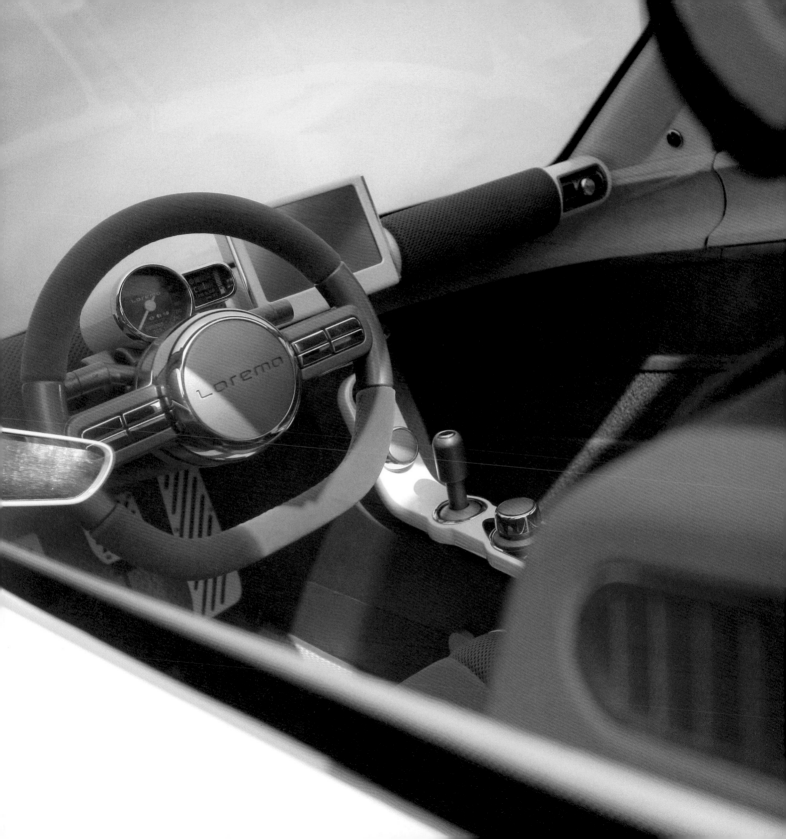

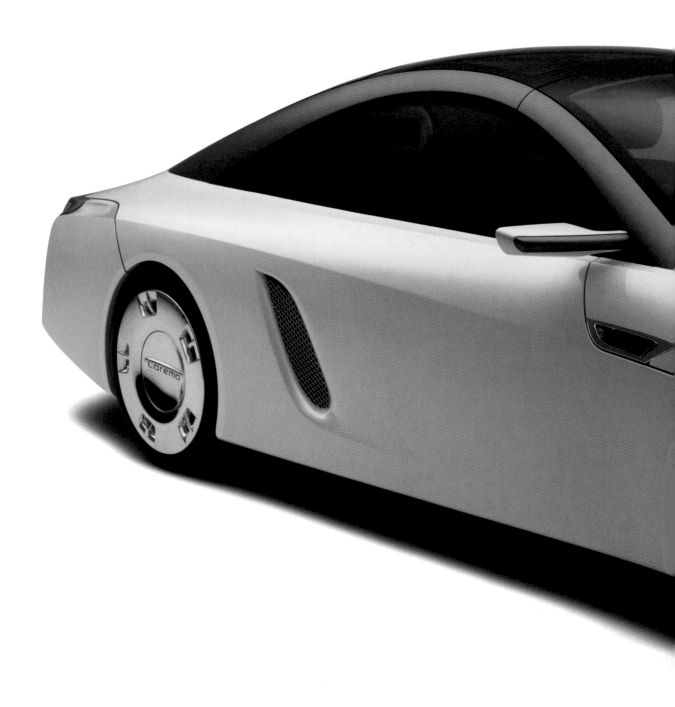

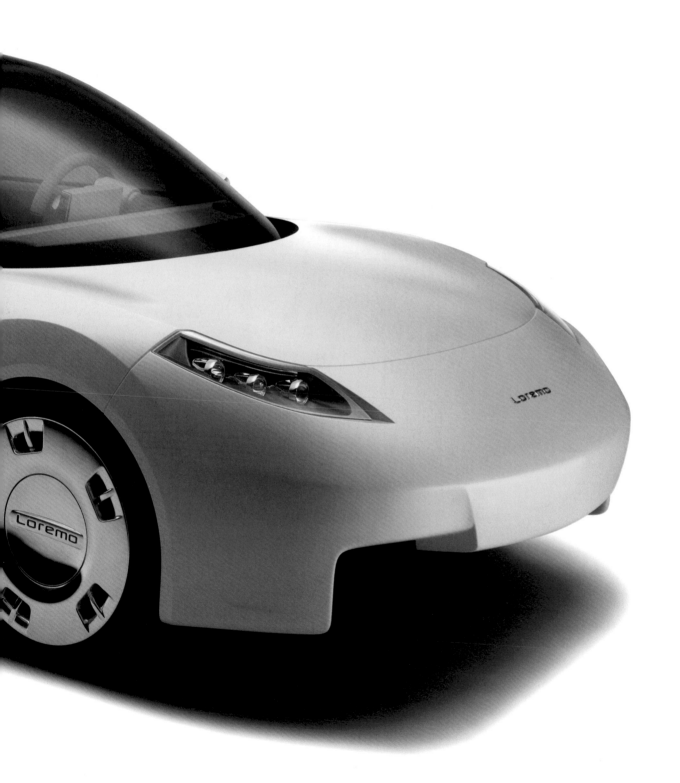

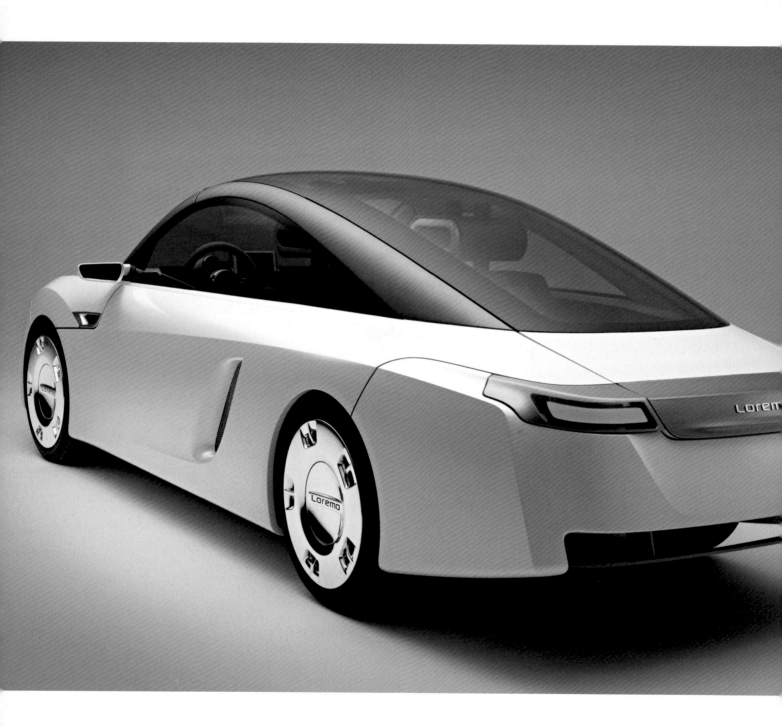

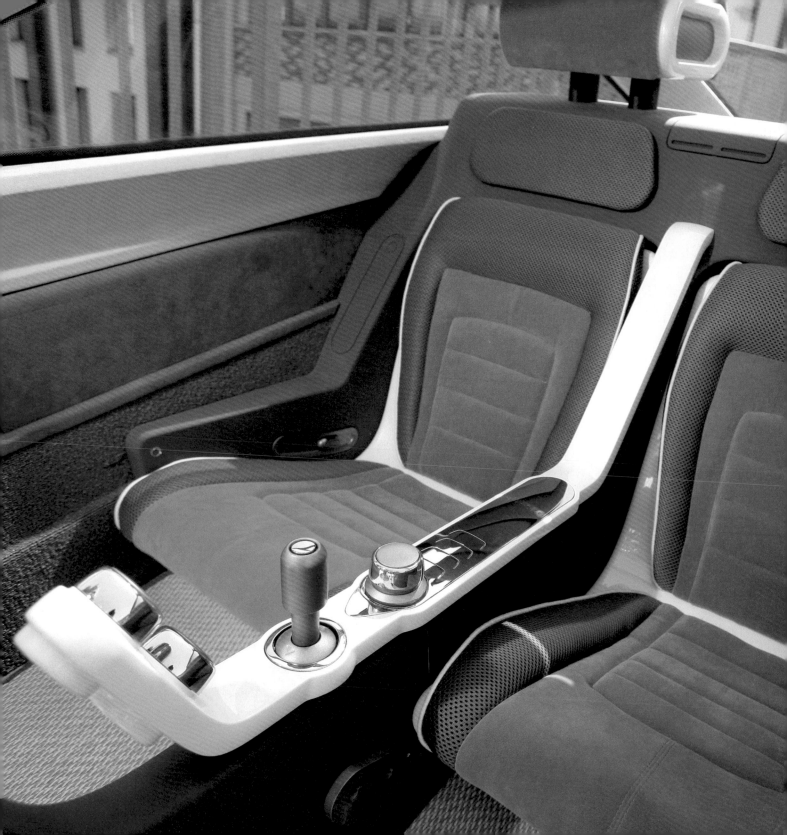

Data and Facts		Bionic Car
Engine Type \| Antriebsart		diesel engine \| Dieselmotor
Status \| Status		concept car
Displacement \| Hubraum		2000 cm³
Output \| Leistung		103 kW; 140 HP \| PS
Fuel Consumption \| Verbrauch		70 mpg \| 4,3 l/100 km
CO₂ Emission \| CO₂-Ausstoß		no data \| keine Angaben
Cruising Range \| Reichweite		no data \| keine Angaben
Acceleration \| Beschleunigung		8.2 s (0-60 mph \| 0-100 km/h)
Max. Speed \| Geschwindigkeit		118 mph \| 190 km/h

Mercedes-Benz Bionic Car | Daimler AG
Nature as the Model | Die Natur als Vorbild
www.daimler.com

Engineers have frequently used nature as a model for new technical solutions in the past. In 2005, Daimler AG developed the Mercedes-Benz bionic car into a complete concept car that is oriented upon models from nature. The model for the Mercedes-Benz bionic car is the boxfish, which lives in tropical waters. Despite its square, cube-shaped body, it has outstanding aerodynamic properties and therefore represents an aerodynamic ideal. The Mercedes-Benz bionic car presents itself as an efficient, drivable compact car of 13.9 feet in length and room for four passengers. With a drag coefficient of 0.19, the concept vehicle is one of the most aerodynamic cars of the size. The boxfish is also a classic example of stiffness and lightweight construction. The Mercedes researchers have translated its bionic structure into the concept vehicle. For example, it was possible to achieve stiffness in the skin of the doors that is up to 40 percent higher than for conventional constructions. If the entire shell structure is calculated according to the bionic pattern, the weight is reduced by about one-third with an unchanged good stability and crash safety. In addition to the perfect aerodynamics and a lightweight construction concept derived from nature, the diesel engine and SCR technology (Selective Catalytic Reduction) make a substantial contribution to fuel economy and the reduction of exhaust emissions.

Die Natur war schon häufig den Ingenieuren ein Vorbild für neue technische Lösungen. Mit Mercedes-Benz bionic car hat die Daimler AG 2005 erstmals ein komplettes Konzeptfahrzeug entwickelt, das sich an Vorbildern aus der Natur orientiert. Beim Mercedes-Benz bionic car ist dies der Kofferfisch, der in tropischen Gewässern lebt. Trotz seines kantigen, würfelförmigen Rumpfes besitzt er hervorragende Strömungseigenschaften und stellt deshalb ein aerodynamisches Ideal dar. Das Mercedes-Benz bionic car präsentiert sich als funktionstüchtiger, fahrbereiter Kompaktwagen mit 4,24 Metern Länge und Platz für vier Passagiere. Mit einem cW-Wert von 0,19 zählt das Konzeptfahrzeug zu den strömungsgünstigsten Autos dieser Größenklasse. Der Kofferfisch ist auch ein Musterbeispiel für Steifigkeit und Leichtbau. Die Mercedes-Forscher haben seine bionische Struktur auf das Konzeptfahrzeug übertragen. So ließ sich beispielsweise an der Außenhaut der Türen eine bis zu 40 Prozent höhere Steifigkeit als bei herkömmlichen Konstruktionen erzielen. Berechnet man die gesamte Rohbaustruktur nach dem bionischen Muster, sinkt das Gewicht bei unverändert guter Stabilität und Crashsicherheit um rund ein Drittel. Neben der perfekten Aerodynamik und einem von der Natur abgeleiteten Leichtbaukonzept tragen auch der Dieselmotor und die SCR-Technologie (Selective Catalytic Reduction) maßgeblich zur Kraftstoffeinsparung und zur Verringerung der Abgasemissionen bei.

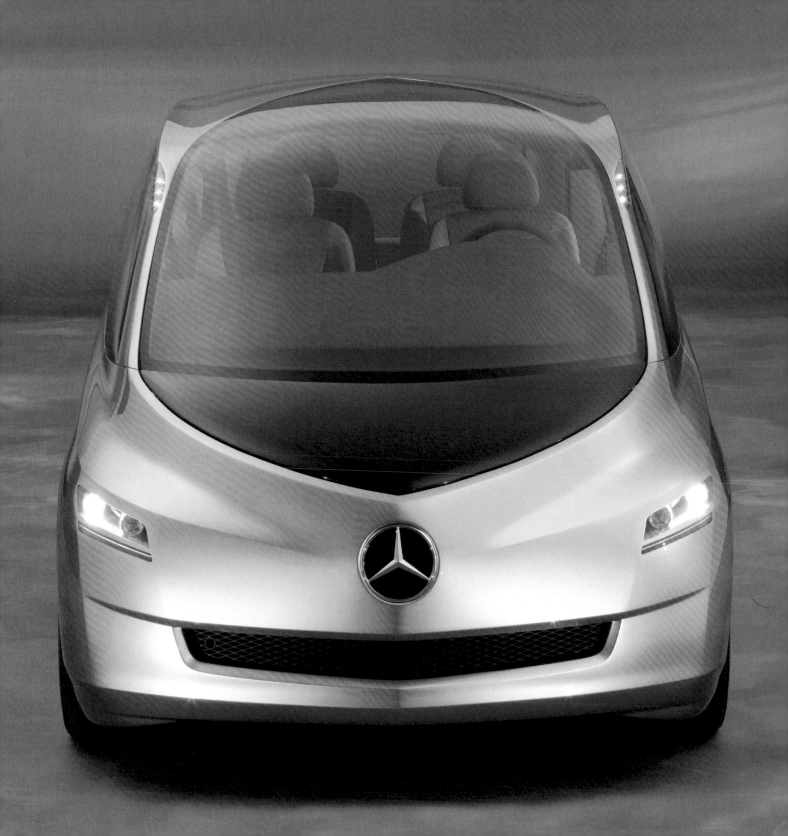

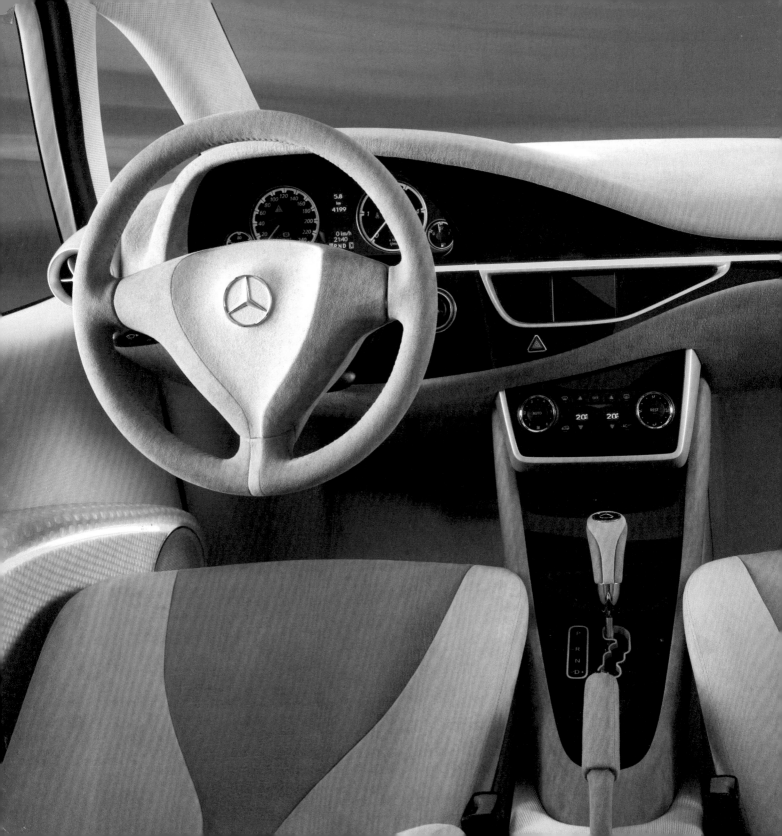

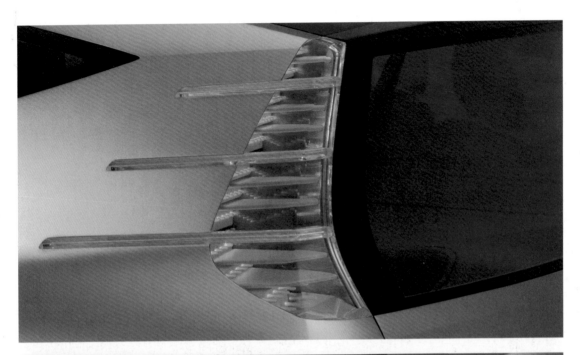

imprint

Bibliographic information published by the Deutsche Nationalbibliothek
The Deutsche Nationalbibliothek lists this publication in the Deutsche Nationalbibliografie; detailed bibliographic data are available in the Internet at http://dnb.d-nb.de.

ISBN: 978-3-89986-098-6

© 2008 avedition GmbH, Ludwigsburg
© 2008 Edited and produced by
fusion publishing GmbH, Stuttgart . Los Angeles
www.fusion-publishing.com

Printed in Austria
by Vorarlberger Verlagsanstalt AG, Dornbirn

Paper: EuroBulk by M-real Hallein AG
It is PEFC, DIN EN ISO 9001, DIN EN ISO 14001 and EMAS certified.

avedition GmbH
Königsallee 57 | 71638 Ludwigsburg | Germany
p +49-7141-1477391 | f +49-7141-1477399
www.avedition.com | contact@avedition.com

EDITORIAL NOTE | REDAKTIONELLE ANMERKUNG:
no data = Data not specified yet.
Keine Angaben = Daten sind noch nicht verfügbar.
"-" = There is no data for this engine type.
"-" = Es gibt keinen Wert für diese Antriebsart.

Team: Ulrich Bethscheider-Kieser (Author),
Jens Kilian (Editorial management, Layout),
Jan Hausberg (Imaging & prepress),
Alphagriese Fachübersetzungen, Düsseldorf (Translations)

Photocredits (car): courtesy Airstream, Inc (Ford Airstream Concept); courtesy Aptera Motors, Inc (Aptera Typ-1); courtesy Audi AG (Audi Metroproject Quattro, Audi Q7 Hybrid); courtesy Automobiles Citroën (Citroën C4 Hybrid HDi, Citroën C-Cactus); courtesy BMW AG (BMW Concept X6 ActiveHybrid, BMW Hydrogen 7); courtesy Commuter Cars (Tango T600); courtesy Daimler AG (Mercedes-Benz E 200 NGT, Mercedes-Benz F 700, Mercedes-Benz S 300 Bluetec Hybrid, Smart Fortwo ed & mhd, B-Klasse F-Cell, Bionic Car); courtesy Dingo (Nissan Mixim); courtesy Fisker Automotive Inc. (Karma); courtesy Fuji Heavy Industries Ltd. (Subaru G4e Concept); courtesy GM (Opel Flextreme (cover), Chevrolet Tahoe Hybrid GMC Graphyte, Chevrolet Volt, Chevrolet Equinox Fuel Cell); courtesy Honda (Honda CR-Z, FCX Clarity); courtesy Hyundai Motor (i-Blue); courtesy Loremo AG (Loremo LS & GT); courtesy Mazda Motor Corporation (Mazda Senku, Mazda Premacy Hydrogen RE Hybrid); courtesy Michel Zumbrunn (Venturi Astrolab, Venturi Fetish); courtesy Nissan Motor Co., Ltd. (Nissan Pivo 2); courtesy Peugeot (308 Hybrid HDi, 207 Epure); courtesy Rinspeed AG (Rinspeed Exasis); courtesy Saab Automobile AB (Saab Aero X, Saab Bio Power 100); courtesy Stephane Foulon (Venturi Eclectic); courtesy Tesla Motors (Tesla Roadster); courtesy Think (TH!NK city); courtesy Toyota Motor Europe (Lexus LS 600h, Toyota 1/X, Toyota FT-HS, Toyota Hybrid X, Prius); courtesy Volkswagen AG (Space Up! Blue); courtesy Volvo (Volvo C30 ReCharge Concept).

Ulrich Bethscheider-Kieser
Born in 1964 and lives in Germany. As a freelance journalist he writes about cars for more than 20 years.

Ulrich Bethscheider-Kieser
Geboren 1964, lebt in Deutschland. Als freier Journalist schreibt er seit über 20 Jahren über Autos.

green designed series (upcoming):

green designed: Kitchen & Dining
green designed: Living & Relax
green designed: Fashion

Further information and links at
www.bestdesigned.com
www.fusion-publishing.com

All books are released in German and English